j

Impressionist and Post-Impressionist Masterpieces

at the Musée d'Orsay

FALMOUTH CAMPUS LIBRARY WITHDRAWN

Impressionist and Post-Impressionist Masterpieces

at the Musée d'Orsay

Foreword by

MICHEL LACLOTTE Inspector-General of French Museums, with special responsibility for the Musée du Louwre (Paintings) and the Musée d'Orsay

Introduction by

Commentaries on the plates by

GENEVIÈVE LACAMBRE Chief Curator at the Musée d'Orsay

ANNE DISTEL CLAIRE FRÈCHES-THORY Sylvie Gache-Patin Curators at the Musée d'Orsay

EDWARD LUCIE-SMITH

With 93 colour plates

THAMES AND HUDSON in collaboration with ÉDITIONS DE LA RÉUNION DES MUSÉES NATIONAUX

Foreword and commentaries translated from the French by Edward Lucie-Smith

Photographs supplied by the Service Photographique de la Réunion des musées nationaux, Paris

Any copy of this book issued by the publisher as a paperback is sold subject to the condition that it shall not by way of trade or otherwise be lent, re-sold, hired out or otherwise circulated, without the publisher's prior consent, in any form of binding or cover other than that in which it is published and without a similar condition including these words being imposed on a subsequent purchaser.

Revised and expanded edition of the work first published as Impressionist Masterpieces at the Jeu de Paume, Paris

© 1984, 1986 Thames and Hudson Ltd, London

Paintings by Bernard, Matisse, Monet, Sérusier and Signac © 1984, 1986 SPADEM, Paris Paintings by Cassatt and Van Rysselberghe © 1984, 1986 ADAGP, Paris

All rights reserved. No part of this publication may be reproduced or transmitted in any form or by any means, electronic or mechanical, including photocopy, recording, or any information storage and retrieval system, without prior permission in writing from the publisher.

Phototypeset by Keyspools Ltd, Golborne, Lancs Colour reproduction by Cliché Lux S.A., La Chaux-de-Fonds, Switzerland Printed and bound in the Netherlands by Royal Smeets Offset b.v.

759.054 IMP RT GA AZ

CONTENTS

Foreword	6
Introduction	8
PLATES AND COMMENTARIES	15
Frédéric Bazille	16
Edouard Manet	18
Edgar Degas	34
Camille Pissarro	50
Paul Cézanne	62
Eugène Boudin	78
Claude Monet	80
Alfred Sisley	104
Pierre-Auguste Renoir	114
Berthe Morisot	126
Mary Cassatt	128
Gustave Caillebotte	130
Odilon Redon	132
Paul Gauguin	142
Vincent van Gogh	158
Georges Seurat	172
Henri-Edmond Cross	176
Théo van Rysselberghe	178
Paul Signac	180
Henri de Toulouse-Lautrec	184
Emile Bernard	194
Paul Sérusier	196
Henri Matisse	198
List of Plates	200

FOREWORD

The history of the national collection of Impressionist painting, now to be seen at the Musée d'Orsay, goes back to 1890, when Claude Monet organized a public subscription for the purchase of Manet's *Olympia* for the Musée du Luxembourg (then the official repository of modern art in Paris), fearing that otherwise it might be lost to France and go to the United States. Two years later, the state bought Renoir's *Jeunes filles au piano* from the artist. But coming as they did after years of indifference or hostility on the part of the establishment – attitudes shared by many collectors and critics – these acquisitions were not as yet real signs of official recognition. Although the Caillebotte bequest of 1894–96, which included masterpieces by Manet, Renoir, Cézanne, Sisley, Monet and Pissarro, was not in fact refused altogether, as legend still has it, only part of it was accepted.

The International Exhibition of 1900 marked the end of systematic opposition from the administrators of the arts, though the artists connected with the Salon and their supporters remained unreconciled to Impressionism and to what was later dubbed Post-Impressionism. A subscription organized in 1901, to acquire Gauguin's major work *D'où venons nous? Que sommes nous? Où allons nous? (Where Have We Come From? What Are We? Where Are We Going?*) for the Musée du Luxembourg, was a failure, and the painting is now in Boston. For its formation, the national collection was forced to rely on private generosity. In 1906, Etienne Moreau-Nélaton gave, among other masterpieces, Manet's *Le déjeuner sur l'herbe*, and in 1911 Isaac de Camondo bequeathed a splendid series of works by Degas, Monet and Cézanne, as well as the collection's first Van Gogh.

Thereafter, this basic collection was augmented by a flow of acquisitions. There were gifts from the families of artists (Toulouse-Lautrec in 1902; Bazille in 1904 and 1924; Renoir in 1923; Monet in 1927; Pissarro in 1930; Signac in 1979; Boutaric for Sérusier in 1983; Redon in 1984), and purchases from the Degas sale of 1917; above all there were gifts from well-informed and generous collectors (May, Kœchlin, Pellerin, David-Weill, Rouart, Goujon, Gangnat, du Cholet, Quinn), and also from the Friends of the Musée du Luxembourg. The Personnaz bequest of 1937 was the last major acquisition before the war.

Today, we cannot but regret the fact that substantial funds for large-scale purchasing were not available in the inter-war period. They would have made it possible for France to retain a number of masterpieces from an artistic movement which, though misunderstood for so long, has now taken its proper place in history.

The light-filled Jeu de Paume museum in the Tuileries was first opened in 1947. The opening took place at a time when artists were enraptured by the idea of pure painting, and it signalled the popular triumph of Impressionism. An active purchasing policy could at long last be put in hand, and an attempt made to fill the gaps in the collection – Seurat, for example – while this was still possible. Once again collectors, and the Society of Friends of the Louvre (to which the Jeu de Paume belonged), provided effective help. There were gifts of single major works by Cézanne, Van Gogh, Gauguin and Renoir. Groups of paintings were given by important collectors such as Polignac, Charpentier, Laroche, Gourgaud, Lung, Bernheim, Halphen, Goldschmidt-Rothschild, Meyer and Kahn-Sriber, who reserved part of their collections for the Louvre. Entire collections were also donated (Gachet, 1951–54; Mollard, 1972; Kaganovitch, 1973), each reflecting not only the taste of their particular owner, but also that of an entire generation. The Jeu de Paume collection grew in another way as well, through the fact that important works of art could now be ceded in lieu of estate duties. This added some major works, among them Renoir's *La danse à la ville* and Monet's *Rue Montorgueil*, in 1978 and 1982 respectively.

Although the Jeu de Paume provided an ideal setting at the time of its opening in 1947, by the late 1970s it became impossible to exhibit the collection as it should ideally be seen, so greatly had it expanded over the years. In 1977 the collection was further enriched by the great number of early paintings from the Musée National d'Art Moderne at the Palais de Tokyo, those by artists born before 1870, which were left behind when the more recent works from that museum went to the new Pompidou Centre. Thus the Neo-Impressionists, the Pont-Aven painters and the Nabis quite naturally joined Seurat and Gauguin. Meanwhile the decision was taken to create an entirely new museum. Just across the Seine from the Tuileries stood a great railway terminus, built in 1900 for the Paris-Orléans Company and derelict since the 1960s. Saved from demolition, this was to house the Musée d'Orsay.

Of course, the new museum is much more than an enlarged Jeu de Paume. With the aim of presenting a general overview of artistic creation in all its forms in the second half of the nineteenth century, it also illustrates other tendencies besides those designated by the names of Impressionism and Post-Impressionism. This is not to say that Impressionist and Post-Impressionist works are mixed together with the others: far from it. The main body of the museum – a succession of 'sequences' set off from each other by the wide variety of spaces afforded by the conversion of the old station – makes possible a clear and unambiguous ordering of exhibits. On the entrance level, paintings by Manet, Monet and their colleagues done before 1870 are displayed together in a series of rooms, in close proximity to those works by their contemporaries that embody related artistic concerns. By contrast, the next 'sequence', the longest and most splendid in the whole museum, traces the flowering of Impressionism and the fruitful crises of Post-Impressionism up to the end of the nineteenth century, and is devoted entirely to a coherent display of the movement's autonomous development. It is housed at the very top of the museum, in the light of the skies.

MICHEL LACLOTTE

INTRODUCTION

Impressionism marks a crisis-point in nineteenth-century art – not merely the abandonment of many ideas which had until then seemed immutably established, but the beginning of attitudes that we still recognize as being modern and immediately relevant to ourselves. At the same time, the Impressionist movement did not spring up suddenly and in total isolation from the historical process. It is not too much to claim that French art had in one way or another been preparing for its appearance ever since the early years of the eighteenth century. Although Impressionism's immediate ancestors were the realists and naturalists of the mid-nineteenth century, its remoter ones included not only Delacroix but Watteau, Boucher, Fragonard and (gazing across the Pyrenees) a number of great Spanish masters, notably Velásquez and Goya. Yet what was undoubtedly new was the Impressionists' concern for the immediate sensation, for the uncensored truth of the eye, conveyed without either forethought or afterthought.

When the senior painters who afterwards formed part of the group began to try to make their careers in the 1860s, during the last decade of the Second Empire, realism had already established, itself in opposition to the conventional academic style favoured by the entrenched Salon juries. This impulse towards a less conventional way of seeing affected artists who were themselves deeply conservative by temperament. We meet with interesting examples in the early work of Degas, for instance in his painting of *La famille Bellelli*, which dates from 1858–60. Here there is a new attitude to composition, evidently inspired by photography – one of the many scientific inventions of the period. These inventions, added together, were completely to alter man's perception of the world, and the Impressionists were the first artists to make a fundamental response to the change. What fascinated early enthusiasts for photography was not merely the notion that nature could now be persuaded to make her own portrait (the camera lens was deemed to be an entirely objective means of recording reality), but that photographic plates captured that reality with a fidelity and a regard for detail hitherto unattainable. The one thing that early photographs lacked, and it was a major omission, was colour.

The nature of colour, and the way in which the human eye perceived it, had naturally enough also attracted the scientific curiosity of the nineteenth century, and the Impressionist masters were the first artists to put the scientists' discoveries into effect. The conclusion of the theorists was that the whole gamut of colours derived in fact from a few pure tones, which blended optically on the retina. It became the ambition of the Impressionist group to demonstrate the truth of this contention by painting in small, pure touches that coalesced to create the required hue only when the spectator stood at a certain distance from the canvas. And in order to achieve a perfect reproduction of what the eye really perceived, the Impressionists believed that pictures were, as far as possible, to be created in the open air, in the very presence of what the artist was depicting.

If this had been all there was to it, the Impressionists would have remained purely a school of landscape painters. And indeed, as the visitor to the Musée d'Orsay will see, landscape subjects do loom very large in their total output. Certain members of the group, notably Alfred Sisley, produced virtually nothing else. It may be unconventional to begin a survey of Impressionist aims with Sisley instead of with greater and more all-encompassing masters such as Manet and Monet, but there is real reason for doing so. Sisley's beautiful *L'inondation à Port-Marly*, painted in 1876, and one of the very finest of all his pictures, shows the close link between Impressionism and somewhat earlier practitioners of *plein air* landscape painting such as Corot. The treatment of the house on the left is very much in Corot's manner, even though the floodwaters themselves are treated with a much broader and more glittering touch. A picture done two years earlier, Sisley's *Le brouillard* of 1874, because of the very nature of its subject, gives a notion of the extremes to which the Impressionists could take their particular view of landscape. The painting seems at first sight to be almost without structure, a capricious piling up of variously coloured dots. What one has here is not a painting of a particular spot, but an attempt to capture a particular effect of light.

This line of thinking was to be carried to extremes by Claude Monet in the latter part of his career. One of Monet's innovations was to paint the same motif over and over again. There are long series devoted to the west façade of Rouen Cathedral (two examples are illustrated in this book), to a group of haystacks in a field, and to the waterlilies which filled the ponds in the garden Monet created for himself at Giverny. Monet may have chosen Rouen Cathedral as the subject for one of these series with polemical intent, since here was a major Gothic structure infused with a wide range of meanings for all Frenchmen, and indeed for all Europeans who might see it. But these meanings were something the painter simply chose to ignore. He was intent only on recording the permutations of light and atmosphere on the complex façade, whose sole function was to modulate the atmospheric flux and make it visible. The Impressionist obsession with analysis of light and the process of seeing becomes the be-all and end-all of art; everything else is pushed aside as an irrelevance.

Monct's studies of Rouen Cathedral are of particular importance because they are the clearest demonstration of the way in which Impressionism altered the morality of painting. Until the middle of the nineteenth century, it had been a universally agreed idea that art was meant to express some moral standpoint espoused by the artist. Impressionism changed all this. It declared morals in paintings to be irrelevant, yet at the same time it turned the actual practice of painting into a series of moral choices: the painter had to be completely true to his own feelings concerning the nature of art. It is this conviction which links two artists otherwise as different from one another as Monet and Cézanne.

The question of morality and the painter's attitude to it is also extremely relevant in the case of Manet, who otherwise seems to fit rather uneasily into the Impressionist group. The Musée d'Orsay is fortunate enough to possess, amongst a superlative group of paintings by this artist, two works which were amongst the most controversial of their whole epoch: *Le déjeuner sur l'herbe* and *Olympia*, both painted in 1863. *Le déjeuner sur l'herbe* was described by an outraged contemporary critic as follows. 'A streetwalker, as naked as can be, shamelessly lolls between two dandies dressed to the teeth.' The irony was that Manet had made use of the most approved classic sources – the composition derives directly from a Renaissance engraving by Marcantonio Raimondi, after Raphael, and is strongly reminiscent of Titian's *Concert champêtre*, then as now one of the glories of the Louvre. *Olympia*, a reclining nude indebted both to Goya's *Naked Maja* and Titian's *Venus of Urbino*, aroused an equivalent anger among conservative critics, who translated into social and moral terms their disapproval of Manet's technical radicalism – his reduction of gradations of tone, and his emphasis on outline and on the importance of the picture-plane. Manet was not at this stage experimenting with optical mixtures, though he painted magnificent *plein air* scenes in the course of his career – *Sur la plage*, of 1873, is a particularly beautiful example.

Sur la plage is also an example of something else: the Impressionists' ability to render the very texture of life in their time. This, even more than their brilliant freshness of colour, is the quality that has made them so firmly beloved by the public. A number of extremely familiar examples of this gift can be found in these pages – Manet's own La serveuse de bocks, Renoir's incomparable Moulin de la Galette, and most of all a whole series of paintings and pastels by Degas. Indeed, Degas was perhaps, among all the contributors to the various Impressionist exhibitions, the one most determined to reflect what he saw as the nature of contemporary life. Yet of all the major Impressionists he remains, I think, the one who is most often misunderstood by the public.

What attitude are we meant to take, for example, towards one of the best-known of all his versions of contemporary urban life, the *Au café* of 1876? Its alternative title, *L'absinthe*, suggests that this may be an exception among Impressionist pictures in having a directly moral purpose, and it is certainly one where any trace of *joie de vivre* seems to be absent – two melancholic figures seated side by side, their psychological distance from one another stressed by their physical proximity. Degas seems to imply a comment on the meaningless character of daily life. But the comment, if there is one, is made with sophisticated obliqueness. Degas is fascinated by the world of Parisian entertainment, but he sees it characteristically in terms of work – the players in *L'orchestre de l'Opéra* are men doing a job, oblivious to events on the stage. The members of *La classe de danse* are similarly preoccupied with what is for them labour, though for others it will become entertainment.

The painter of a younger generation who best understood what Degas was trying to do was Toulouse-Lautrec, who not only shared Degas's fascination with the world of popular entertainment, but who possessed a similarly aristocratic attitude which made him indifferent to other people's reactions to his choice of subject-matter. Lautrec expands upon Degas's achievement in two ways. First, his characters are sharply individualized – so much so that they almost become caricatures – and second, he is even better at combining the initimate and the dispassionate than his examplar. In this respect it is worth comparing Lautrec's brothel scenes to the monotypes which Degas made of similar subjects; he catches the quotidian nature of the activities more surely than the older man.

In complete contrast to Lautrec, with his emphasis on the particular, are the paintings of the Neo-Impressionists, represented in this collection by Seurat, Signac, Cross and Van Rysselberghe. The first three of these were French, but Théo van Rysselberghe was a Belgian, one of the founder members of the important Brussels exhibition society *Les XX*, where many members of the French avant-garde were better received than they were at home. Paul Signac and Henri-Edmond Cross were among the first to discover the South of France as a paradise for artists, and, like a number of other Neo-Impressionist painters, were affiliated politically to anarchism. In their work, Impressionism is rigorously systematized; Neo-Impressionist painting does not merely base itself on new scientific discoveries, it actually aims to turn art into a science. Signac, the chief theoretician of the group, defined Neo-Impressionism or Divisionism as follows (incidentally rejecting the term Pointillism):

The Neo-Impressionist does not dot [*ne pointille pas*]; he divides. To divide is to secure all the advantages of luminosity, colour and harmony by:

(1) the optical mixing of pure pigments only (all the hues of the spectrum and all their tones);

(2) the separation of the various elements (local colour, colour of light, their interactions, etc.);

(3) the balancing and proportioning of these factors (according to the laws of contrast, colour shift, reflection, etc.);

(4) the adoption of a brushstroke which is in proportion to the size of the painting.

Only one of the original Impressionists was for a time seduced by this doctrine. Camille Pissarro painted a number of works in Neo-Impressionist style (see, for example, his *Femme dans un clos* ... *Eragny*). But Pissarro is a complicated case – the most advanced of the original Impressionist group, yet also the one with the greatest attachment to the more humane and emotional realism of the midcentury. His *Jeune fille à la baguette* demonstrates a secret hankering for a kind of art which Neo-Impressionist doctrine seemed to make impossible: the profoundly touching peasant scenes of J.F. Millet. It is fascinating to compare Pissarro's Milletesque figure paintings with a small group of paintings created by the leader of the Neo-Impressionists, Georges Seurat. *Le cirque* comes from the very end of Seurat's short life. It demonstrates no interest in character as such (compare it, for example, with Lautrec's circus scenes, which were produced at almost the same time). Nor is it imbued with the general concern for 'humanity' which we discover in Pissarro. Instead it is an attempt to systematize the expression of emotion as well as the actual method of picture-making: Seurat looks back to the seventeenth century, and in particular to Poussin's theories about art. In a letter to his patron Chantelou, written in 1639, Poussin says that the figures in his painting *The Israelites Gathering Manna* are each to be read as an expression of a different emotional state, and that together they form a narrative that one can read in the same way that one reads a description in a book.

Poussin held an equal fascination for Cézanne, who once said that his ambition was to 'bring Poussin to life through contact with nature'. For a time in his early career Cézanne could be classified as an Impressionist of the first generation; he even showed in the Impressionist exhibitions of 1874 and 1877, and thus can be regarded as an official member of the group. At this stage he was chiefly influenced by Pissarro, whom he had known as early as 1862, when he worked at the Académie Suisse. The curious satirical work *Une moderne Olympia*, showing the squat, balding artist goggling at the naked goddess uncovered for his inspection, may express some of the doubts that long plagued him. Cézanne only fully discovered his own method and his own potential in 1882, when he went to live at Aix-en-Provence. It was then that he seemingly abandoned Impressionist precepts in favour of their complete opposite. But in fact this abandonment is already becoming apparent in *La maison du pendu*, painted as early as 1873. And it is of course entirely visible in later work such as *Le vase bleu* and *Nature morte aux oignons*. These latter paintings are both classical examples of Cézanne's preoccupation with absolutely commonplace subject-matter, which he uses as the raw material for a stringent, immutable pictorial architecture having nothing to do with the impression made by the fleeting moment or a particular effect of light.

The full consequences of pursuing this attitude can be seen in the great canvases of *Baigneurs*, painted between 1890 and 1900, and especially in the more drastic of two versions of this subject in the Musée d'Orsay. Here one notes how the ostensible subject-matter has become a mere pretext for the act of making a painting, which Cézanne sees in terms of a surface completely organized by means of colour and line, a statement sufficient to itself, without reference to anything outside.

If Cézanne strives to be impersonal, Gauguin and Van Gogh deliberately imbued their work with their own characters. There are few artists where our knowledge of the biographical facts matters so much to our appreciation of what they do. Van Gogh did not encounter Impressionism first-hand until 1886, when he came to Paris to join his brother Theo, and his canvases touched by its influence do not reveal the full extent of his powers. In fact, if Impressionism based itself on the objective evaluation of appearance, and in particular of the effects of light, Van Gogh pursued an almost opposite line. His method was to project his own emotions on to what he saw. The famous canvas showing *La chambre de Van Gogh à Arles* is not simply a representation of a commonplace room but is instead a reflection of a highly charged state of feeling, symbolized both by the objects the room contains and by the way these objects, and indeed the very space they occupy, are depicted. The same is true of the later painting of *L'église d'Auvers-sur-Oise*, which was done in 1890, the year of Van Gogh's suicide, and which radiates the manic intensity of the artist's state of mind. One has only to imagine what Sisley or Pissarro might have made of the same subject to see how totally different Van Gogh's intentions are. His portraits, and especially his self-portraits, are similarly subjective, a search not so much for truth to physical appearances as for the spirit which lives within a man.

Van Gogh did not set out to found a school: Gauguin did. There was always in him something of the teacher and leader, and he adopted Impressionism only in order to reject it. Gauguin's real independence of Impressionism began with his first visit to Pont-Aven in Brittany in 1886, though the final break did not come until two years later, as a result of his contact with the young Emile Bernard. Bernard, a rebellious young artist some twenty years junior to Gauguin, preached the superiority of what he called Synthetism – the bringing together of all the elements in an experience, subjective as well as objective – as opposed to the mere analysis of appearances, which is what Impressionism was all about. Gauguin passed these doctrines on to a group of Bernard's contemporaries, who called themselves the Nabis, after the Hebrew word for 'prophet'. Paul Sérusier's little landscape, *Le talisman*, painted under Gauguin's direct supervision, became a totem object for the group. It was later described by Maurice Dents, one of its members, as 'a transposition, a caricature, the passionate equivalent of an experienced sensation'. The search for this equivalence was what characterized Synthetism, and indeed Symbolist painting in general.

The final stage of Gauguin's rejection of Impressionism is marked by his departure for Tahiti in 1891, in search of a completely different world. The pictures he painted in the South Seas are those which have fixed his image forever in the popular mind. Even though we know that Gauguin was guilty of fictionalizing what he found, the act of creating these Tahitian paintings, even in defiance of the facts, answered a pressing need within himself, and that was the point of producing them. The voyage to the South Seas was not as decisive as has been claimed. It is, for example, interesting to compare Gauguin's images of *luxe, calme et volupté* with certain late paintings by Renoir, most of all perhaps with the wonderful double nude *Les baigneuses*, which Renoir painted in 1918–19 at the very end of a long creative life. No more than Gauguin's South Sea beauties do these have anything to do with what the artist has actually observed. The pretence that appearances are being meticulously analysed (never very strong in Renoir's work) has long since been abandoned. What we get instead is a sensual hymn of praise for the richness offered by the life of the senses.

The quintessential Symbolist among the artists represented here is, however, not Gauguin, but Odilon Redon, who often abandons any pretence that he is painting something directly observed, and presents us instead with the visions conjured up by his inner eye. Where he does paint a thing which has been directly perceived, such as *La coquille*, he transforms it into something otherworldly, removed from the more mundane sphere inhabited by the Impressionists, with their frank pleasure in the life of the senses.

A surprising range of artists, of contrasting temperaments, felt the attractions of Symbolism. Matisse's early *Luxe, calme et volupté* is first and foremost a demonstration of the impact made upon him by Neo-Impressionism, but the theme itself relates him to the work of Puvis de Chavannes, who attempted with some success to unite Symbolism with academic ideas inherited from the artists of the very beginning of the nineteenth century.

The change in artistic climate even had its effect on painters who had been long established. If we turn for a second time to the late work of Renoir, and to *Les baigneuses* in particular, we become aware, even here, of the affinity with Redon. Renoir's bathers, like Redon's shell, transcend the sensual surface. Renoir, the supreme sensualist, here makes an important acknowledgment – that what the world brings to us through our most basic perceptions is also, necessarily, the material from which we build our dreams.

EDWARD LUCIE-SMITH

PLATES AND COMMENTARIES

The following abbreviations have been used for the authors' names :

- AD Anne Distel
- ся-т Claire Frèches-Thory
- SG-P Sylvie Gache-Patin
- GL Geneviève Lacambre

Frédéric BAZILLE (1841–1870)

L'atelier de la rue de La Condamine (The Studio in the Rue de La Condamine), 1869–70

Oil on canvas, $38\frac{5}{8} \times 50\frac{5}{8}$ (98 × 128.5)

Bequest of Marc Bazille, brother of the artist, 1924 (R.F. 2449)

Bazille, who came from a well-known family in Montpellier, was a friend of Bruyas, Courbet's patron. Together with Monet, Renoir and Sisley, whom he met at Gleyre's studio, he was one of the first admirers of Manet, who in 1863 became their leader. It is this group of friends which Bazille depicts here, at his studio in the Batignolles quarter of Paris, which he occupied with Renoir from 1 January 1868 to 15 May 1870. In the autumn of 1869 he started work on several paintings. They included a studio interior and a female nude for the Salon – pictures which were to occupy him all winter. The female nude La toilette (The Toilet) (Musée de Montpellier) is depicted unfinished in this work, hanging above the sofa. It was rejected by the Salon of 1870. Also visible to the left is the Pêcheur à l'epervier (Fisherman with a Net), rejected in 1869. Behind the easel is the Tireuse de cartes (The Fortune-teller), while the large painting on the wall above the piano is Terrasse de Méric (The Terrace at Méric) of 1867 (Musée de Montpellier). Above the pianist (Edmond Maître, a friend of Bazille), a still-life by Monet is a reminder that Bazille helped the artist by buying his work, notably Femmes au jardin (see p. 80). The large framed picture above this is almost certainly the 'landscape with two figures' by Renoir which was rejected from the Salon of 1866. As can be seen from an old photograph, part of the left-hand side of the picture survived as Dame à l'oiseau (Lady with a Bird, present location unknown). On the easel is the Vue de village (View of a Village) of 1868 (Musée de Montpellier), which Manet is examining, hat on head. Bazille is the tall, slim figure in the centre painted, as he wrote to his father on I January 1870, by Manet, whose vigorous brushwork is clearly recognizable. The identification of the three figures to the left is less certain. Are we to identify the man next to Manet as Monet or Zacharie Astruc? And are those grouped to the left Renoir and Zola, or Monet and Sisley? These artists and writers were among Manet's admirers, and were depicted by Fantin-Latour at the same epoch in his L'atelier des Batignolles (Studio in the Batignolles, Musée d'Orsay). But, unlike Fantin-Latour, who remained faithful to the example of the Dutch masters, Bazille has produced a totally modern composition, which evokes the quasi-bourgeois atmosphere of the place where he liked to entertain his friends. His death in battle a few months later makes this work, painted for his own pleasure, a particularly moving testament. GL

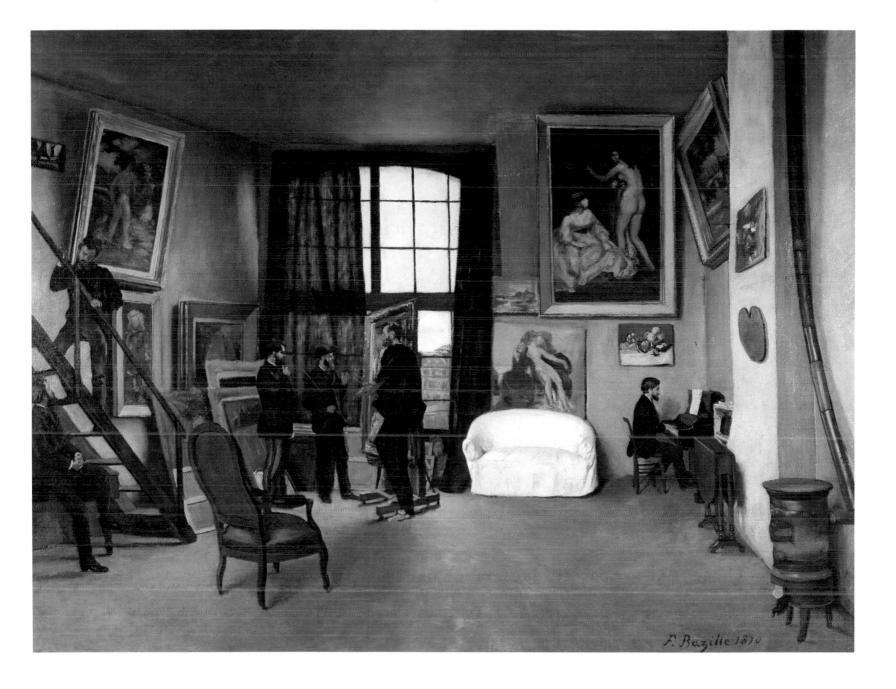

Portrait de M. et Mme Auguste Manet, 1860

Oil on canvas, $45\frac{1}{2} \times 35\frac{7}{8}$ (115.5 × 91)

Purchased with the help of the Rouart family, of Mme J. Weil Picard and of an anonymous foreign donor, 1977 (R.F. 1977–12)

After six years study in the studio of Thomas Couture – which included several clashes with the master – and after having visited numerous European museums, Manet submitted his first painting, *Buveur d'absinthe (Absinthe-drinker*), to the Salon of 1859. It was rejected. In 1861, at the next Salon, he had two works accepted and was given an honourable mention. The *Chanteur espagnol (Spanish Singer)* aroused the admiration of a group of realist painters, among them Fantin-Latour, Legros and Carolus-Duran, but this portrait of his parents was found disconcerting and was badly received by many people. It was considered vulgar and over-realistic. Jacques-Emile Blanche reports that a friend of Mme Manet's said that 'they look like two concierges'.

Manet portrays his parents in their dining-room, in the clothes they would normally wear at home. Depicted two years before his death, his father, who was an important magistrate and a judge at the court of appeal, looks strained and ageing. His wife was only fifty at the time of the portrait, and was to survive both her husband and her son. She seems uneasy, and is busy with her embroidery wools – they add a rare touch of colour in this dark, austere picture – choosing threads with which to continue her work which lies to the right on the table. The painting evokes the severe and strict way of life of an upper-middle-class couple at the time of the Second Empire, and makes this as striking a reflection of the society of that period as Ingres' *Portrait of M. Bertin* is of the July Monarchy of Louis-Philippe.

As so often, Manet worked on this painting for a long time. Treatment with X-rays has shown that his father was originally shown looking younger, without a moustache and with a less bushy beard.

GL

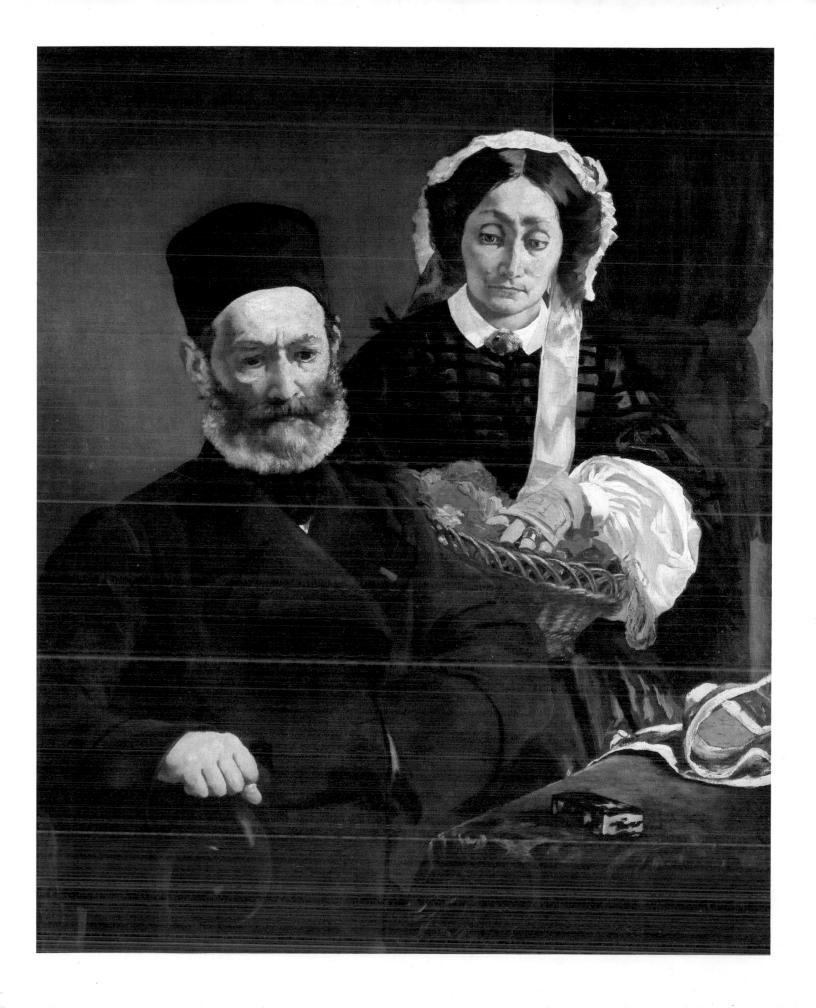

Le déjeuner sur l'herbe (Luncheon on the Grass), 1863

Oil on canvas, $81\frac{7}{8} \times 104$ (208 × 264) Gift of Etienne Moreau-Nélaton, 1906 (R.F. 1668)

On I January 1867 Emile Zola wrote: 'Le déjeuner sur l'herbe is Manet's greatest picture, the one in which he has realized a dream common to all painters, that of putting life-size figures into a landscape setting.' The landscape itself – a light-filled forest interior with a river – was something Manet had already attempted a little earlier, in La pêche (Fishing, New York, Metropolitan Museum). The boat in that picture reappears in this composition, which is made up of studies done at Saint-Ouen on the Seine near Manet's country house at Gennevilliers, together with memories of landscapes by Carracci and Rubens.

The Old Master sources for *Le déjeuner sur l'herbe* are well known, notably the *Concert champêtre* by Titian in the Louvre (at that time being attributed to Giorgione) and Marcantonio Raimondi's engraving (then well known in artists' studios) after Raphael's *Judgment of Paris*. But it looks as if Manet also wanted to set himself up as the rival of Courbet, to surpass him in the presentation of subjects drawn from everyday life by producing works even more daring than Courbet's *Baigneuses* (*Women Bathing*, Musée de Montpellier) which was shown at the Salon of 1853, or his *Demoiselles des bords de la Seine* (*Young Ladies on the Banks of the Seine*, Petit Palais, Paris), with their suggestive déshabille, which was shown at the Salon of 1857.

For *Le déjeuner sur l'herbe*, Manet had young people of his own day adopt exactly the same poses as the figures in Raimondi's engraving. And just as Titian's figures wear contemporary sixteenthcentury costume, so too these wear the fashions of their time. In the centre is the Dutch sculptor Ferdinand Leenhoff, brother of Manet's mistress Suzanne; seen in profile is one of his brothers. The seated nude is Victorine Meurent, who had been Manet's favourite model for the past year. She is obviously a model resting, just about to put her clothes on again, and not the ideal figure that Cabanel, Baudry or Amaury-Duval would have been painting at that period.

A fortnight later, in the neighbouring galleries of the Palais de l'Industrie, the opening of the Salon des Refusés took place, having been set up at Napoleon III's behest to compensate for the severity of that year's jury of academicians. Here Manet enjoyed a *succès de scandale* with his picture, then entitled *Le bain (The Bath)*. It was shocking because of its subject – Manet himself simply described it as a 'foursome' – and equally so for its breadth of handling. This made it seem like a sketch, except for the lower left-hand corner, which is treated as a virtuoso still-life.

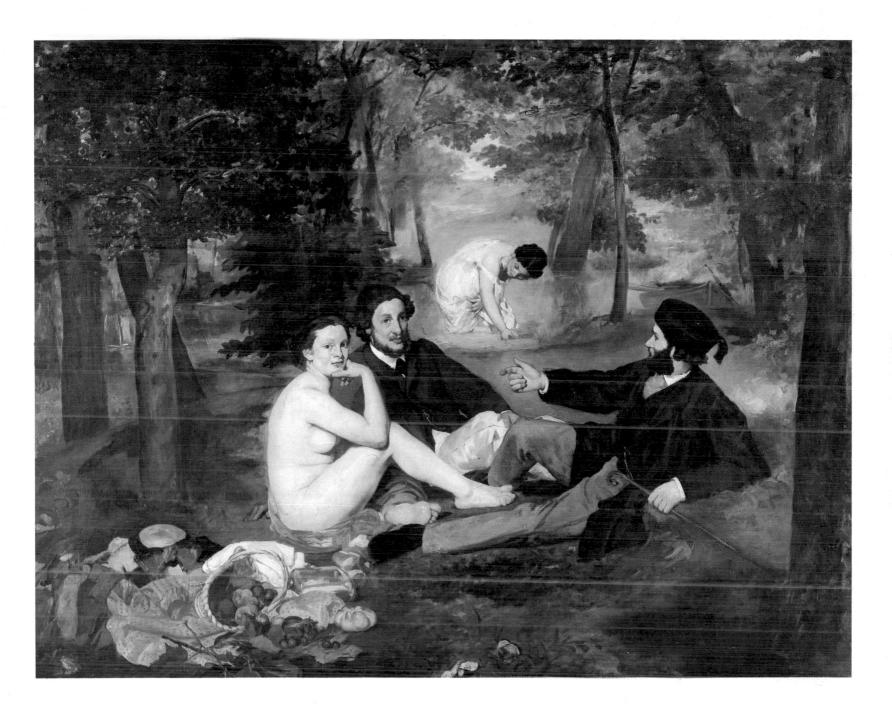

Olympia, 1863

Oil on canvas, $51\frac{3}{8} \times 74\frac{3}{4} (130.5 \times 190)$

Donated to the national collections through public subscription initiated by Claude Monet, 1890 (R.F. 644)

Like *Le déjeuner sur l'herbe*, Manet's *Olympia* is now recognized worldwide as one of the classic masterpieces of art, and has been the inspiration of modern artists, ranging from Cézanne (see p. 62) to Picasso and Larry Rivers. It is on a par with Ingres' *Grande odalisque*, and was hung side by side with it at the Louvre in 1907. In the Salon of 1865, however, when it was first shown, it aroused an unprecedented scandal and more or less general hilarity. The drawing was criticized, the shadows were 'like streaks of shoe-blacking' according to Théophile Gautier, and the painter's claim that he wished to represent 'an aristocratic young woman' (the phrase comes from the poem by Zacharie Astruc which accompanied the enigmatic title in the Salon catalogue) was flatly disbelieved. People saw the woman as a contemporary model taking a pose, a realistically depicted nude, a prostitute staring at the spectator while her black servant brings her a bouquet sent by one of her clients.

With this picture Manet wanted to confront the masters of the past once again, while at the same time parodying a theme which occurred frequently in the Salons of the nineteenth century. The obvious historical source is Titian's *Venus of Urbino*, which Manet copied in Florence, here using the general scheme of the composition as well as the pose; the arrogance and insolence he borrows from Goya's *Maja desnuda (Naked Maja)*. But he has transposed his models into a naturalistic key, painting – as his friend Antonin Proust reports – what he actually saw. Contemporaries were shocked by the striking contrasts, the flat colour, and were not attuned to the classic harmony of the composition, nor to the refinement of the whites, ivories and rosy hues, nor to the richness of the background, which has now been revealed once again by recent restoration. They were blind to the virtuosity of the bouquet composed of just a few splashes of colour, its reds echoing Olympia's ribbon and the flowers on the shawl – in fact to everything which now appears to us as a demonstration of the pleasure Manet took in painting with such skill.

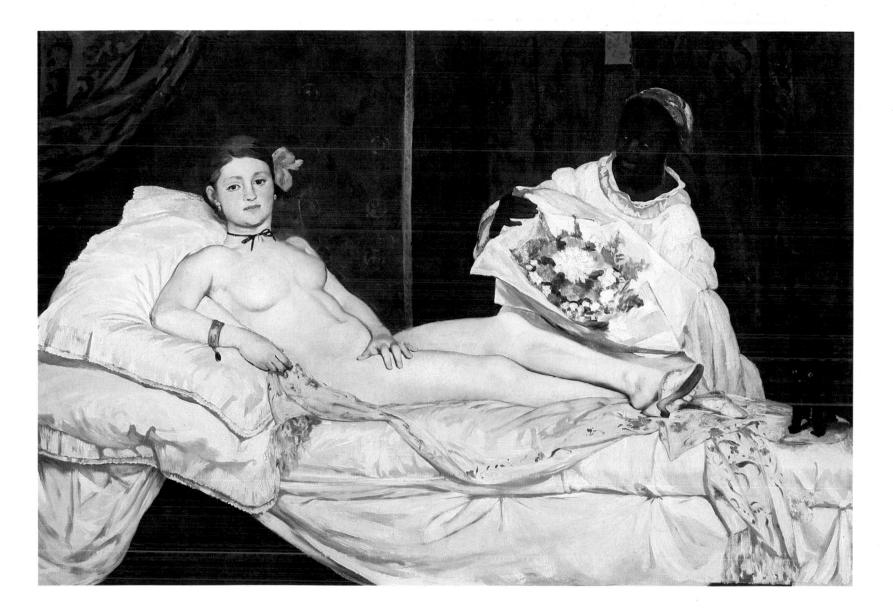

Le fifre (The Fifer), 1866

Oil on canvas, $63 \times 38\frac{5}{8}$ (160 × 98)

Count Isaac de Camondo bequest, 1911 (R.F. 1992)

The young model is a 'fifer of the light infantrymen of the Guard' – a boy-soldier who was a member of the troop of the Imperial Guard quartered at the La Pepinière barracks. He was brought to Manet by his friend Commandant Lejosne, Bazille's uncle. Like Manet's *L'acteur tragique (Tragic Actor* – a portrait of Rouvière in the role of Hamlet, rejected as was the present picture at the Salon of 1866, and now in the National Gallery of Art, Washington DC), *Le fifre* was done in homage to the art of Velásquez, which had so impressed and delighted him when he saw it at the Prado, during his trip to Spain in August 1865. He seems to be defining his own approach when he writes to Fantin-Latour, describing a work by the man he called the 'quintessential painter': 'The most outstanding painting in his marvellous œuvre, and perhaps the most astonishing ever painted, is the one the catalogue calls *Portrait of a Famous Actor of the Time of Philip IV*. The background disappears. It's pure atmosphere which surrounds the figure, which is dressed from head to foot in black and totally alive.'

Zola, who was brought to Manet's studio by the painter Guillemet, soon afterwards had an enthusiastic article published in *L'Evénement* on 7 May 1866, which led to his own dismissal from the paper. Writing about *Le fifre*, he said: 'I don't believe it is possible to get a more powerful effect by simpler means. M. Manet is brusque – he tackles things directly. He is not put off by the brusqueness of nature; he passes from black to white without hesitation. He renders with vigour the contrast between different objects, one separated from the other.'

Manet was accused of having painted a crude popular print, a playing-card picture, because of the sharp contrast of red and black on a grey ground, with a few touches of acid yellow so typical of him. In fact he was paying tribute, not only to Spain, but to the unmodulated blacks in the Japanese prints he then admired. GL

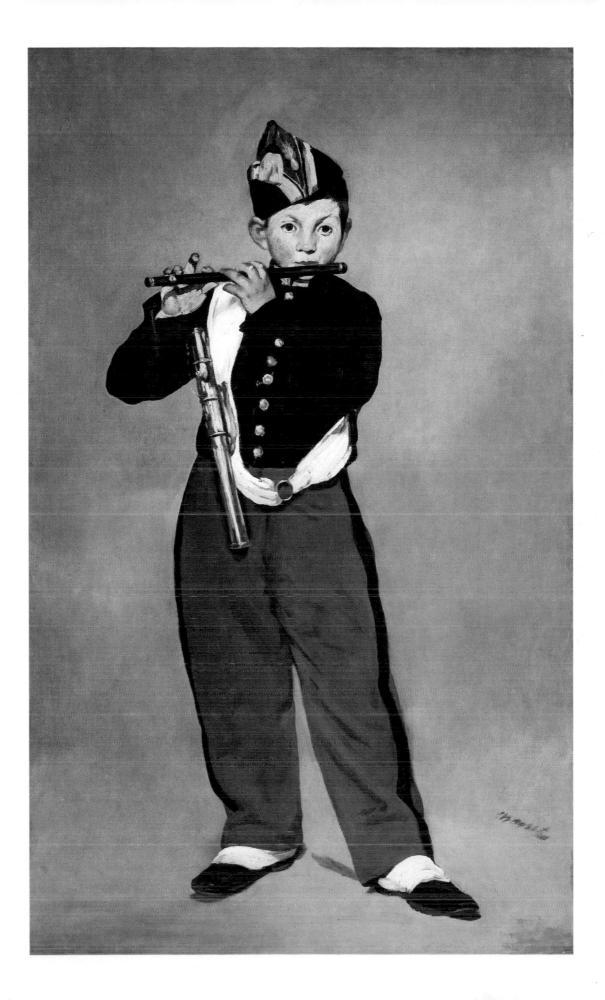

Portrait d'Emile Zola, 1868

Oil on canvas, $57\frac{1}{2} \times 44\frac{7}{8} (146 \times 114)$

Gift of Mme Emile Zola but retained by her for her lifetime, 1918; entered the national collections in 1925 (R.F. 2205)

The naturalistic novelist Emile Zola, who was a childhood friend of Cézanne, took an interest in painting from very early on, and defended Manet stoutly when he was rejected by the Salon of 1866. Soon afterwards, Zola further developed his ideas in an article which attracted much attention when it was published in the *Revue du XIX ème siècle* on I January 1867. It was entitled 'A New Method of Painting. Edouard Manet', and was reprinted as a pamphlet for Manet's one-man show in the Place de l'Alma, which was timed to coincide with the International Exhibition of 1867. As a gesture of thanks – and to set the seal on a relationship which had developed from admiration to loyal friendship – Manet offered to paint Zola's portrait. He signed it with the title of Zola's celebrated pamphlet, which is placed behind the writer's pen, on the table on the right.

The picture was probably begun in November 1867, and did not exactly go unnoticed at the Salon of 1868; in fact it was the centre of lively controversy. Many criticized the sitter's distant, indifferent expression, and the young Odilon Redon saw in it 'something more like a still-life than the expression of a man's character'.

It is clear that Manet scrupulously worked out, within a framework of horizontals and verticals, a setting which would illustrate the interests of both the painter and his critic. Thus the frame high up to the right contains several emblematic images. There is a reproduction – could it be a photograph of an engraving? – of *Olympia* (see p. 22). She gives Zola a look of thanks – he thought the picture Manet's finest masterpiece when he saw it at the Salon of 1865, and described it as 'the complete expression of his temperament'. Above this there is an engraving of *Los Borrachos* (*The Drinkers*), no doubt the one by Nanteuil after Velásquez, which indicates both Manet's admiration for the artist and Zola's penchant for a realism that is 'thick, brutal and violent', to quote Charles Blanc, author of *Histoire des peintres de toutes les écoles*. Zola has one of the illustrated volumes of this on his knees. Finally, there is a print by Utagawa Kuniyaki II, *The Wrestler Onaruto Nadaemon from Awa Province* – an example of the brightly coloured late Ukiyo-e prints which encouraged artists to seek for simplicity and modernity. This print echoes the Japanese screen which is partly visible to the left – a prop often used at this period by other artists who belonged to the same group, such as Whistler, Tissot and Alfred Stevens.

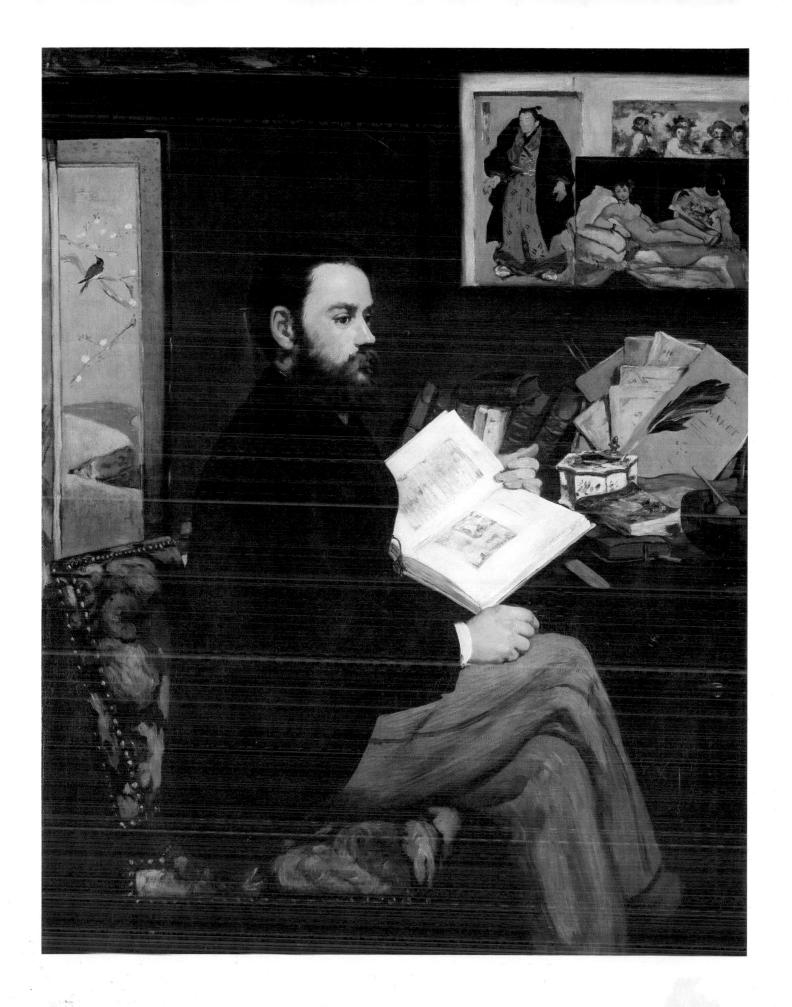

the set

Le balcon (The Balcony), 1868–69

Oil on canvas, $66\frac{1}{2} \times 49\frac{1}{4}$ (169 × 125) Gustave Caillebotte bequest, 1894 (R.F. 2772)

Manet got the first idea for this painting from a scene he caught sight of during the summer of 1868 at Boulogne-sur-Mer, but the composition itself is one of the final examples of Spanish influence on his art. It was inspired by one of Goya's pictures – the *Majas on a Balcony*, which he may have seen, when he was still an adolescent, in the Spanish collection which belonged to Louis-Philippe, and which had, in any case, just been reproduced (in 1867) in Yriarte's book on Goya. True to his established method, Manet painted the scene from life, during long sessions with the models in his studio in the Rue Guyot in the Batignolles quarter of Paris, during the autumn and winter of 1868–69. The sitters are Berthe Morisot, seated (this being her first appearance in Manet's work); Fanny Claus, a young concert violinist, a friend of the Manet household, and Antoine Guillemet, a landscape painter who was to make an honourable career for himself at the Salon, and who was, on a number of occasions, to come to the help of his Impressionist friends. In the background, the child carrying a jug must be Léon Leenhoff, the boy Manet brought up.

There is nothing left here of Goya's genre scene, with its whispered conversations. It is the image of one particular moment, a sort of snapshot of a scene from contemporary life, where each of the characters is, so to speak, frozen in his or her individual psychology, and does not communicate with the others. The painting disturbed even the theoreticians of naturalism, and aroused a multitude of hostile reactions at the Salon of 1869. The green of the louvred shutters and of the balcony, the brilliant blue of Guillemet's cravat, echoed by the subtler blue of the hydrangea – a kind of emblematic evocation of the open air – the violent contrasts between lights and darks: all these acted as provocation. The painting has not lost its enigmatic power, as Magritte's composition with the same title, done in 1950, confirms. In this work (now in the museum at Ghent) Magritte replaces the three figures with three coffins, one in a seated position.

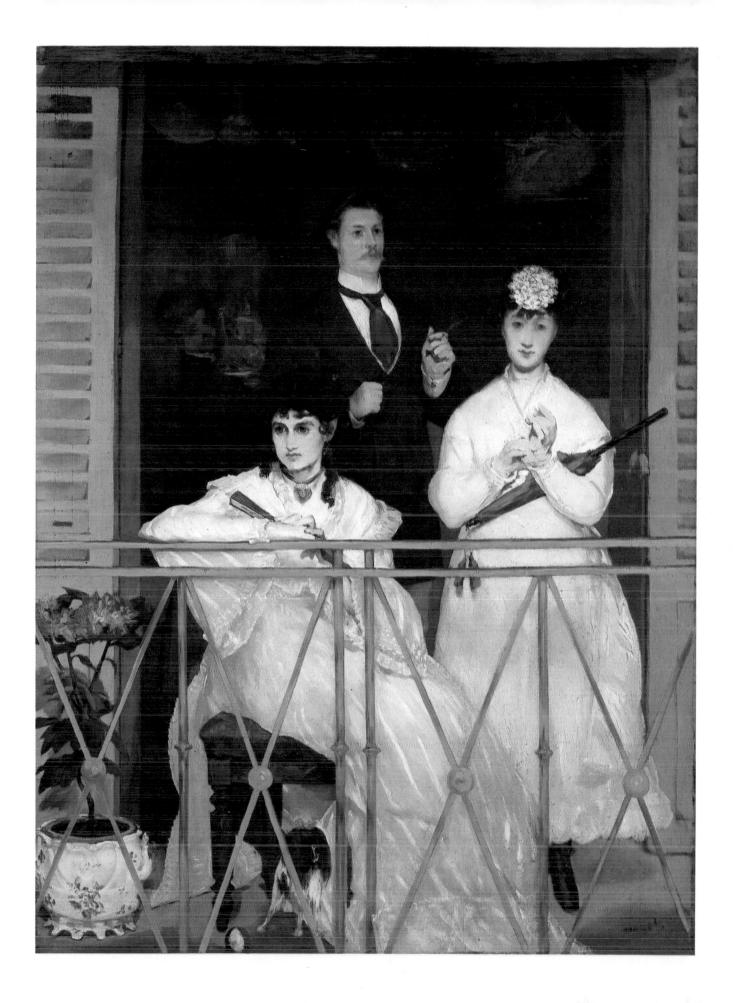

Sur la plage (On the Beach), 1873

Oil on canvas, $23\frac{1}{2} \times 28\frac{3}{4} (59.6 \times 73.2)$

Gift of Jean-Edouard Dubrujeaud but retained by him for his lifetime, 1953; entered the national collections in 1970 (R.F. 1953–24)

At the time when this was painted, Manet was not only venerated by a small group of artists and writers, but had also started to know better times financially. In 1872 he sold a large number of paintings to the dealer Durand-Ruel, whose meeting with Monet in London in 1871 had led to his interest in the Batignolles group. At the Salon of 1873, Manet had his first major success since 1861, with *Le bon bock (The Good Glass of Beer)*, a portrait of the print-maker Belot which demonstrates the artist's admiration for Frans Hals, whose work he had seen at Haarlem in 1872. One can detect further reminiscences of Hals in these figures painted from life – as proved by some grains of sand still in the paint – at Berck-sur-Mer. Manet spent a three-week family holiday there in July 1873. His wife Suzanne is recognizable, reading, and also his brother Eugène, lost in thought.

In comparison with Boudin's beach-scenes, or those which Monet did during the same period, Manet endows his figures with exceptional monumentality. Here they occupy the larger part of the canvas; the horizon line is placed very high, and a thin strip of sky is punctuated by the dark sails of some boats. Into this universe of sand and sea, all grey, ochre and blue, Manet introduces as a counterpoint a little touch of red on Madame Manet's shoes in the foreground, which helps to create the brightly lit atmosphere of this northern French beach-scene.

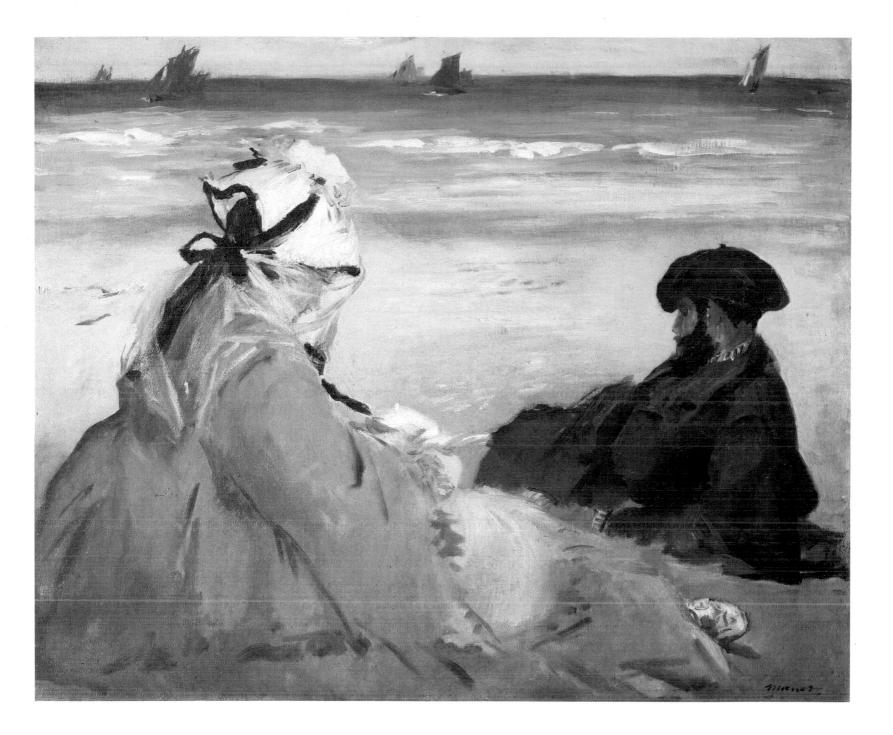

La serveuse de bocks (The Waitress), 1879

Oil on canvas, $30\frac{1}{2} \times 25\frac{1}{2} (77.5 \times 65)$

Formerly Matsukata Collection. Ceded under the terms of the peace treaty with Japan, 1959 (R.F. 1959-4)

From 1877–78 onwards Manet, like Degas at this time, was painting numerous café scenes. Drawings made from life were the basis of paintings later constructed in the studio – of which this painting is an important example. It shows the Reichshoffen café-concert, which was probably in the Boulevard Rochechouart in Paris. Manet began work on it in August 1878, but then cut the painting into two parts, which he reworked separately. The right-hand portion, *Coin de café-concert (Corner of a Café-concert*, National Gallery, London), corresponds generally to the picture illustrated here. But our painting nevertheless differs in many details, and seems to be a fresh version of the same subject – simplified, better worked out, and arguably later.

Thus the horizontal line of the brightly lit stage is here suppressed to create a tighter composition, punctuated by the verticals of the background which are echoed by those of a top-hat and of the tankards of beer, painted a wonderful orange colour. Many details have disappeared: the musicians in the orchestra and the diagonals made by their instruments, and the table set obliquely and the drinking glasses to the left, have gone – to be replaced by a sort of close-up of characters from many different walks of life, sitting side by side, without knowing each other: a workman in his blue overall, a bourgeois in a top hat, a woman with a high chignon. Above them all rises the waitress. The customers look towards the stage, some more attentively than others, where (on the left of the picture) there appears the long dress and the arm of a singer. But her presence does not concern the waitress going about her work. She deliberately looks towards someone who is invisible – in fact towards the viewer of the painting – thus giving to the painting the reality of life itself.

What one has here is a subtle preparation for the device used in Manet's final masterpiece Un bar au Folies-Bergère (A Bar at the Folies-Bergère, 1881–82, Courtauld Institute, London). There the man who is speaking to the abstracted and melancholy bar-maid actually appears in the mirror behind her.

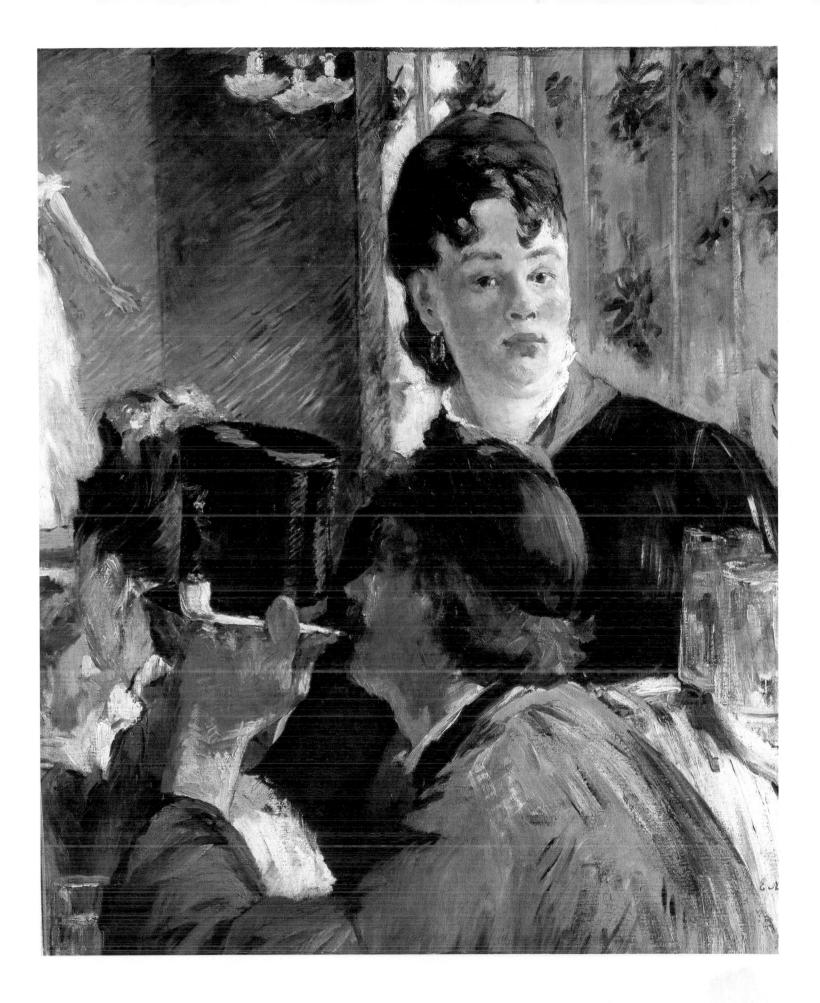

Edgar DEGAS (1834–1917)

La famille Bellelli (The Bellelli Family), 1858-60

Oil on canvas, $78\frac{3}{4} \times 98\frac{3}{8} (200 \times 250)$ Purchased in 1918 (R.F. 2210)

When Degas died, this family portrait was one of the many paintings found in his studio. It is an early work, until then practically unknown, representing Degas' aunt, Laure Bellelli (née de Gas), her husband Gennaro Bellelli, and their two daughters Giovanna and Giulia. Preceded by numerous drawings and sketches, the canvas was begun in 1858 in Florence where Degas stayed for a long period during one of his journeys to Italy and where Bellelli, a supporter of Cavour and in exile from Naples, was also living at the time.

Degas was twenty-five when he began the painting, and its mastery is astonishing even now. It is not merely that the young artist had so completely assimilated the lessons of the painters he admired – Van Dyck and the Florentine Bronzino among the Old Masters, and Ingres among the moderns – but also that he embues this work with a new spirit through his sensitive representation of contemporary reality. The way the people are dressed, the furniture, the mirrors (providing additional images), the hangings, objects like the work-basket on the table – all these immediately place the people in their own epoch and in the bourgeois milieu to which they belong.

At the same time few portraits so clearly reveal the psychology of their models: Laure Bellelli, a little haughty, neurasthenic, and estranged from a husband who here appears eclipsed and distant; the little girls, Giovanna standing under her mother's protective arm, Giulia seated half off the chair – the only one who seems to want to break the constraints. Using a device which appears frequently in his work, Degas introduces an additional allusion by showing, in a drawing hanging behind Laure Bellelli, a portrait of her grandfather, Hilaire-René de Gas, who had recently died – which explains why the sitters are dressed in mourning.

34

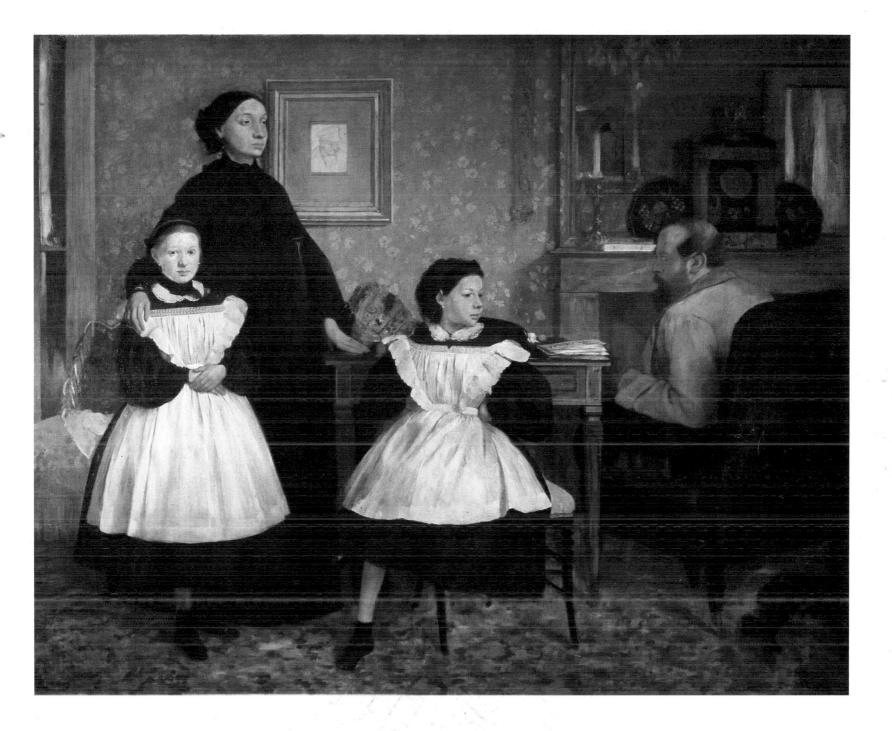

Edgar DEGAS (1834-1917)

L'orchestre de l'Opéra (The Orchestra of the Opéra), c. 1868-69

Oil on canvas, $22\frac{1}{4} \times 18\frac{1}{8} (56.5 \times 46)$

Purchased from Mlle Marie Dihau, but retained by her for her lifetime, 1924; entered the national collections in 1935 (R.F. 2417)

Since it entered the Jeu de Paume collection, this painting has been entitled *Musicians in an* Orchestra, because it portrays several of Degas' friends as violinists – a painter, a medical student, the ballet-master of the Opéra – who were indeed not violinists at all. But in our opinion it should once again be known by the title the artist gave it. His idea was, as he wrote in one of his notebooks, to create, in a highly naturalistic style, 'a series on instruments and instrumentalists and on their forms – the way the violinist twists his arms, his hands and his neck; the way the cheeks of the bassoonists and oboe-players swell up and deflate, etc.'

Being himself musical and enjoying French and Italian music in particular, Degas delighted in the company of musicians, of whom he made numerous portraits. In 1868 he became friendly with Désiré Dihau, a bassoonist at the Opéra, and also with his sister Marie, who was a singer, and through them became acquainted with other members of the orchestra who used to meet at a restaurant near the opera house called 'Chez la Mère Lefebvre', on the Rue de la Tour d'Auvergne. When Dihau asked Degas to paint his portrait, Degas first thought of representing him on his own, but then hit on the idea of this group painting, where – for the first time – the emphasis is put on the musicians who generally pass unnoticed at a performance. In the box nearest the stage, high up to the right, can be seen the face of the composer Emmanuel Chabrier; in the orchestra pit, all the musicians are portraits of identifiable people. Turned towards a conductor who remains invisible to the right, they are: Pillet (cello); Désiré Dihau (bassoon); Altès (flute); Lancien and Gout (first violins); and Gouffé (double-bass). The scroll of Gouffé's instrument is silhouetted against the stage where, in the dazzling artificial light, several ballerinas in pink and blue tutus dance, their heads and feet cropped - a daring evocation of the performance as it would have appeared in reality. The composition, designed with great sophistication, is a play of oblique lines made by the instruments and the legs of the dancers against the strong horizontals of the footlights and the edge of the orchestra pit, with an unexpected set of rectangles created by the back of Gouffé's chair and the wall of the auditorium next to the box. GL

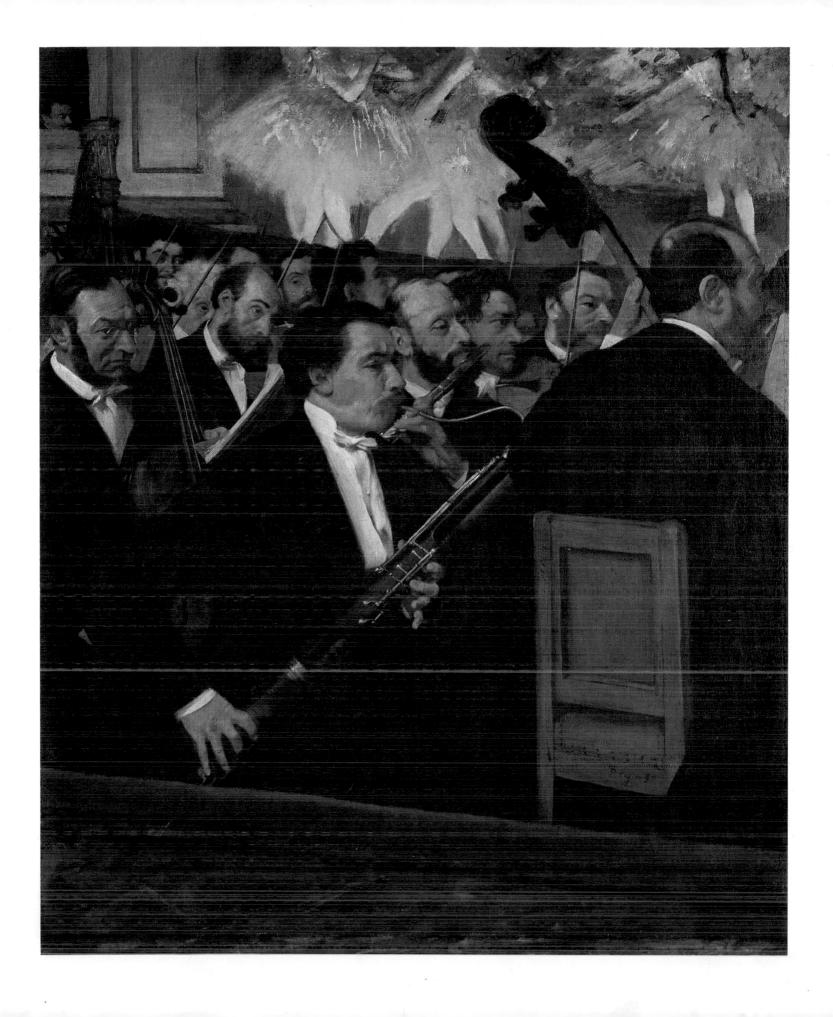

La classe de danse (The Dancing class, originally entitled Preliminary Steps), c. 1873–75

Oil on canvas, $33_2^1 \times 29_2^1 (85 \times 75)$ Count Isaac de Camondo bequest, 1911 (B.F. 1976)

In 1872 Degas began work on a series depicting the life of ballerinas, as he observed them at the Paris Opéra in the Rue Le Peletier, often making several versions of the same subject. Paintings on this theme appeared in the Impressionist exhibitions of 1874, 1876 and 1877, but this one does not seem to have been among them. It was, however, the subject, as is shown by an X-ray, of numerous rehandlings which enable us to trace the creative processes of the artist. Although, in his Journal for 13 February 1974, Edmond de Goncourt spoke of Degas as 'the man who is at the present moment best able, in the copying of contemporary life, to catch its spirit', Degas in fact spent a long time on his compositions, first of all building up a huge repertory of gestures, figure by figure. Here all the alterations serve to emphasise the focus on the role of the ballet-master Jules Perrot in the composition. He was at first turned towards the back wall but the final pose is given in a quick study in thinned oil colour on paper dated 1875 (Philadelphia, Henry McIlhenny Collection), which indicates that the painting itself was thus altered in that year. Two dancers in the foreground at first looked towards the viewer. One, wearing a tutu with a green ribbon, has her back to us, while the other is obscured – one sees only part of her face – behind the new figure of the dancer seated on the piano and scratching her back. This casual pose was noted by a reviewer writing for an English newspaper, The Echo, on 22 April 1876, when the painting was shown at the Deschamps Gallery in London. There it was soon sold to a collector, Captain Henry Hill of Brighton, who showed it, together with L'absinthe, in a local exhibition in the autumn of 1876. Sold at Christie's in May 1889, the painting returned to France by way of Theo van Gogh, who was then working for the picturedealer Goupil. GL

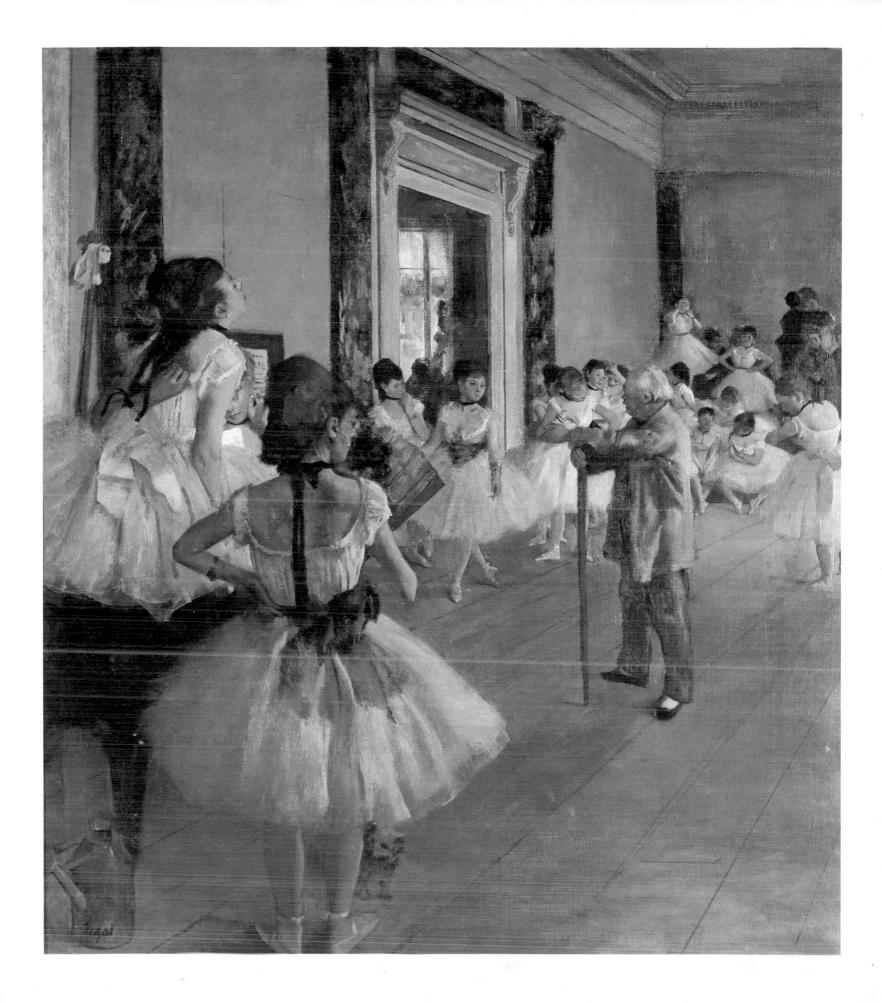

L'absinthe, 1876

Oil on canvas, $36\frac{1}{4} \times 26\frac{3}{4}(92 \times 68)$ Count Isaac de Camondo bequest, 1911 (R.F. 1984)

Degas here reinterprets, in more than one respect, the traditional Flemish theme of drinkers in a tavern. He presents a resolutely contemporary scene, a sort of illustration to Zola's novel *L'Assommoir (The Dram-shop)*, which was appearing in parts that same year. Two figures sit silently before their glasses, apparently ignoring one another, on a bench at the Nouvelle Athènes café in the Place Pigalle in Paris, which was the latest haunt of Manet, Degas and their friends. A year or so earlier they had abandoned the famous Café Guerbois and were drawn to the Nouvelle Athènes by the personality of the painter and print-maker Marcellin Desboutin. It is Desboutin whom Degas represents here, wearing the same bohemian costume which is to be seen in the full-length portrait of him by Manet, done in 1875 (*L'artiste*, Museu de Arte de São Paulo), which was rejected by the Salon of 1876. In Degas' painting, a supporting role is played by the pantomime actress Ellen Andrée, who also posed for Renoir, Manet and Gervex. Dazed, she sits beside Desboutin, in front of a glass of absinthe, with its sulphurous bright green colouring.

Degas' originality, in this masterly composition which demonstrates both direct observation and psychological acuity, is to have placed the figures in the upper right-hand corner. The rest of the picture – seen as if the artist was sitting at a neighbouring table – is filled with empty table-tops on which have been thrown some newspapers mounted on wooden rods. These were provided for customers who spent hours waiting, looking out at the passers-by, just as Desboutin is here looking in the direction of a window covered by a net curtain and reflected brightly in the mirror behind him. Characterized by a subtle understanding of Japanese art, this kind of composition was taken up again by Degas in his portrait of Duranty (Glasgow Museums and Art Galleries). It was Duranty who, in his book *La Nouvelle Peinture (The New Painting*), wrote, speaking of Degas, that 'the appearance of things and people can take on a thousand unexpected aspects when we meet them in reality'.

It was as a representative of this 'new painting' that Degas soon found a purchaser in England: Captain Henry Hill, a Brighton collector who in the autumn of 1876 lent the picture to a local exhibition (see also p. 38). The triviality of the subject-matter caused a scandal when the painting was shown again in 1893 at the Grafton Gallery in London, and it soon thereafter returned to France and – then entitled *L'apéritif* – became part of the Camondo Collection.

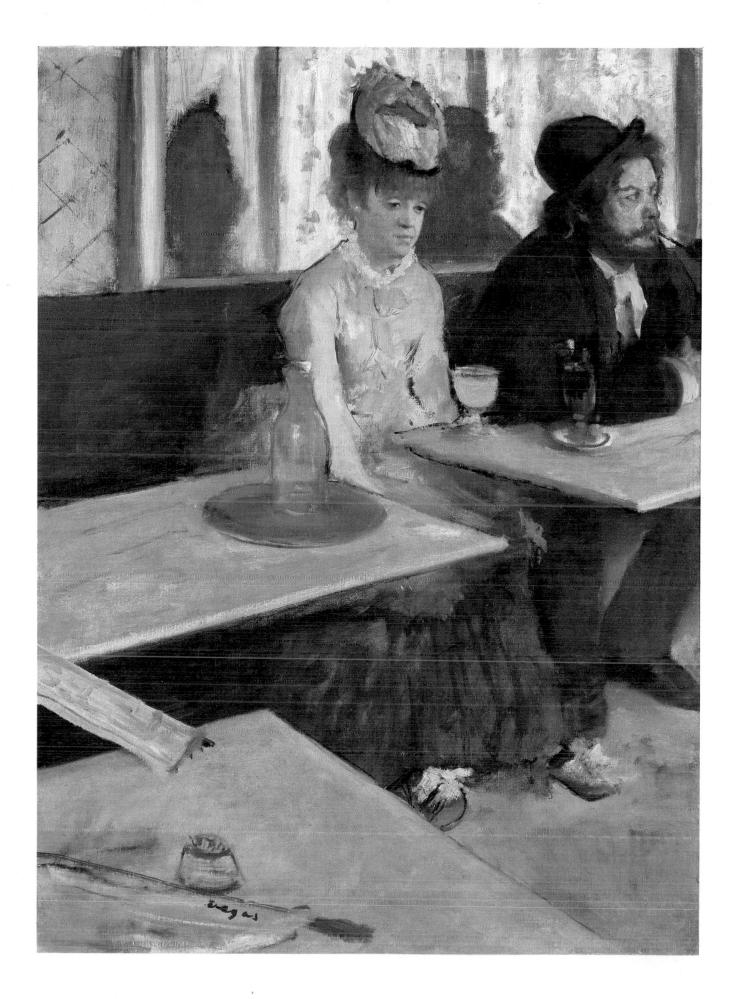

L'étoile or La danseuse sur la scène (The Star or Dancer on Stage), 1878

Pastel on paper, $23\frac{5}{8} \times 17\frac{3}{8} (60 \times 44)$ Gustave Caillebotte bequest, 1894 (R.F. 12.258)

For about ten years Degas had concentrated on showing dancers at work – in rehearsal, resting, fatigued, even totally worn out – in the wings or in the rehearsal-rooms of the Opéra. But this suffering and effort were rewarded by the grace of the ballerinas when they appeared on stage. To begin with, Degas showed views of the whole ensemble, then he fixed his attention, as he does here, upon a single soloist isolated on stage, transformed by the footlights into an incarnation of feminine grace, while the other performers appear only as silhouettes half-hidden in the wings. From the objective study of a particular milieu, he now moves to this analysis of movement, which was soon to be continued in a series of sculptures, among them the remarkable *Grande danseuse habillée (Large Clothed Dancer)* of 1881 (illustrated on the back cover).

In 1878 he was preoccupied above all with a new exploration of the physical media of the artist, using pastel for preference in order to render the vaporous quality of the dancer's costume. He contrasts areas which are delicately finished with others that are rapidly coloured in. These latter allow the impression printed in monotype, which was the first state of the composition and which supplies its actual structure, to remain visible. This was a frequent technique with Degas, and here gives a remarkable solidity to those parts which are simply sketched in, such as the backcloth. Some particularly brightly lit areas, such as the neck and leg of the dancer, are balanced against touches of black (the dancer's floating ribbon, and the man to her left, who is a stage manager or admirer appearing in the wings) and strikingly set off this almost supernatural image of the artificial life of the stage.

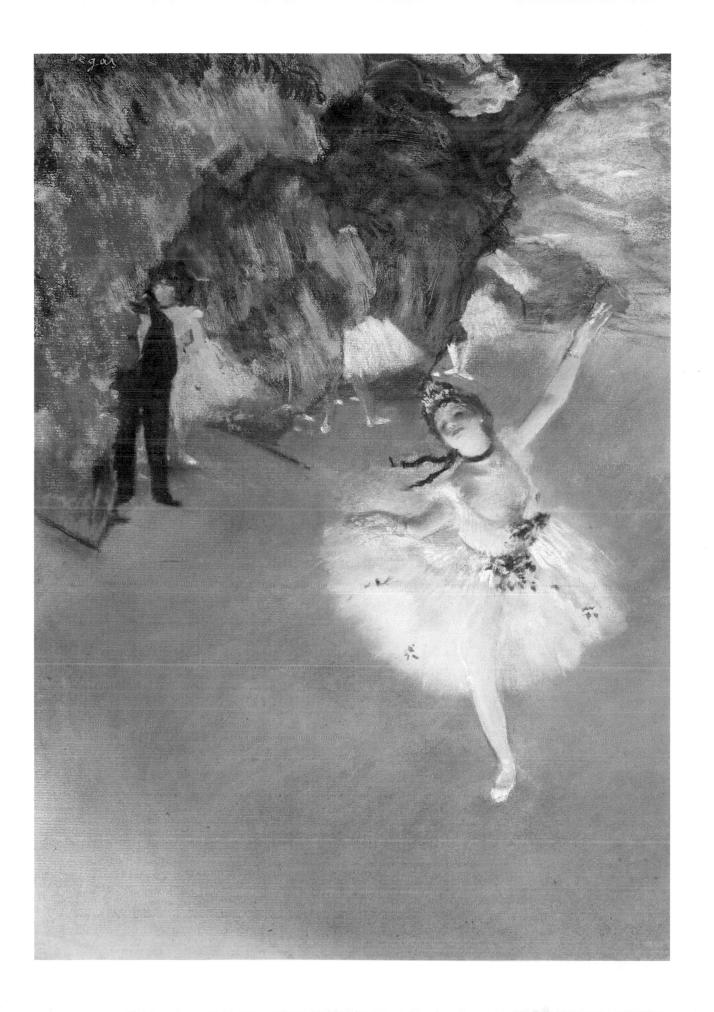

Chevaux de courses devant les tribunes

(Racehorses in Front of the Stands), c. 1879

Thinned oil colour on canvas, $18\frac{1}{8} \times 24$ (46 × 61) Count Isaac de Camondo bequest, 1911 (R.F. 1981)

From 1860 onwards, Degas began to be interested in horse-racing, an amusement he discovered in Normandy when visiting his friends the Valpinçons. It is sometimes difficult to date works on this theme, as it is one that he used frequently for twenty years. This example, painted in a thinned medium which gives a lighter and more transparent effect than conventional oils, is probably the painting listed as no. 63 in the fourth Impressionist exhibition of 1879 under the title *Chevaux de courses : essence (Racehorses : thinned oil colour)*. It was formerly thought that the picture was painted much earlier, before Degas' trip to New Orleans. The fact that several drawings, notably for one of the jockeys, date from around 1866 would appear to support this view.

Degas' paintings of horses are not only the results of single encounters with an especially interesting contemporary scene, whether a provincial entertainment or, as here, a Parisian one. They also grow from his study of paintings and drawings of the same subject-matter, by Géricault, Alfred de Dreux, and, as here, Meissonier. Meissonier's long-awaited painting of Napoleon III à la bataille de Solférino (Louvre), finally shown at the Salon of 1864, attracted copyists as soon as it entered the Musée du Luxembourg in August of that year. In his sketchbooks now in the Bibliothèque Nationale, Degas drew several riders from it, notably those seen from the rear in the left foreground, moving towards the group of the Emperor's general staff. The horses in the painting reproduced here, though now ridden by jockeys, are standing in very much the same way, but are differently placed; the one on the right in the original is put on the left, and vice-versa. Their movement away from one another accentuates the effect made by the open space of the race-track. There is a play of diagonals crossing one another which encompasses in addition the line of the stands and the barrier to the left, and also the long shadows cast by the horses. Despite the fact that he had borrowed his theme from another artist, Degas has here composed an original painting, alive and full of light, punctuated by the bright colours of the silks worn by the jockeys, with everything kept in balance by the horizontal band of the sky. The work no longer has anything in common with Meissonier's miniaturism.

It must also be remembered that, when Degas began his career, he was by no means hostile to the Salon as an institution, and took part in its exhibitions until the fall of the Second Empire. GL

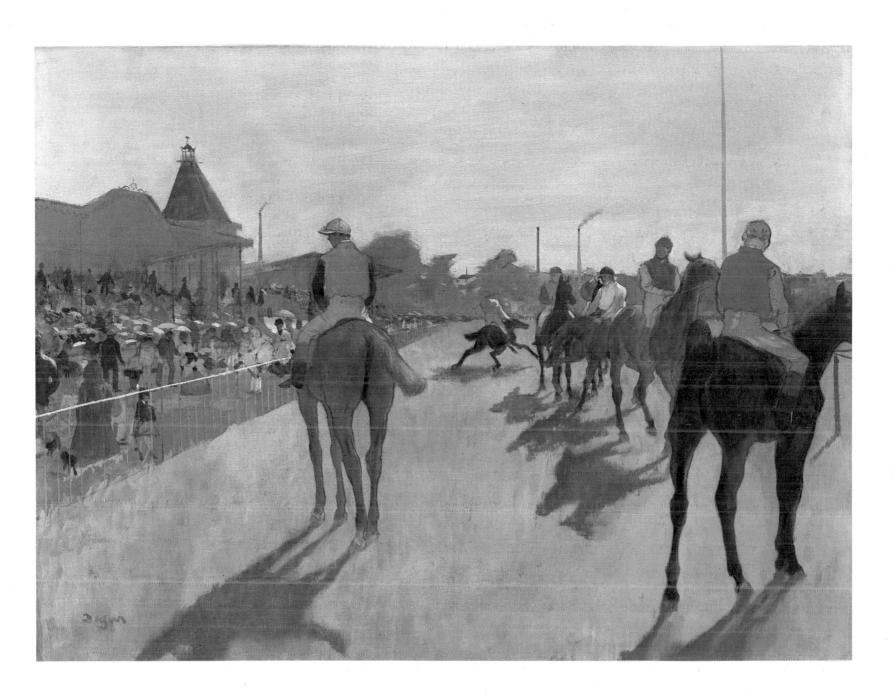

Les repasseuses (Women Ironing), 1884

Oil on canvas, $29\frac{7}{8} \times 31\frac{7}{8} (76 \times 81)$

Count Isaac de Camondo bequest, 1911 (R.F. 1983)

After a visit to Degas, Edmond de Goncourt noted in his Journal on 13 February 1874: 'After many experiments, trial-runs and feelers put out in all directions, he has now fallen in love with the contemporary and, amidst the contemporary, has fixed his attentions on washerwomen and dancers. I cannot find fault with his choice, since I too, in Manette Salomon, lauded these two professions as those providing, in our time, the female models most suited to depiction by a contemporary painter.' The first of the *Repasseuses* by Degas is the pastel of 1869 acquired by the Louvre as part of the Personnaz bequest; it is the earliest study of a theme-he took up many times in the course of perfecting it. The canvas illustrated here is one of the most famous examples. Painted in about 1884, it is a rehandling of a composition in pastel of two years earlier, now in the Durand-Ruel Collection, but contains a number of variations. These two women, hard at work and utterly exhausted, give us an uncompromising insight into the depth of human experience which Degas, born an aristocrat, had come to know, and which he also displays in L'absinthe (p. 40). These women ironing provide an echo of the naturalistic literature of the period – for example, Zola's L'Assommoir (*The Dram-shop*), published in 1877 – which inspired many artists, among them Steinlen and Forain. But this powerful image also demonstrates astonishing technical virtuosity, on a par with pastel in its rendering of texture. It must have made an impression on Picasso in 1904 during his Blue Period, when he adopted the theme and took it in the direction of pathos (New York, Solomon R. Guggenheim Museum). CF-T

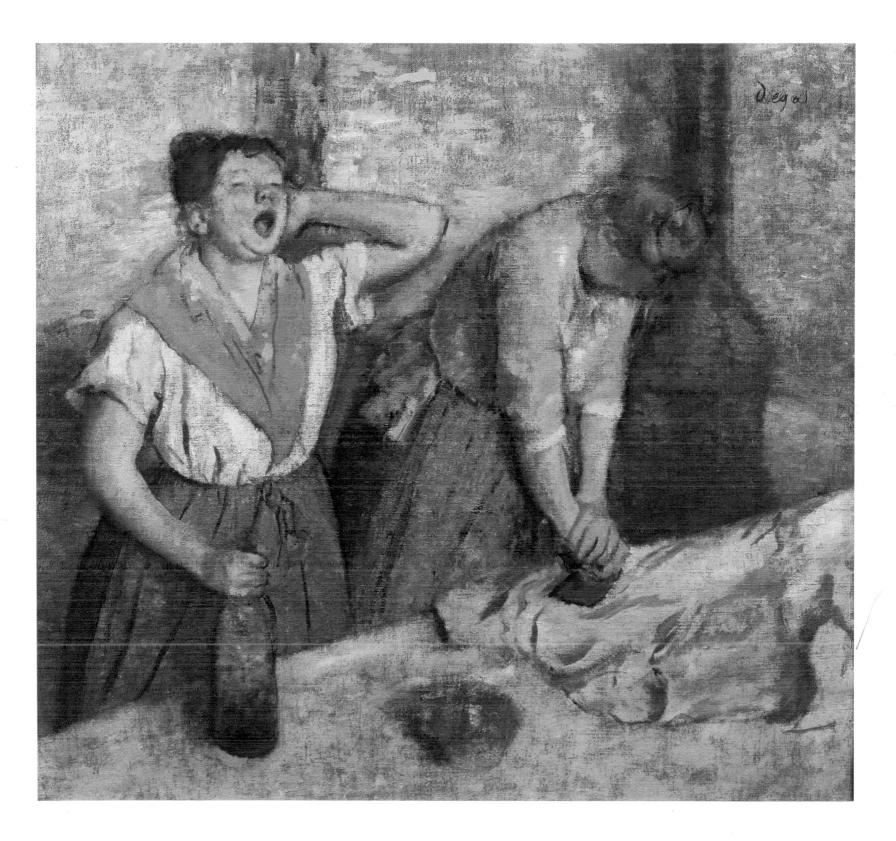

Le tub (The Tub), 1886

Pastel on cardboard, $23\frac{5}{8} \times 32\frac{5}{8}$ (60 × 83) Count Isaac de Camondo bequest, 1911 (R.F. 4046)

This famous painting by Degas entered the Louvre, along with *L'absinthe* and *Les repasseuses* (pp. 40, 46) as part of the magnificent Camondo bequest. The collection contained an important series of pastels by Degas showing women at their toilet. As the painter himself explained, this group of nudes, which occupied him intensely for a dozen or so years between about 1878 and 1890, was intended to represent 'the human animal pre-occupied with herself, like a cat licking itself'. 'Up till now,' he added, 'the nude has always been represented in poses which presuppose the presence of a spectator. But my women are simple, straightforward creatures interested only in what they are doing physically. Here's another, washing her feet – it's as if you were looking at her through the keyhole.' This candid parti-pris for unadorned observation, as opposed to the academic nudes which were always prized at the Salon – and which had only recently been attacked by Manet's *Olympia* (see p. 22) – shocked visitors to the final Impressionist exhibition of 1886, where Degas showed a series of his nudes.

At this time, the artist turned more and more frequently to pastel, carrying the technique to new and unequalled heights of virtuosity, often mixing distemper and thinned oil colour with it to get new effects of texture and light. Several years later, when his sight was failing, he made sculpture the medium of his observations, taking up once again his favourite themes: dancers, horses and women at their toilet. In this pastel the originality of the spatial organization, where the plane of the still-life cuts boldly into the space occupied by the tub, owes much to Japanese art, from which painters were then borrowing new compositional formulae. Degas was a past-master at locking together different picture-planes. In this he influenced Gauguin at the beginning of his career, and also Bonnard, Vuillard and Maurice Denis who were to become the leaders of the Nabis. The continuing influence of Ingres (whose disciple Degas was) can be traced through Degas' nudes to the work of twentieth-century artists such as Maillol, Valadon and Picasso. CF-T

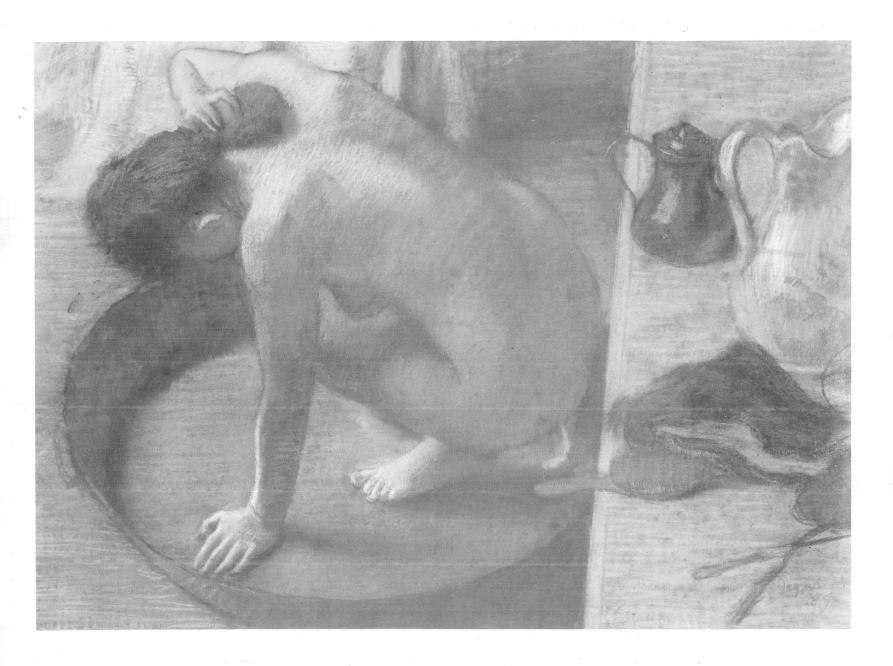

Entrée du village de Voisins

(Entrance to the Village of Voisins), 1872

Oil on canvas, $18\frac{1}{8} \times 21\frac{5}{8} (46 \times 55)$

Gift of Ernest May, but retained by him for his lifetime, 1923; entered the national collections in 1926 (R.F. 2436)

Camille Pissarro was born in St Thomas in the West Indies, then a Danish colony, but most of his career was spent in France, where both his parents came from, and where he settled for good in 1855. By the time he went to London in 1870, and as is most notably demonstrated by some large landscapes shown at the Salon (where Zola admired them), he was in full possession of his artistic powers, and had been responsible for a number of masterpieces. The austere, strongly constructed pictures of this period were certainly those which influenced the early work of Paul Cézanne, who was Pissarro's oldest and most faithful friend. Pissarro's exile to London in 1870 – he took refuge there from the Franco-Prussian War – brought with it a closer relationship with Claude Monet, and was marked by a movement towards a more supple technique and a more colourful palette. When he returned to France, Pissarro, who preferred life in the country to life in Paris, settled first at Louveciennes, then in 1872 went to live at Pontoise, where he remained until 1882. Nearly all the paintings of this period take the landscape of the Ile de France for their subject.

The *Entrée du village de Voisins* is a particularly brightly lit work, and is a good summary of Pissarro's art at this period. He often painted this particular kind of motif – a road bordered with pollarded trees, passing through well-populated countryside. The strongly marked structure of the composition is also a constant in Pissarro's work. The donor of the painting, Ernest May, who was one of the first to collect Impressionist paintings, chose to frame it as a kind of triptych with two other Impressionist landscapes – one by Monet, showing sailing boats at Argenteuil, and the other by Sisley – thus emphasising the particular personality of each artist, while at the same time underlining the similarity of their pictorial experiments.

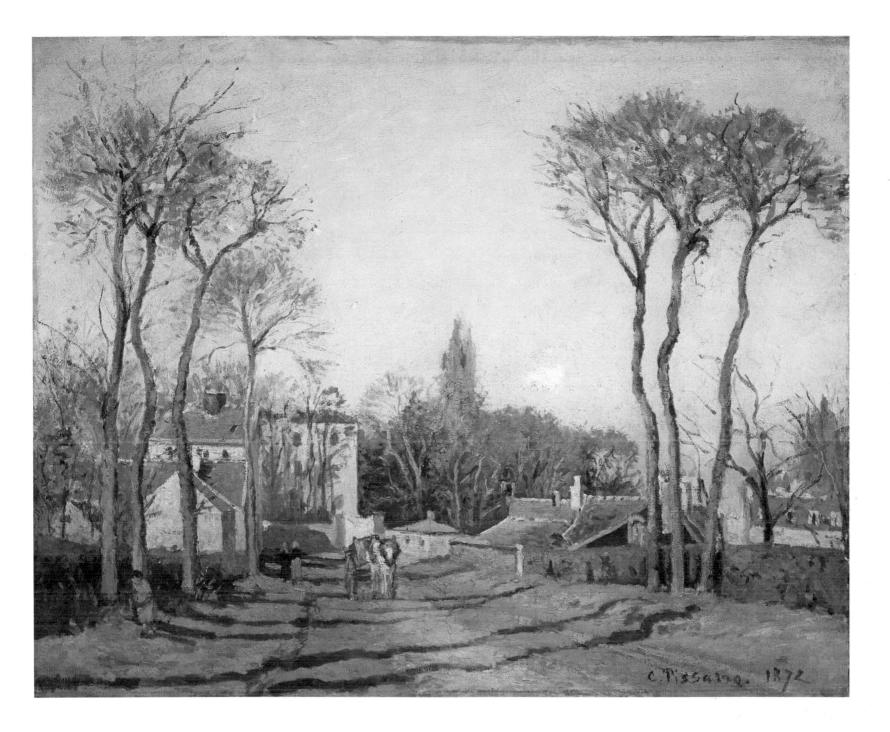

Coteau de l'Hermitage, Pontoise (The Hermitage Hillock, Pontoise), 1873

Oil on canvas, $24 \times 28\frac{3}{4}$ (61 × 73) Acquired in lieu of estate duties, 1983 (R.F. 1983–8)

The complex topography of Pontoise, built on an escarpment above the Oise, lent itself to unusual compositions and provided Pissarro with an inexhaustible supply of subject-matter. He particularly liked the intermingling of countryside and town, which can still be seen there today to some extent. In this painting, done with highly fragmented touches of blue, green, grey and beige, the artist uses the contrast between the sinuous lines of the hill and trees and the rectilinear profiles of the buildings. The surprising way the patches of cultivation are handled accentuates still further the bizarre quality of the space thus depicted. As was his custom, Pissarro used the same motif a second time, but painted it under snow. In this, he compares with Monet, who also liked to explore different effects of light on familiar landscapes. When one thinks of this period at Pontoise, it is essential to remember that Paul Cézanne, living sometimes at Pontoise and sometimes in the neighbouring village of Auvers-sur-Oise, often worked side by side with his friend and that such habitual contact set up reciprocal currents of influence.

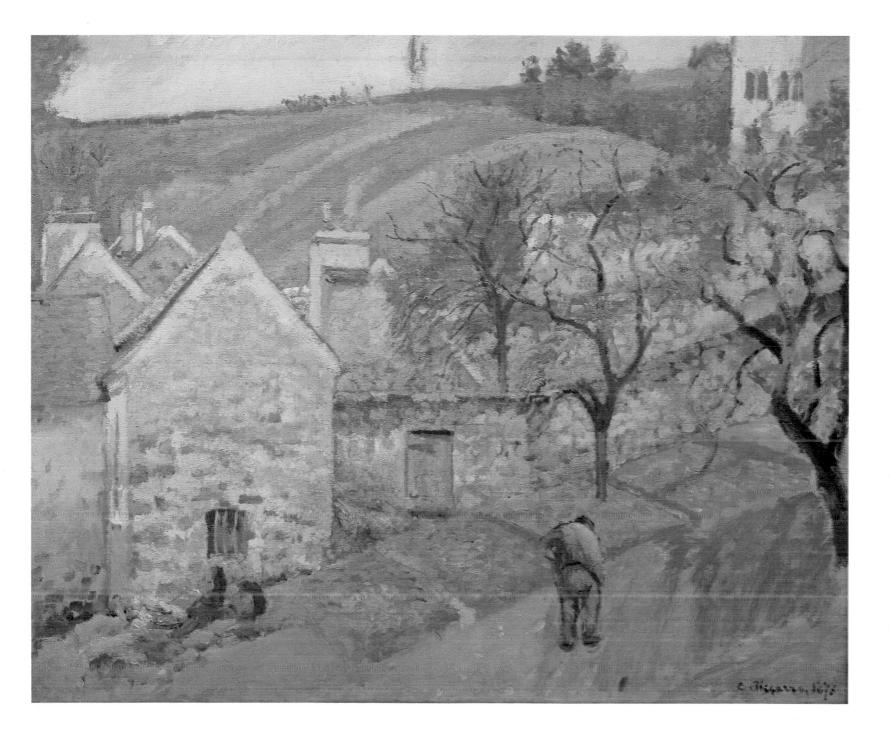

Portrait de l'artiste (Self-portrait), 1873

Oil on canvas, $22\frac{1}{2} \times 18\frac{1}{8} (56 \times 46)$

Gift of Paul-Emile Pissarro, but retained by him for his lifetime, 1930; entered the national collections in 1947 (R.F. 2837)

In 1883, Camille Pissarro wrote to his son Lucien: 'You must remember that I have a rustic, melancholy kind of nature - that there's something unpolished and uncouth about me. People only like me when they've known me for a while – people who take to me have to have a soft spot for me. For the mere passerby a glance is not sufficient – he sees only the surface and, not having the time, he just passes by! ... Painting, and art in general, delight me. They're my whole life. What does anything else matter!... Isn't that all an artist should really want? Well, that's quite a speech!' This passionate profession of faith accords very well with the extreme simplicity of this self-portrait, where the face alone stands out against a background showing paintings which it is hard to identify, closely hung against a patterned wallpaper of the kind one sees in still-lifes by Pissarro and Cézanne. It is the only self-portrait from this period of his mature work – he did not paint another one until the very end of his life. Pissarro, who was often compared by his contemporaries to Moses, or to God the Father, was soon regarded as a patriarch both because of his physique and because of his kindly nature. The latter, however, did not stop him showing combative energy when it came to organizing the first Impressionist exhibition of 1874, or, later, giving his support to the Anarchist cause, which he did by making drawings to illustrate the periodicals published by the movement. AD

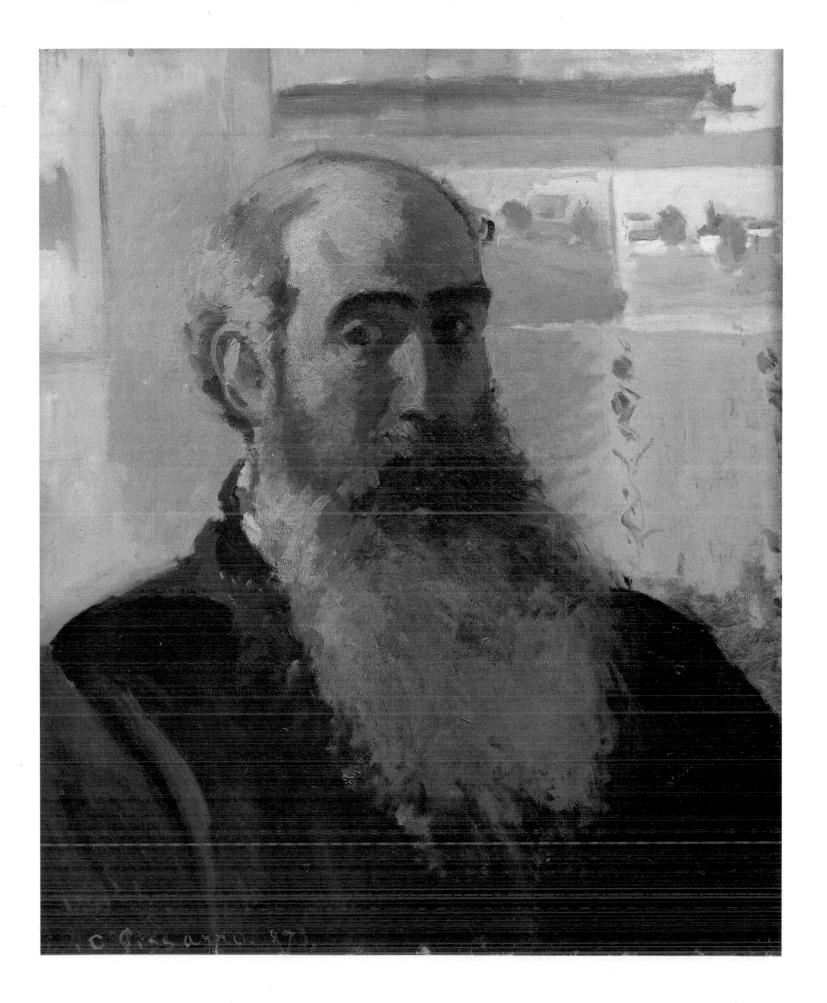

Jeune fille à la baguette (Girl with a Stick), 1881

Oil on canvas, $31\frac{7}{8} \times 25\frac{1}{4} (81 \times 64)$ Count Isaac de Camondo bequest, 1911 (R.F. 2103)

For Pissarro, as for the other members of the Impressionist group, the beginning of the 1880s was, if not a time of crisis, then at least one of taking stock of what had happened in the preceding years. *Jeune fille à la baguette* is one of the first paintings in which Pissarro gave such a prominent place to the human figure – with the exception, that is, of self-portraits, the few portraits of members of his family, or of intimate friends such as Cézanne. It is also one of the first where the background has only the kind of importance accorded to the generalized foliage of a 'verdure' tapestry. It is not an isolated work, and can be seen as part of a series of paintings showing young peasant girls in repose. Pissarro's choice of this theme reflects his interest in country people and in their position in contemporary society. It echoes the work of his friend Degas – his 'modern' pictures showing women at work or dancers in rehearsal – rather more than it does that of Millet, to whom Pissarro has often been compared.

The handling – with rough little touches of colour which are sometimes surprisingly bright in hue – calls attention to the sobriety and rigour of the composition. Such figures, often seemingly melancholy, placed in a space which is essentially abstract despite the references to the vegetation which seems actually to support them, particularly stimulated Gauguin, who was then a mere beginner. In fact, it was under Pissarro's aegis that Gauguin painted his first pictures, then exhibited with the Impressionists.

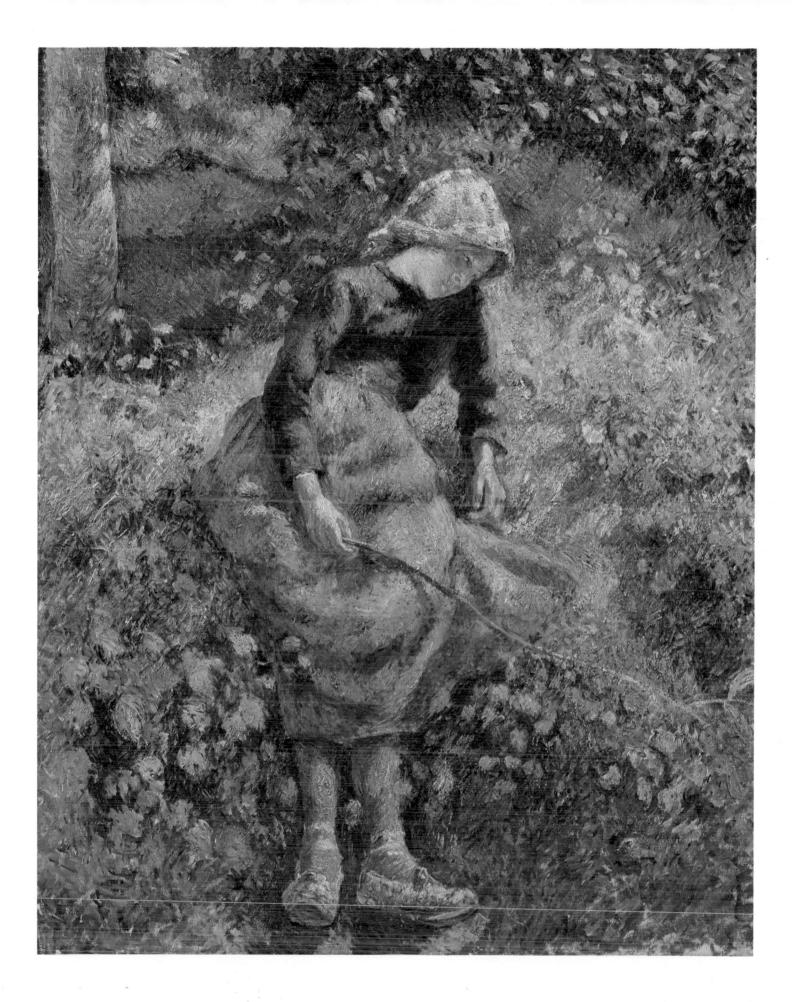

Femme dans un clos, soleil de printemps dans le pré d'Eragny

(Woman in an Orchard, Spring Sunshine in the Meadow at Eragny), 1887

Oil on canvas, $21\frac{1}{4} \times 25\frac{1}{4} (54 \times 65)$ Antonin Personnaz bequest, 1937 (R.F. 1937–47)

In 1884 Pissarro left Pontoise, but remained in the immediate neighbourhood, settling for good at Eragny-sur-Epte, which remained his chief place of residence until his death. Eragny is thus the setting for this painting, which is a revealing specimen of the artist's brief Divisionist interlude between 1886 and 1890.

In 1885 Camille Pissarro had got to know two young painters, Signac and Seurat. Their new theory, based on recent scientific research, was explained by Pissarro to his dealer Durand-Ruel as the substitution of an optical mixture of pure touches of colour which appear on the canvas itself for the mixture which the artist makes in advance on his palette. These touches produced a comparable effect to the conventional process of colour blending, 'but the optical mixture gives much more intense luminosity than mixing pigments'. Pissarro applied these new principles to his work, and at the last Impressionist exhibition of 1886 showed Pointillist works – to the astonishment of his former colleagues in the movement, and of informed collectors. Seurat, Signac and Pissarro's son Lucien, who was also a painter, exhibited canvases done in the same manner. *Femme dans un clos*, dating from 1887, already shows a somewhat freer interpretation of Pointillist principles, and from 1889 Pissarro reverted to a way of painting which was close to his earlier style.

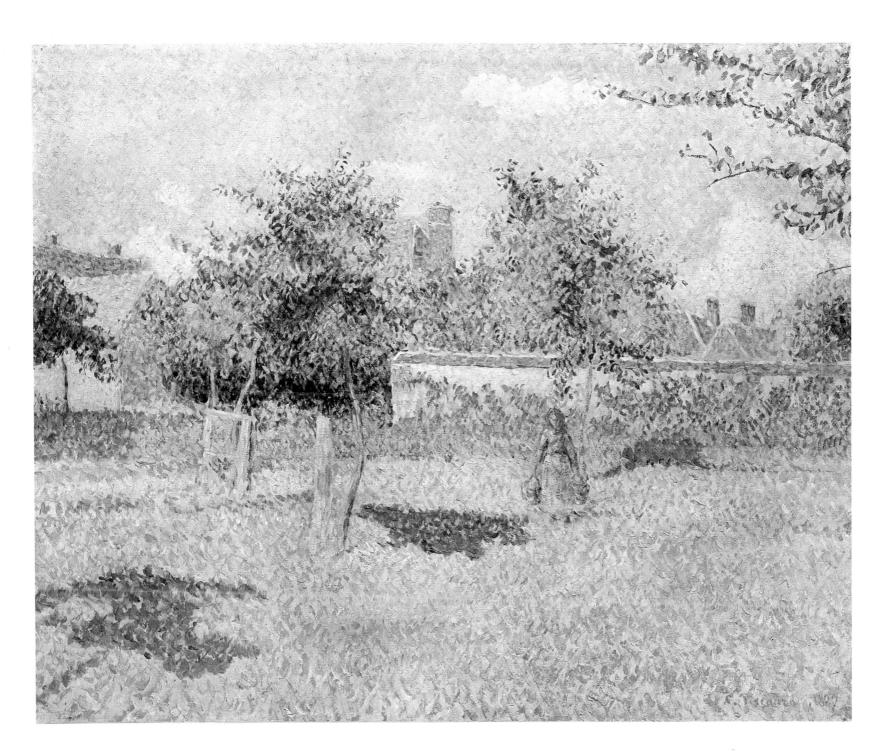

Le port de Rouen, Saint-Sever (The Port of Rouen, Saint-Sever), 1896

Oil on canvas, $25\frac{5}{8} \times 36\frac{1}{4} (65 \times 92)$ Eduardo Mollard bequest, 1972 (R.F. 1972–31)

Pissarro's first prolonged visit to Rouen took place in 1883. He returned twice in 1896, and painted – chiefly from the windows of hotel-rooms overlooking the river – the extraordinary animation of the port and of the bridges spanning the Seine. In 1896, the year when *Le port de Rouen, Saint-Sever* was painted, Pissarro described the scene in a letter to his son: 'It's as beautiful as Venice, dear boy – it has terrific character and is really very beautiful! It's real art, and corresponds to my feeling for things.' Rouen's new industrial quarters – like Saint-Sever – attracted Pissarro just as much as the historic parts, with its cathedral and narrow streets of Gothic and Renaissance buildings. He nevertheless hesitated to exhibit the paintings done at Rouen because, modest as ever, he feared comparison with Monet's brilliant series of *Cathédrales* which had been shown in 1895.

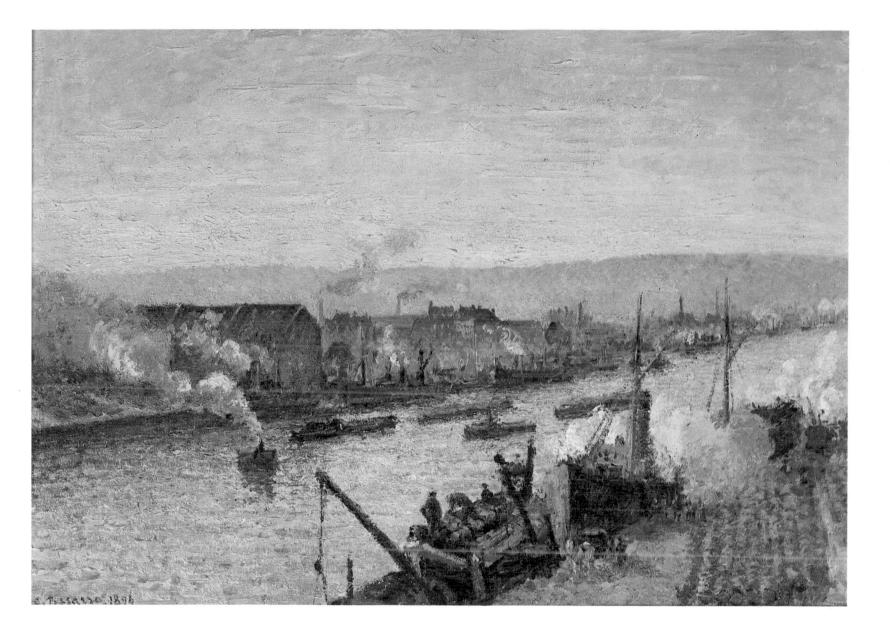

Une moderne Olympia (A Modern Olympia), c. 1873-74

Oil on canvas, $18\frac{1}{8} \times 21\frac{5}{8} (46 \times 55)$ Gift of Paul Gachet, 1951 (R.F. 1951–31)

Cézanne's earliest paintings, which were in dark tones, were strongly influenced by the Old Masters and by Delacroix, Daumier and Courbet. A typical painting of this period was an earlier one also entitled *Une moderne Olympia* (1870, formerly in the Pellerin Collection), painted in response to Manet's large canvas which had provoked such a scandal in the Salon of 1865 (see p. 22).

A few years later, Cézanne tackled the theme again, but this second version is quite different. Its brilliant, sparkling hues and dashing execution recall the paintings of Fragonard. Cézanne's style was at this point evolving towards Impressionism. It was during a visit to Auvers-sur-Oise as the guest of Dr Gachet, who later owned the painting, that the artist, inspired by an animated discussion about painting, picked up his brush to create this colourful sketch. In it he makes a new and more audacious interpretation of the subject. The contrast between the nudity of the woman, who is unveiled by a negress, and the elegant dress of the man in black, seated on a sofa with his back to us and looking at her, along with the strange little dog in the foreground, helps to give the scene an erotic, theatrical atmosphere which is accentuated by the presence of the curtain on the left. The bearded figure is strangely like Cézanne himself.

At the first Impressionist exhibition of 1874 this hallucinatory vision conjured up by Cézanne attracted the mockery of both public and critics. One critic saw it as 'a fantastic figure appearing to an opium-smoker in an opium-laden sky. This naked, rosy apparition, driven on by a kind of demon in the cloudy empyrean, in which is hatched this fragment of an artificial paradise, like a vision of voluptuous pleasure, has stifled even the bravest . . . and M. Cézanne seems no more than a kind of madman, with the fit on him, painting the fantasies of *delirium tremens*.' (Marc de Montifaud, L'Artiste, I May 1874.)

La maison du pendu, Auvers-sur-Oise (The House of the Hanged Man, Auvers-sur-Oise), 1873

Oil on canvas, $21\frac{5}{8} \times 26$ (55 × 66)

Count Isaac de Camondo bequest, 1911 (R.F. 1970)

La maison du pendu, like *Une moderne Olympia* (see p. 62), was among the works by Cézanne shown at the first Impressionist exhibition of 1874, and it was just as badly received: 'when it comes to landscape, M. Cézanne sees fit not to take us right up to his *Maison du pendu*... he makes us stop half way there.' (Marc de Montifaud, *L'Artiste*, 1 May 1874.)

This canvas, painted at Auvers-sur-Oise, shows Cézanne under the influence of his older mentor, Pissarro, who was then living at Pontoise. Although Cézanne here was still using a thick impasto and continued to employ the palette-knife in places, he was at this time abandoning dark tonalities in order to substitute brighter hues, while at the same time adopting the broken Impressionist touch. He remained faithful to his objective of constructing space rigorously, something which he for his part communicated to Pissarro. It is interesting to compare this village landscape with contemporary works by Pissarro (see p. 52), in order to study the influence the two painters exercised on one another at this period, when they were working together.

As well as showing a change of technique, this painting bears witness to a new choice of subjectmatter. Henceforward Cézanne was to abandon dramatic and literary themes in favour of insignificant subjects like this cross-roads. The subject has become a mere pretext; it is now only the 'motif', and is given its full meaning through the artist's interpretation.

This painting is one of the few signed by the artist (in red, in the bottom left-hand corner). As for the title – it does not in fact (as the art-historian Venturi points out) derive from an actual tragic event. Can we surmise, then, that this is a last vestige of the romanticism of Cézanne's earlier period?

This painting, the fruit of Cézanne's own revision and transformation of Impressionism, which he thereby turned into an entirely personal creation, represented the artist in the Centennial Exhibition of French Art held at the International Exhibition of 1889.

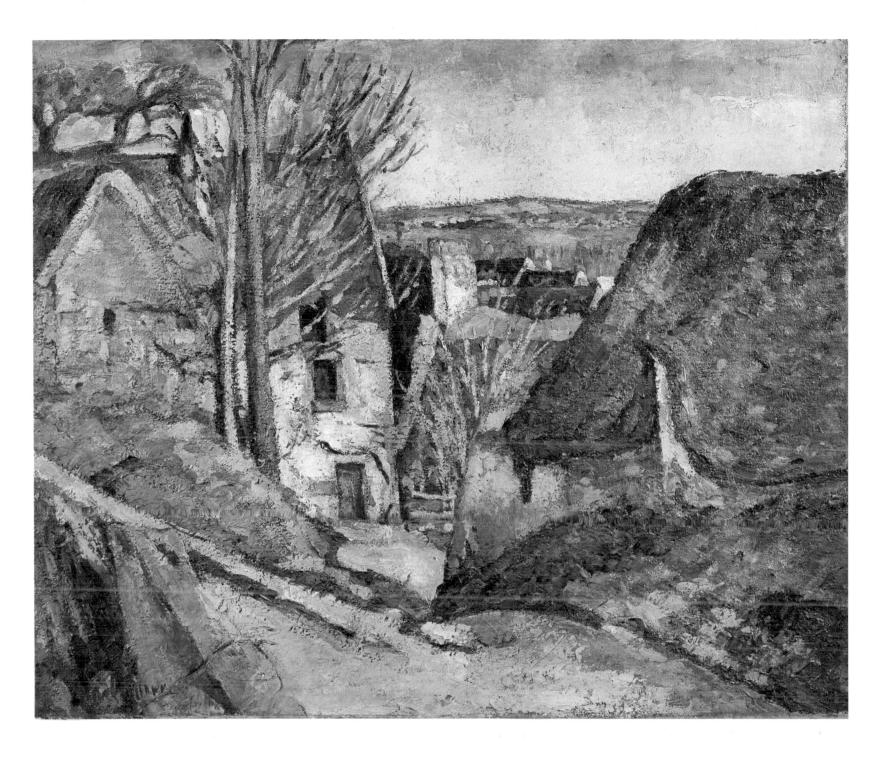

L'Estaque: Vue du golfe de Marseille (L'Estaque: View of the Bay of Marseilles), c. 1878–79

Oil on canvas, $23\frac{1}{4} \times 28\frac{3}{4} (59 \times 73)$ Gustave Caillebotte bequest, 1894 (R.F. 2761)

Cézanne's mother owned a house at L'Estaque, west of Marseilles, where the artist took refuge during the Franco-Prussian war of 1870–71. He afterwards returned several times, drawn no doubt by the Mediterranean, since his few seascapes were all painted there.

In 1876 Cézanne described to Pissarro the panoramic landscape which stretched before him: 'your letter finds me at the seaside, at L'Estaque. I've begun work on two little paintings which show the sea ... It's like a playing-card. Red roofs against the blue sea ... there are themes here which would encourage one to spend three or four months' work on them ... since the vegetation doesn't alter. The olive-trees and pines keep all their foliage. The sun is so brilliant that it seems as if objects rise up in silhouette, not merely in black and white, but in blue and red and brown and violet ... it's the antithesis of modelling.'

This view, looking down into the Bay of Marseilles, which was probably painted two or three years later, also has the appearance of a playing-card, in the way that the planes of colour are flat and well delineated. A similar effect had been achieved by Manet in his *Le fifre* of 1886 (p. 24), which was severely criticized by contemporary critics for this very reason. The composition of this painting of L'Estaque is divided into four distinct zones, each marked by their different treatment and colour. In the foreground is the shoreline, the heaviest and most thickly painted part; then the smooth blue surface of the water interrupted here and there by the white fleck of a sail; and then the range of mountains with a thin strip of sky above. The horizon is placed extremely high. The synthesis of planes, which seem to rear up towards the spectator as they get further away, constitutes an abolition of traditional perspective which seems to go beyond the boundaries of Impressionism.

Another, rather different version of this view, entitled *La mer à L'Estaque (The Sea at L'Estaque)*, in which the tall factory chimney also appears, entered the national collections as part of the Picasso Collection.

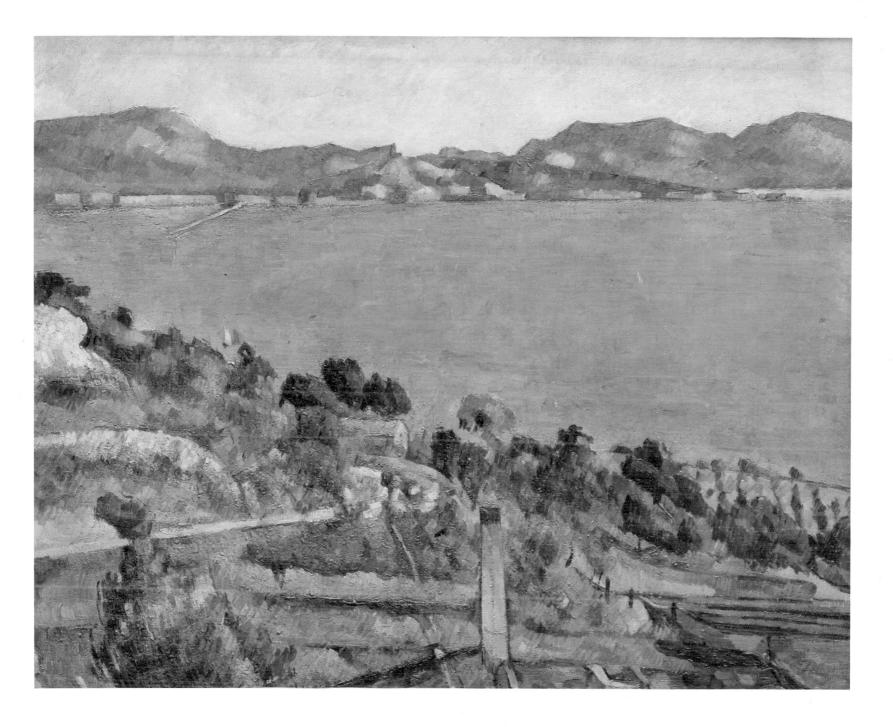

Le vase bleu (The Blue Vase), c. 1885–87

Oil on canvas, $24 \times 19\frac{5}{8}$ (61 × 50) Count Isaac de Camondo bequest, 1911 (R.F. 1973)

Cézanne is here more interested in colour modulation than in the depiction of flowers in bloom. Once again the subject is put at the service of one of his major preoccupations: the way light falls on objects and the resultant changes of colour. Space is constructed by means of a skilful play of verticals and horizontals and of a balanced distribution of volumes, while the harmony of the whole is ensured by the subtle use of different blues. The composition is centred exactly on the vase standing on the table.

Ten years earlier, at Auvers-sur-Oise, Cézanne had painted a number of flower pieces (of which the Musée d'Orsay has several examples, thanks in the main to the gift made by Dr Gachet's son), but here he adds a new element: apples. Prominent because of their colour, they recall his still-lifes with fruit, which are much more numerous than the flower paintings. Cézanne once said to Gachet that he'd 'given up flowers. They fade immediately. Fruit is more reliable.' This canvas is enriched by the association of the two themes that had once led to Cézanne's being nicknamed 'Flowers and Fruit'. The apparent simplicity and sobriety of this painting are far removed from the exuberance and richness of Renoir's flower-pieces. It is interesting to recall that this painting first belonged to Vollard, the famous picture-dealer, who also represented Renoir, Gauguin and Picasso.

Le vase bleu was shown at the Cézanne retrospective organized as part of the Salon d'Automne of 1904, two years before the artist's death. sg-p

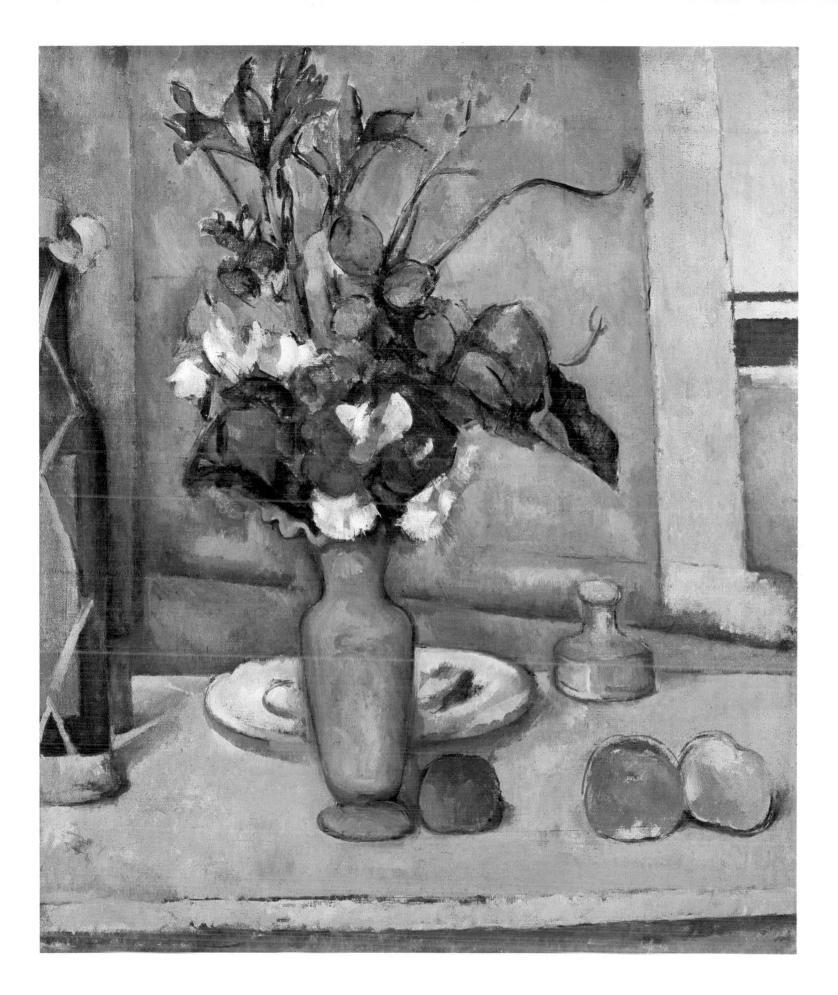

La femme à la cafetière (Woman with a Coffee-pot), c. 1890-95

Oil on canvas, $51\frac{1}{8} \times 37\frac{3}{4} (130 \times 96)$

Gift of M. and Mme Jean-Victor Pellerin, 1956 (R.F. 1956–31)

'The culmination of art is figure painting', Cézanne once said to Vollard. The artist painted portraits chiefly at the beginning and end of his career. He has been criticized for the abstracted air of his figures, who are sometimes compared to the enigmatic personages of Piero della Francesca. Cézanne tried to render, not fugitive expressions animating a face, but the essence of the model, his or her character; and hence produced these imposing effigies whose stability and monumentality remind one of Zurbarán. This is the impression one gets from *La femme à la cafetière*. Extreme slowness of execution and a certain shyness explain why Cézanne took his models from among those closest to him (above all his wife), and from among friends and the people he came across at the Jas de Bouffan (for example, farm-workers and servants; see also p. 72). This woman, with her hieratic pose, must be one such, though she cannot be identified with certainty.

Portraits such as this one prove how, in Cézanne's work, the exploration of the plasticity of the forms, here very much simplified, takes precedence over psychological analysis. The woman's body, a heavy sculptural mass, is studied as if it were still-life – in fact, the artist demanded of his models the same immobility that he got from apples. The woman's arms, following the example set by the coffee-pot and the cup, obey Cézanne's recommendation that 'nature should be rendered as a sphere, a cylinder or a cone'. This geometricization of volumes, together with the perspective used for the table, whose surface is tilted up, is the precursor of Cubism. (See also *Les joueurs de cartes*, p. 72, and *Nature morte aux oignons*, p. 76.)

This rigorously constructed work is a good illustration of the famous statement attributed to Cézanne, that 'drawing and colour are not separate; one draws as one paints; the more harmonious the colour, the more precise the draughtsmanship. When the colour reaches full richness, form reaches full plenitude. The secret of drawing and modelling lies in contrasts and juxtapositions of tone.'

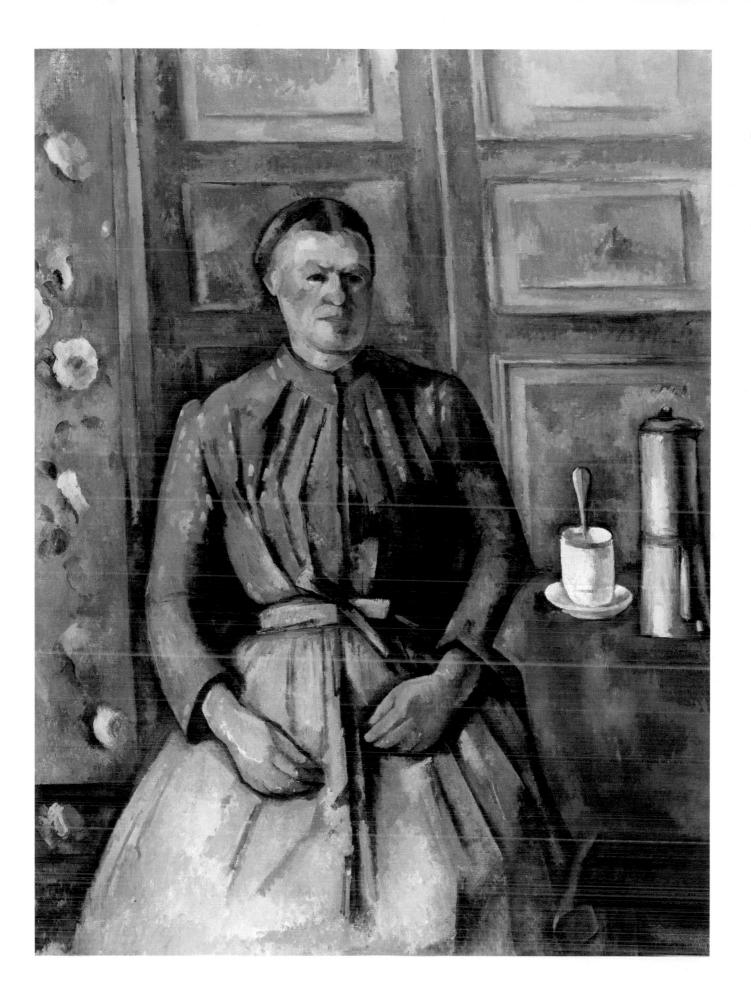

Les joueurs de cartes (The Card-players), c. 1890-95

Oil on canvas, $18\frac{1}{2} \times 22\frac{1}{2} (47 \times 57)$

Count Isaac de Camondo bequest, 1911 (R.F. 1969)

Cézanne is certain to have seen, in the museum at Aix-en-Provence, a painting of card-players which came from the studio of the Le Nain brothers. In the 1890s, he made use of this Caravaggesque theme on several occasions, but transformed it to accord with his own personal vision. For him everything was a pretext for the sophisticated exploration of line and volume. The central axis of this composition is the bottle catching the light; it divides the space into two symmetrical zones, and thereby accentuates the opposition of the players. They are ordinary country people and could well have been among those at his father's property at the Jas de Bouffan near Aix. The man smoking a pipe has been identified as 'Père Alexandre', the gardener there. (See also p. 70.)

Besides numerous preparatory studies, Cézanne devoted no less than five paintings to this theme. They differ in format, in the number of figures, and in the degree of importance given to the setting. The largest contains five figures (Merion, Barnes Foundation); another (New York, Metropolitan Museum) has four; while the three simplest have two apiece. Several theories have been put forward as to the order in which they were painted. The three simplified versions, of which this is one, seem to have been the subject of a long-pondered process of construction which leads one to believe that they are later than the two others, which are more cluttered but less elaborate. Faithful to his own temperament, Cézanne is here moving towards simplification, completely effacing the anecdotal aspect of this type of traditional genre-scene, and at the same time abandoning traditional perspective.

The recurrence of this theme in Cézanne's art during his last years has given rise to an interesting interpretation. Is the confrontation of the two players emblematic of the conflict between the artist and his father, as Cézanne tried to get the latter to give him recognition for his painting, which he here symbolizes by a playing-card?

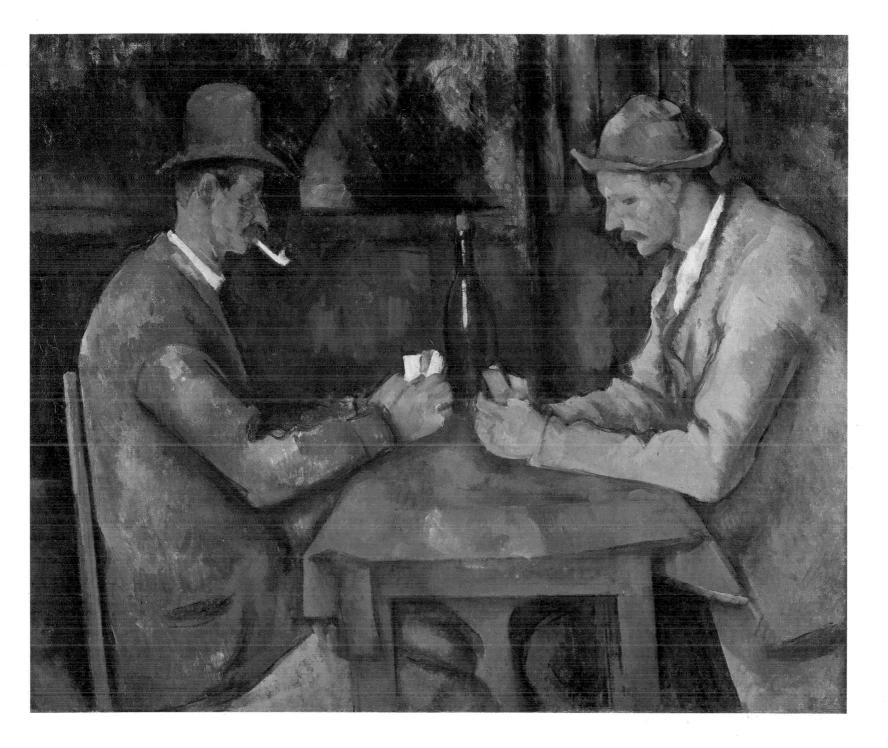

Paul CÉZANNE (1839–1906)

Baigneurs (Bathers), c. 1890-92

Oil on canvas, $23\frac{5}{8} \times 32\frac{1}{4} (60 \times 82)$

Gift of Baronne Eva Gebhard-Gourgaud, 1965 (R.F. 1965-3)

The airy space of *Baigneurs* creates a complete contrast to the enclosed one of *Les joueurs de cartes* (p. 72). Even the clouds take up the rhythm of the trees and the human bodies. The two subjects can be thought of as antithetical – the latter, portrayed in sombre hues, being associated with the notion of conflict, while the former, dominated by blues and greens, shows the artist trying to express the harmony of man and nature, and even a certain fusion between the two. Cézanne is perhaps thinking of his childhood at Aix, and of joyous bathes in the river Arc with his friends, Zola among them. He must also have seen soldiers bathing in this river.

The painter here analyses the integration of figure and landscape, following in the steps of masters such as Giorgione, Titian, Rubens and Poussin. His researches culminated in the creation of three large paintings of bathers, in which he revivified a theme already traditional in French art – Watteau, Boucher, Fragonard, Courbet and Renoir all painted women bathing. The theme is evident in Cézanne's work from 1870 onwards, and obsessed him particularly in his last years. He returned tirelessly in many of his paintings and watercolours to poses suggested by Old Master drawings and ancient sculptures.

In this example, one of the most complete and best constructed, the figures are used to make a balanced pyramidal composition, like a tympanum, a device frequently used in Italian art. Like the bottle in *Les joueurs de cartes*, the central tree serves as the axis. The man holding the piece of drapery seems to have been inspired by a Signorelli drawing and has also been compared (by Charles Sterling) to a figure in El Greco's *Laocoön*. In other variants, the bathers are arranged to make a frieze.

This painting was shown at the Salon d'Automne of 1904, and had an important influence on the young painters of the time. Several of them owned versions of it, among them Denis, Matisse and Picasso.

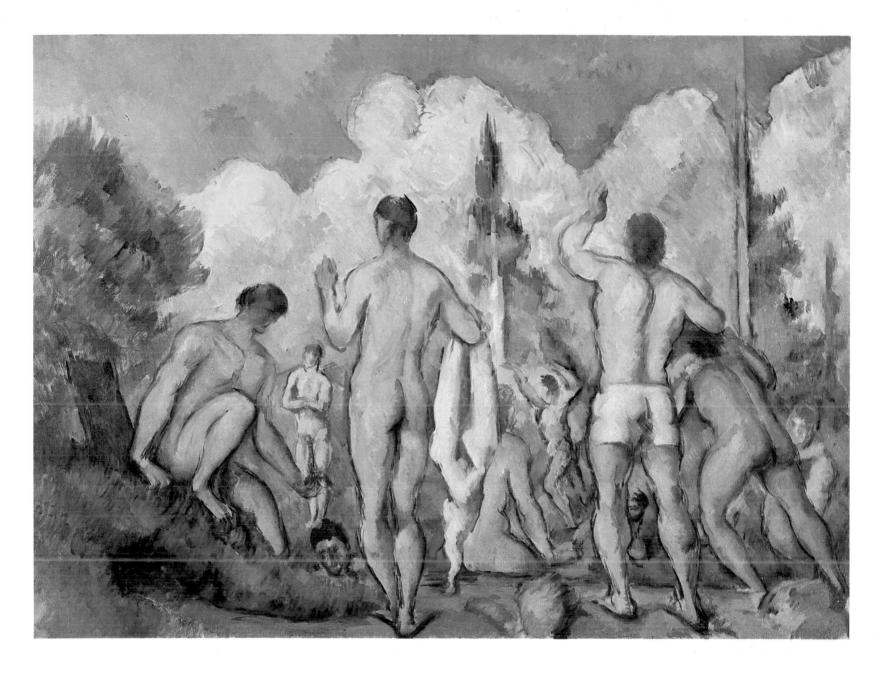

Paul CÉZANNE (1839–1906)

Nature morte aux oignons (Still-life with Onions), c. 1895

Oil on canvas, $30 \times 32\frac{1}{4}$ (66 × 82) Auguste Pellerin bequest, 1929 (R.F. 2817)

The medium of still-life, which was in harmony both with Cézanne's character and with his method of working, retained his attention throughout his career. Following the example of the Spanish and Dutch masters, who were attuned to the 'silent life of objects', Cézanne was attracted by the poetry of the familiar accessories of daily life. But it is the name of Chardin which suggests itself even more forcefully in his work than those of Vermeer, Zurbarán or Goya; and Cézanne doubtless saw and admired the paintings by Chardin which became part of the Louvre collection in 1869, as a result of the La Caze bequest. In order to give the illusion of depth, for example, Cézanne borrows from Chardin the device of a knife placed diagonally in the composition – something that Manet had also made use of.

In addition to fruit, whose spherical forms, like those of onions, were an ideal subject for his investigations into the nature of volume, Cézanne here represents a number of other simple objects, some of which can still be seen today in his studio at Aix-en-Provence (such as pottery and pieces of glass). This fidelity to the same props shows that the painter concentrated his attention on the disposition of the objects and on the architecture of the composition, and also studied the fall of light on the forms. 'Yes, draw', he wrote in 1905; 'but it is reflections that wrap things round – light, which by its general reflection, provides them with an envelope'.

On this table with its scalloped edge, Cézanne introduces, as in many of the still-lifes of his last period, a decorative piece of drapery which counterbalances the vertical made by the bottle and conceals the rigorously ordered construction of the picture. This drapery stands out, like the bottle, against a totally empty neutral background which differentiates this painting from other late stilllifes which are much more crowded. Cézanne at this time was adopting a new perspective system which was to open the door to Cubism: the objects are seen from above, and from several different viewpoints at once.

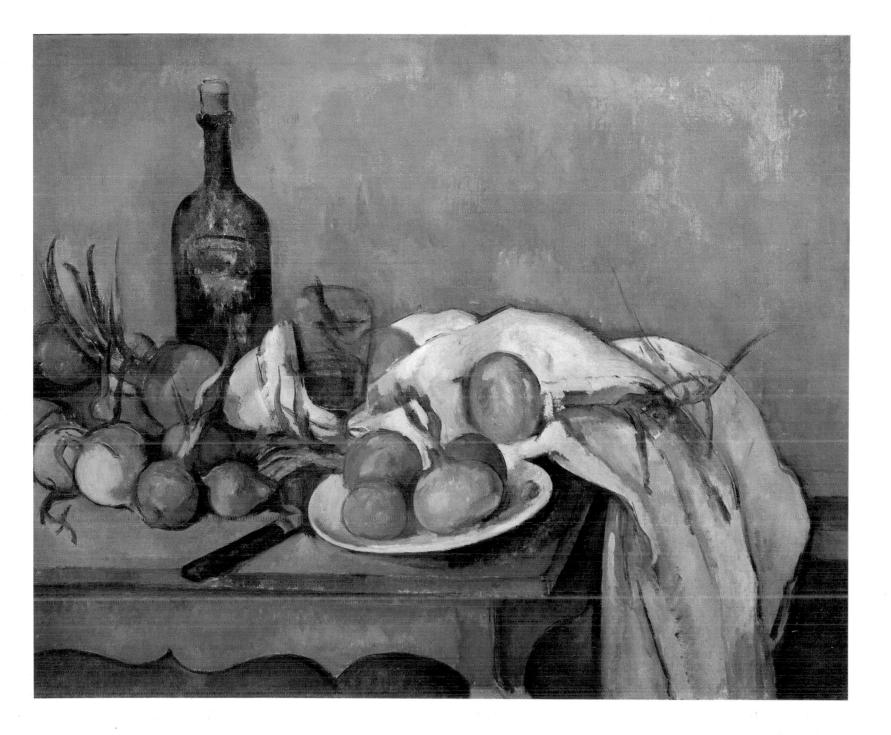

Eugène BOUDIN (1824–1898)

La plage de Trouville (The Beach at Trouville), 1864

Oil on panel, $10\frac{1}{4} \times 18\frac{1}{8} (26 \times 48)$ Gift of Eduardo Mollard, 1961 (R.F. 1961–26)

Boudin's début in the domain of art was a modest one, beginning as he did as a paper-merchant and framer at Le Havre, and using his shop to show work by painters such as Troyon and Millet who passed through the town. These men encouraged him to paint, and a grant from the town council enabled him to go and study in Paris in 1851. But he always remained faithful to the Normandy coast, where in 1858 he met Claude Monet, whose first teacher he became. He also got to know Courbet and Baudelaire; the latter was delighted with his sky studies, and supported him when he exhibited at the Salon for the first time in 1859 with an ambitious and relatively large work, *Le pardon de Sainte-Anne-la-Palud (The Pardon of Sainte-Anne-la-Palud*, now in the museum at Le Havre). The painting depicts a picturesque throng gathered round white tents and market-stalls exposed to the open air, all set in a wide blue landscape.

Certain elements from *Le pardon de Sainte-Anne-la-Palud* – among them the hill and the chapel with its bell-tower – occur again here in this delightful little painting of the beach at Trouville. To the right are the high slate roofs of a villa, and the hill behind the beach; in the centre are summer visitors, standing about, or seated on chairs, with brilliant white bathing cabins and two tall flagpoles in the background. All of this occupies only the bottom of a composition in which the sky occupies most of the space.

In the same year that this was painted, Boudin met Courbet and Manet at Trouville, which was then a smart watering-place. He had started to paint its bustling fashionable society in 1862, on the advice of Eugène Isabey, a famous marine painter. In 1863 he depicted *L'impératrice Eugénie et sa suite à Trouville (The Empress Eugenie and Her Suite at Trouville,* Glasgow Museums and Art Galleries, Burrell Collection) in a dazzling swirl of crinolines, and submitted *La plage de Trouville* to the Salon in 1864.

Out of loyalty to his Impressionist friends, Boudin took part in the first Impressionist exhibition of 1874, but thereafter remained faithful to the Salon, which did not hold his temporary apostasy against him.

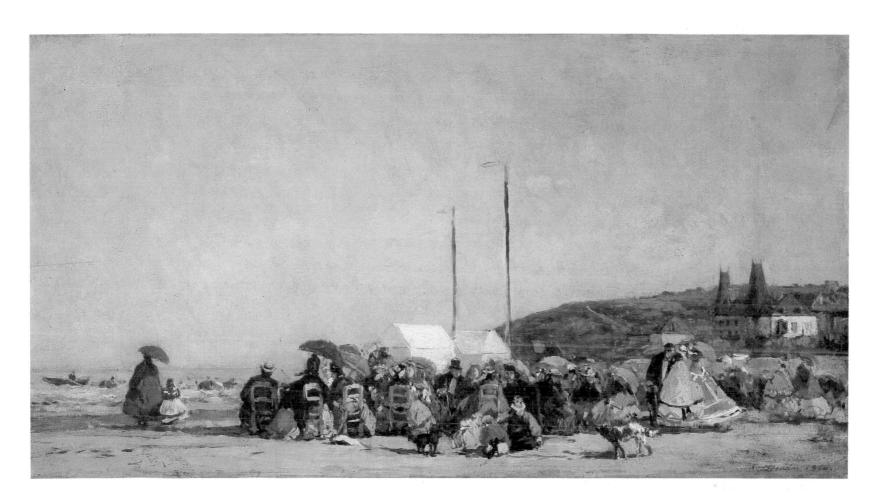

Femmes au jardin (Women in the Garden), 1866-67

Oil on canvas, $100\frac{3}{8} \times 80\frac{3}{4} (255 \times 205)$ Purchased in 1921 (R.F. 2773)

Claude Monet spent his childhood and youth in Le Havre, where he found his first real teacher, Eugène Boudin, and formed links with the Dutch landscape painter Jongkind. The example set by these two resolutely nonconformist painters decided the direction the young artist was to take. When he arrived in Paris, he joined Gleyre's studio, and there met Bazille, Renoir and probably Sisley. In 1865, he sent two landscapes to the Salon which were favourably received, and had further success the following year with *Camille* (Kunsthalle, Bremen), which was influenced by Courbet and also by Manet. With this to encourage him, Monet started work on a huge composition showing figures in the open air – a second *Déjeuner sur l'herbe*. It was done in homage to Manet, but also perhaps as a challenge to him. He left it unfinished while he turned to painting *Femmes au jardin*. He worked on this at Sèvres, near Paris, and also at Honfleur during the winter of 1866–67.

In order to preserve the freshness of his first sight of the scene in the finished painting, Monet decided to do all the work on it outdoors. This was not an easy matter in view of the huge size of canvas he had chosen. Camille Doncieux, whom he was to marry in 1870, posed for all three figures to the left of the composition, set in a middle-class garden in a Paris suburb. Because of the artist's choice of a 'common' subject (which nevertheless pleased Zola in its modernity), and also because of the technique, which stressed strong contrasts of light and shade and brilliance of colour, the picture was rejected by the jury at the Salon of 1867. This check to his progress aggravated Monet's financial difficulties, and confirmed his position as a dissident. It is worth recalling that the painting belonged first to Bazille, then to Manet, before finding its way back to its author, who, having made his reputation, sold it to the national collections in 1921.

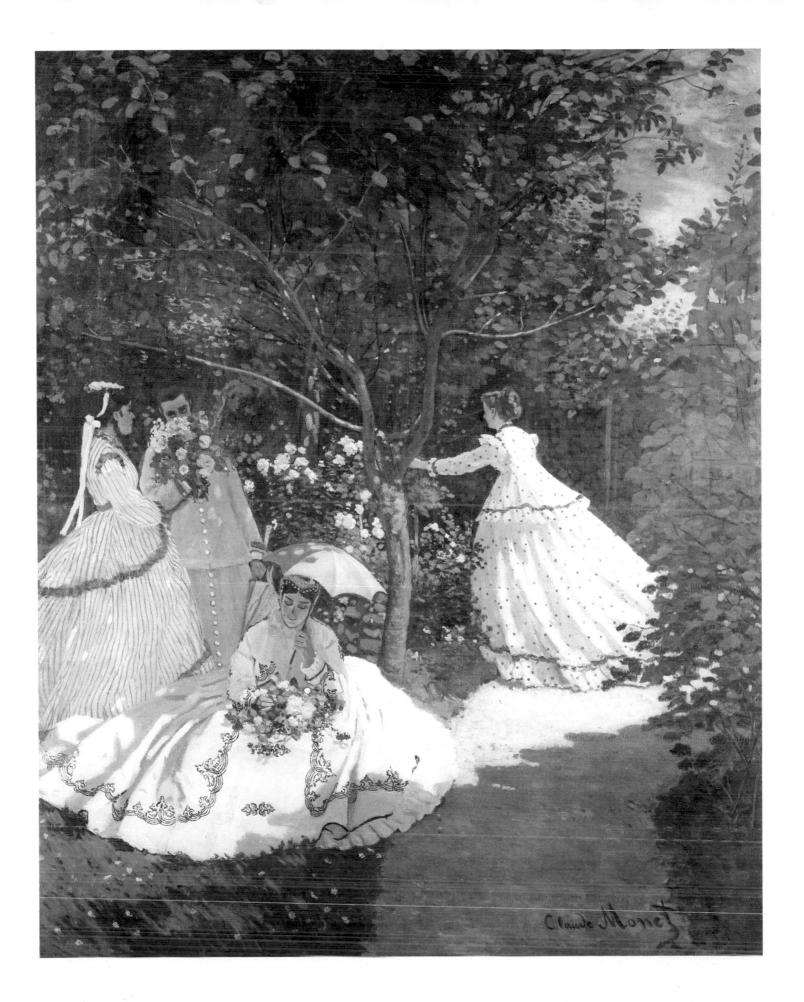

La pie (The Magpie), c.1869

Oil on canvas, 35 × 51¹/₄ (89 × 130) Purchased in 1984 (R.F. 1984–164)

Both the subject and style of this dazzling snowscape, traditionally called *La pie* (*The Magpie*), inevitably prompt comparison with the paintings done by Monet at Honfleur in 1867, the year in which he finished *Femmes au jardin (Women in the Garden)*. These include *La charrette, route sous la neige, Honfleur (The Cart, Snowy Road, Honfleur)*, also in the collections of the Musée d'Orsay, and *Environs de Honfleur; neige (Near Honfleur; Snow)*, which hangs with the Hélène and Victor Lyon gift in the Louvre. A journalist from Le Havre, who published a long article about Monet in a local paper in October 1868, described how he found the artist painting, as he always used to, from life: 'It was winter, during a snowy spell which lasted a few days ... It was cold enough to crack open the very stones. First we saw a little brazier, then an easel, then a fellow wearing three overcoats and gloves, his face half frozen – Monseiur Monet, making a study of a snowscape.' *La pie* is not precisely dated, but recent research suggests that it was not in fact painted at Honfleur in 1867, but during the winter of 1868–69, when the artist was at Etretat. *Grosse mer à Etretat (Rough Sea at Etretat)*, from the Moreau–Nélaton Collection, also in the Musée d'Orsay, is another masterpiece from this period.

The large scale suggests that Monet intended this to be a finished, considered composition and not just an informal study after nature. Perhaps it was his intention to include the picture in his submission to the Salon of 1869, from which he was rejected. Whatever the circumstances, *La pie* is one of the masterpieces of his early period (he was not yet thirty), novel both in style and in subjectmatter. His intentions were obviously realistic (the hedge, the rustic fence and the peasant cottage which evoke the Normandy countryside are all done with great precision), and there is no anecdotal element. The absence of figures is particularly striking; in this sense Monet goes further than Courbet who had tackled similar themes a short time previously. The artist's basic aim seems to have been to render faithfully the brilliance of the snow and the strength of the contrasts which struck him with such immediacy as he looked at the motif.

Later in his career Monet often painted snow and winter scenes. A notable example is *L'église de Vétheuil (The Church at Vétheuil)* of 1879 (p. 94).

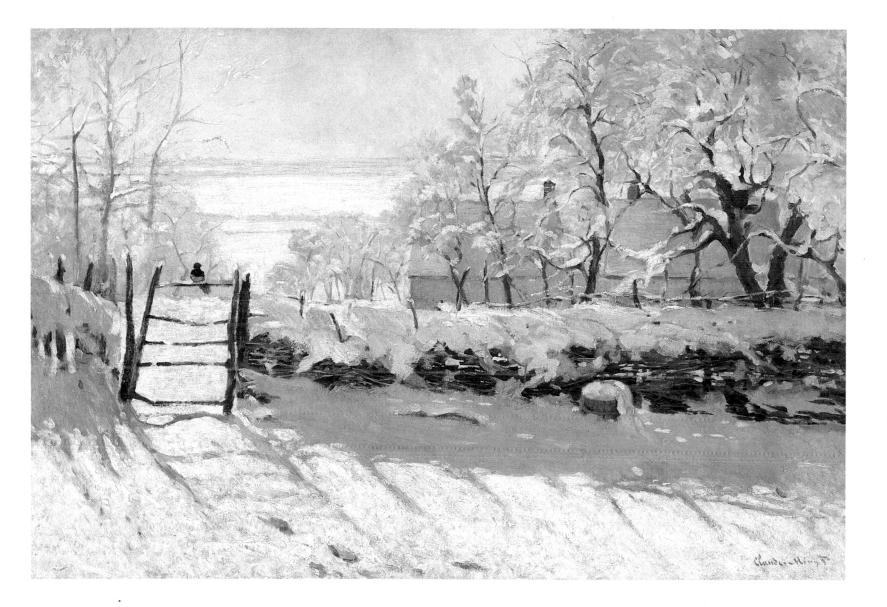

L'hôtel des Roches Noires à Trouville (The Roches Noires Hotel at Trouville), 1870

Oil on canvas, $31\frac{1}{2} \times 21\frac{5}{8} (80 \times 55)$

Gift of Jacques Laroche, but retained by him for his lifetime, 1947; entered the Jeu de Paume in 1976 (R.F. 1947–30)

In the 1860s Monet often painted on the Normandy coast in the area around Le Havre, the town where his family lived. When he did this picture at Trouville, he was getting ready to leave France for London after war was declared between France and Prussia. The irony is that the impression of gaiety one immediately gets from the picture is in total contrast with the financial difficulties against which Monet was then struggling, with few collectors interested in his work, which had been officially condemned by repeated rejections at the Paris Salon. In its subject-matter, *L'hôtel des Roches Noires à Trouville* recalls the most seductive works by Boudin, that delightful chronicler of fashionable society at the seaside – Trouville and Deauville being 'launched' under the Second Empire. But in its form it is a wonderful example of Monet's technical virtuosity. With a few vigorous brush-strokes he creates light and shadow, gives life to silhouettes that are just touched in; and with a wide sky in which the wind chases puffs of cloud, he conjures up the seaside freshness of this promenade. The traditional title of the work, *L'hôtel des Roches Noires*, links it to a world evoked considerably later by Proust.

84

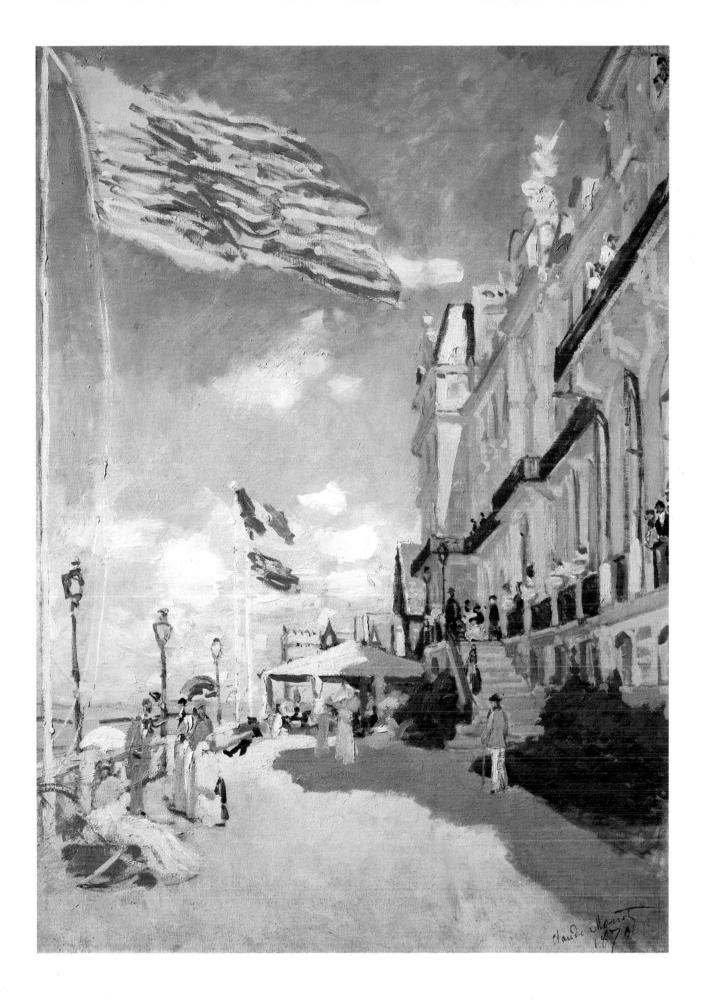

Les coquelicots (Wild Poppies), 1873

Oil on canvas, $19\frac{5}{8} \times 25\frac{5}{8}$ (50 × 65) Gift of Etienne Moreau-Nélaton, 1906 (R.F. 1676)

When he got back from England in the autumn of 1871, Monet lost no time in finding himself somewhere to live at Argenteuil, which was then no more than a largish village on the Seine near Paris. It was frequented chiefly by boating enthusiasts, who sailed their craft on the broad expanse of the river. The name of the village has now become a kind of symbol for the full flowering of Impressionism, not merely because Monet himself found subjects there for numerous brightly lit landscapes – themselves an accomplished statement about things in motion – but also because nearly all the painters linked to the movement came to paint there at his invitation. They included Renoir, Sisley and even Pissarro (who was then living nearby at Pontoise), and above all Manet who, prompted by the example of his young friend, painted some high key works in the open air at Argenteuil on the theme of canoeists.

Les coquelicots was certainly one of the paintings shown at the first Impressionist exhibition of 1874, held in the Boulevard des Capucines in Paris in a building which had been the photographer Nadar's studio. The painting was thus the companion of Monet's famous *Impression, soleil levant* (*Impression: Sunrise*, Musée Marmottan, Paris), whose title, taken up in jest by a hostile critic, was the origin of the term Impressionism. This small picture is a colourist's straightforward reaction to the redness of poppies blooming in a field. Its size contrasts with the large canvases Monet used in the 1860s, and it has preserved all the freshness of a sketch – nevertheless revealing a constant preoccupation with rhythm and balance. The duplication of the group showing a woman with an umbrella and a small child (no doubt they are Monet's wife Camille and his son Jean) suggests movement but also acts as a means of containing the joyous, shimmering colour of the blossoms on the left.

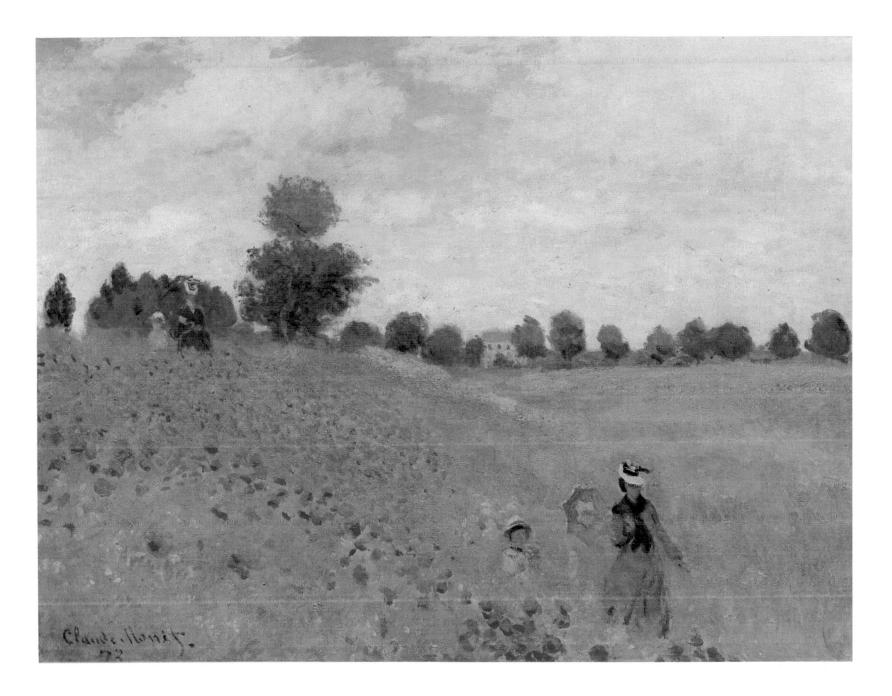

Le pont à Argenteuil (The Bridge at Argenteuil), 1874

Oil on canvas, $23\frac{5}{8} \times 31\frac{1}{2}$ (60 × 80) Antonin Personnaz bequest, 1937 (R.F. 1937–41)

One of Monet's favourite themes at Argenteuil was that of sailing-boats on the Seine. Several regatta scenes hang in the Musée d'Orsay, but here the boats are moored near the road bridge at Argenteuil, and the artist has concentrated on representing the iridescent surface of the water and the landscape it reflects. The extremely precise technique, despite the apparent freedom of touch, is extremely typical of this period. The years Monet spent at Argenteuil – he lived there until the beginning of 1878 – were a time of stability for him. Contented with his lot, and supported by his dealer Paul Durand-Ruel who was striving tirelessly to widen the still very restricted circle of collectors loyal to the Impressionists, Monet was free to explore the possibilities offered by a kind of high-key painting based on direct observation of a theme in the open air.

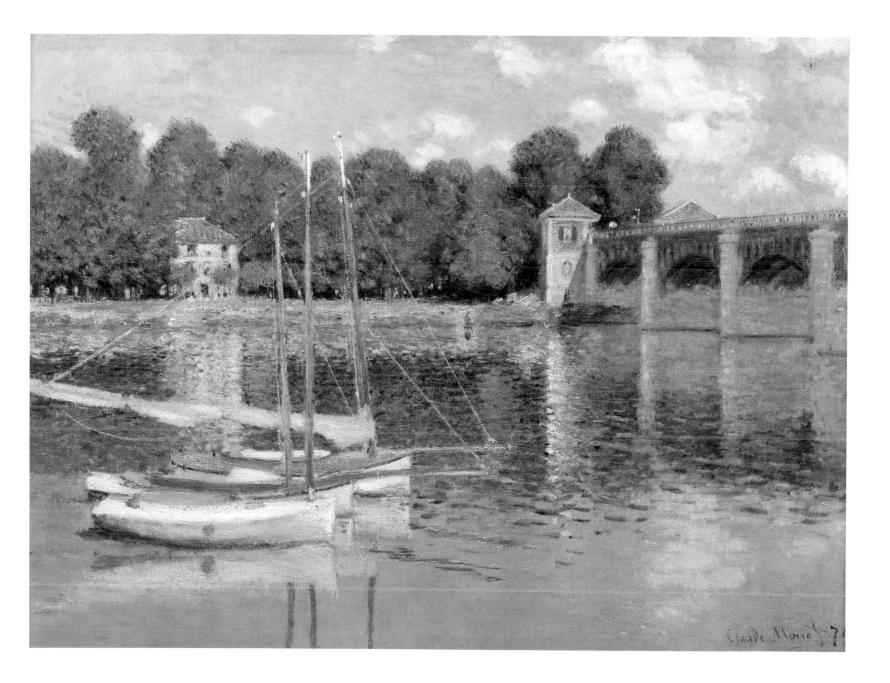

La gare Saint-Lazare (Saint-Lazare Station), 1877

Oil on canvas, $29\frac{1}{2} \times 41$ (75 × 104) Gustave Caillebotte bequest, 1894 (R.F. 2775)

In Paris, the terminus for the line from Argenteuil was the Gare Saint-Lazare, and so Monet knew it well. This may in part explain the attraction he felt for this 'contemporary' subject, which had also been attempted by Manet in 1873 in his famous *Le chemin de fer (The Railway*, National Gallery of Art, Washington DC). Unlike Manet, and even Gustave Caillebotte who in 1876 painted passers-by on *Le pont de l'Europe* (which was part of the station complex), Monet comes down to the level of the platforms and penetrates the huge canopy of glass and steel which forms the station roof. The human figures are lost amid the coils of white or bluish smoke, which take their colour from the prevailing light conditions. In this respect, the Gare Saint-Lazare series, of which this painting is one, seems to be where the systematic procedure used in his paintings of Rouen cathedral first took shape (pp. 98–101).

Writing about the third Impressionist exhibition of 1877, Zola warmly defended the artist's unorthodox choice of subject: 'This year Monet is showing some wonderful railway station interiors. You can hear the noise of the trains the station swallows up; you see the floods of smoke which unroll under the huge roofs. That's the art of today . . . our painters have been forced to discover the poetry of railway stations, as their fathers discovered that of forests and rivers.' These lines take on their full significance when one recalls that several years later the novelist was to create *La Bête humaine* (published in 1889–90), which was very much a contemporary allegory.

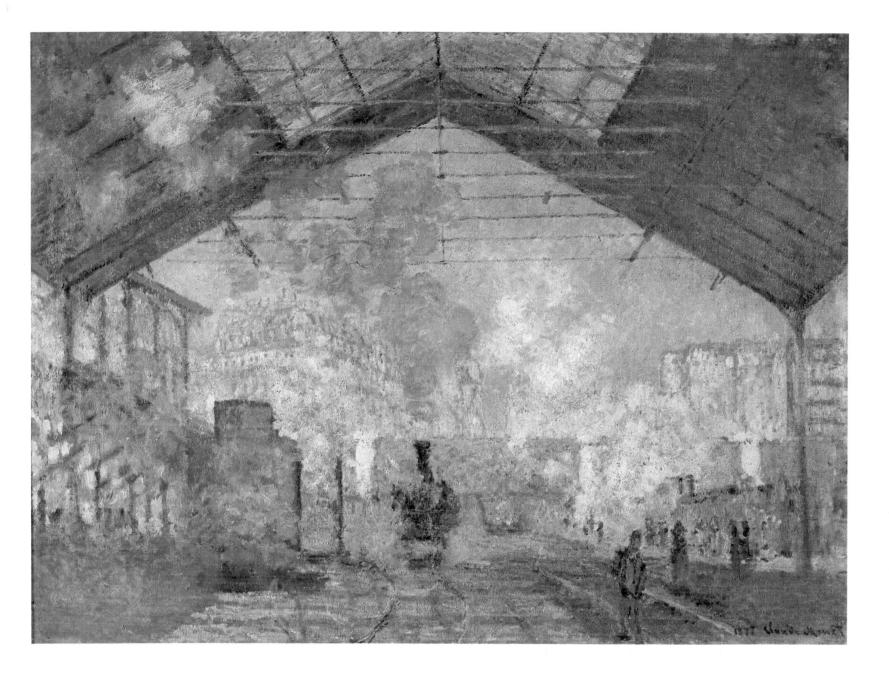

La rue Montorgueil: fête du 30 juin 1878 (Rue Montorgueil Decked Out with Flags)

Oil on canvas, $31\frac{1}{2} \times 19\frac{5}{8} (80 \times 50)$ Acquired in lieu of estate duties, 1982 (R.F. 1982-71)

Like Manet when he painted his *La rue Mosnier pavoisée (Rue Mosnier Decked Out with Flags*, Bührle Collection, Zürich), Monet has here been attracted by the idea of multicoloured flags fluttering in the wind – a theme which later frequently provided inspiration for the Fauves. Most of the Impressionist painters enjoyed painting Paris street-scenes, and here Monet offers one of the earliest examples of a view in perspective taken from a height, of the kind also attempted by Pissarro and Caillebotte. In this painting the dense colours are brought to life by a multitude of closely set brush-strokes. Seen from close to, the picture seems almost entirely abstract; it is only as one steps back that one understands Monet's virtuosity – the composition becomes clear and legible, one becomes aware of the crowd swarming down the street and of the movement of the flags which almost conjures away the presence of the vertical buildings on either side. A very similar picture belongs to the Musée des Beaux-Arts in Rouen, which represents the Rue Saint-Denis on the same day – 30 June 1878 – when the city was hung with flags on the occasion of the International Exhibition. It is thus not in fact a celebration of Bastille Day (14 July), as is sometimes suggested; this did not become a public holiday until later.

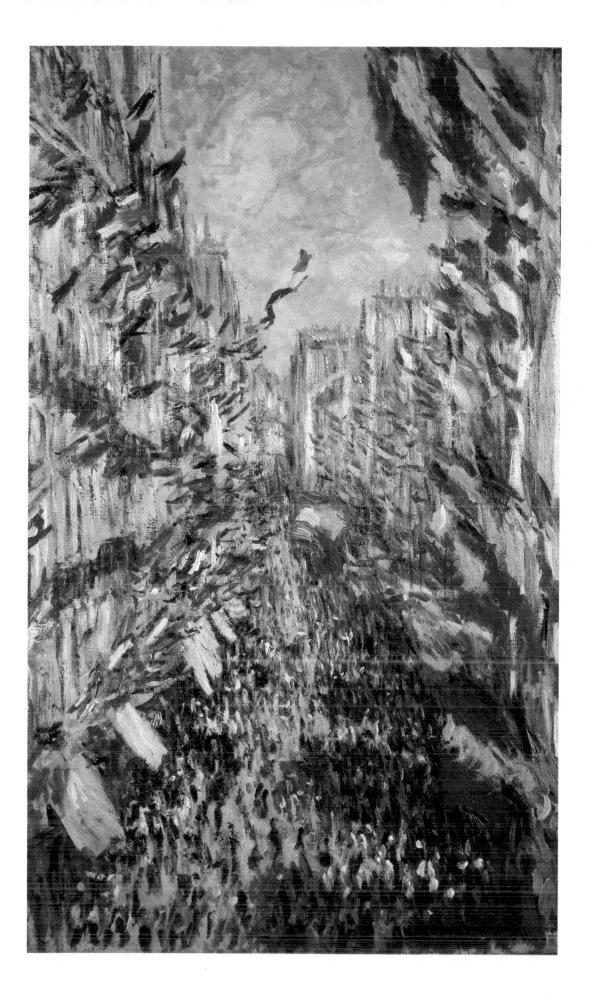

L'église de Vétheuil (The Church at Vétheuil), 1879

Oil on canvas, $25\frac{5}{8} \times 19\frac{3}{4} (65 \times 50)$

Gift of Max and Rosy Kaganovitch, 1973 (R.F. 1973–18)

In September 1878, Monet wrote to tell his friend Murer of his recent move to 'Vétheuil, beside the Seine – a really delightful place'. This village, on the right bank of the Seine, was in an unusual situation. Up on a bluff, it overlooked a bend of the river, scattered with wooded islets. It was the kind of landscape which was bound to fascinate the painter, giving him something which was different from Argenteuil, but still near to Paris.

During his first winter at Vétheuil, Monet several times depicted the village under snow. He often chose to take up a position somewhat removed from the scene itself - he would paint it from the river on his boat converted to make a studio, or from one of the islets, or else from the opposite bank. Monet's paintings show the houses with their snowy roofs grouped around the church, a collegiate building of the twelfth century altered during the Renaissance. In the background can be seen the square tower which dominates the composition. It is prominent here because it is seen from a viewpoint somewhat closer than Monet usually chose, and the upright format of the painting stresses the verticality of its architecture which is counterbalanced by the horizontal foreground. In order to render the snowy river bank and the movement of the water, the artist has had recourse to the fragmented touch he had begun to use at Argenteuil. Snow often fascinated Monet and the Impressionists, following in the wake of Courbet, because it prompted a close study of the effects of light and reflection (see also p. 110). This wintry landscape evokes a mood of sadness which can be attributed not only to the season but to the financial and personal preoccupations felt by the artist at this time. This mood characterizes most of the paintings done at Vétheuil, and in particular the series showing the breaking up of the ice, which dates from the winter of 1879–80. SG-P

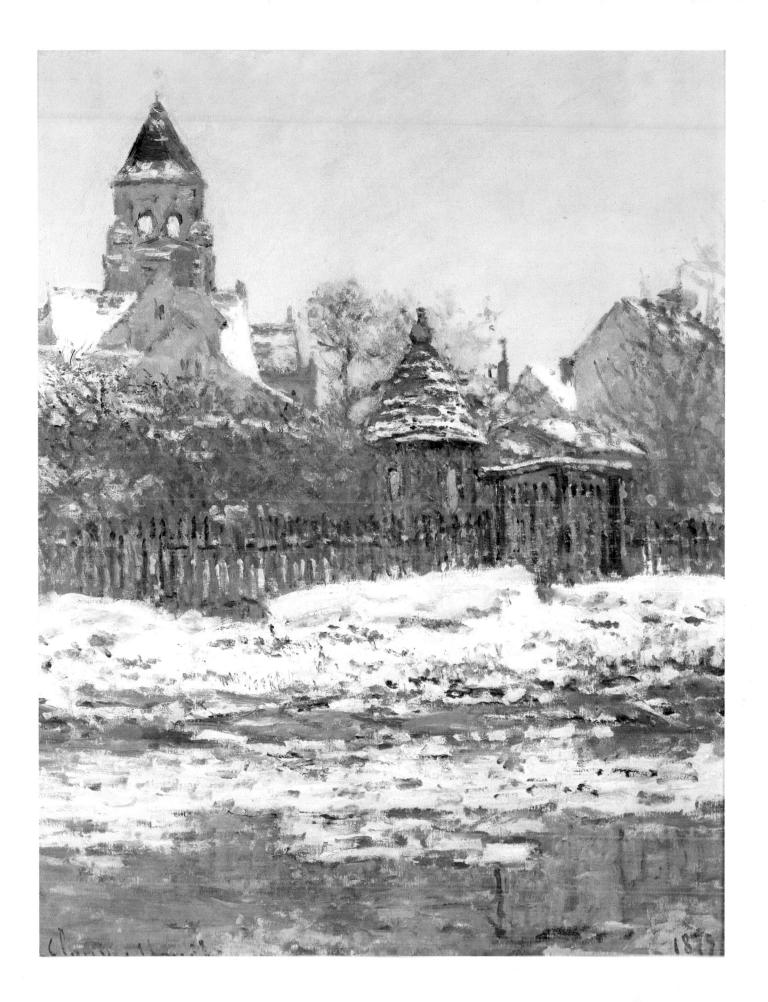

Femme à l'ombrelle tournée vers la gauche (Woman with a Parasol, Turned Towards the Left), 1886

Oil on canvas, $51\frac{5}{8} \times 34\frac{5}{8} (131 \times 88)$

Gift of Michel Monet, son of the artist, 1927 (R.F. 2621)

In August 1887, Monet wrote from Giverny to the critic Duret: 'I'm working as hard as ever, but on something new – figures in the open air as I understand them, treated like landscape. It's an old dream which has always plagued me, and I'd like to realize it at last – but it's so difficult!'

The artist had for a long time abandoned figure painting, which he had attempted at the beginning of his career (see p. 80), and also when he was at Argenteuil. Suddenly, around 1885, and for the last time, Monet started to work on the relationship of figures to landscape. He treated the problem from the point of view of an Impressionist landscape painter, concerning himself above all with the light enveloping his characters. His favourite models were the daughters of Alice Hoschedé, whom he was then living with, and who was to become his second wife.

Suzanne Hoschedé, then aged eighteen, must have been the model for the *Femme à l'ombrelle*; the artist shows her walking at Giverny sometime during the summer of 1886. In the pair of paintings given by Monet's son to the Louvre (the other is reproduced on the cover), the painter rendered the moment just as it presented itself to him – clearly it was something which evoked memories of his first wife. In 1875 he had painted Camille in a similar pose, walking along a cliff-top and silhouetted against the sky. Here, in this painting, Monet was so much struck by the impression the scene made on him that he has barely sketched in the face, and has thus depersonalized the model. The two pictures were exhibited at Durand-Ruel's gallery in 1891, under the significant title *Essai de figure en plein air (Attempt at Figure-painting in the Open Air*). Monet has tried to render the plant shows the direction of the wind, and the figure moves in step with the movement of the clouds in the background.

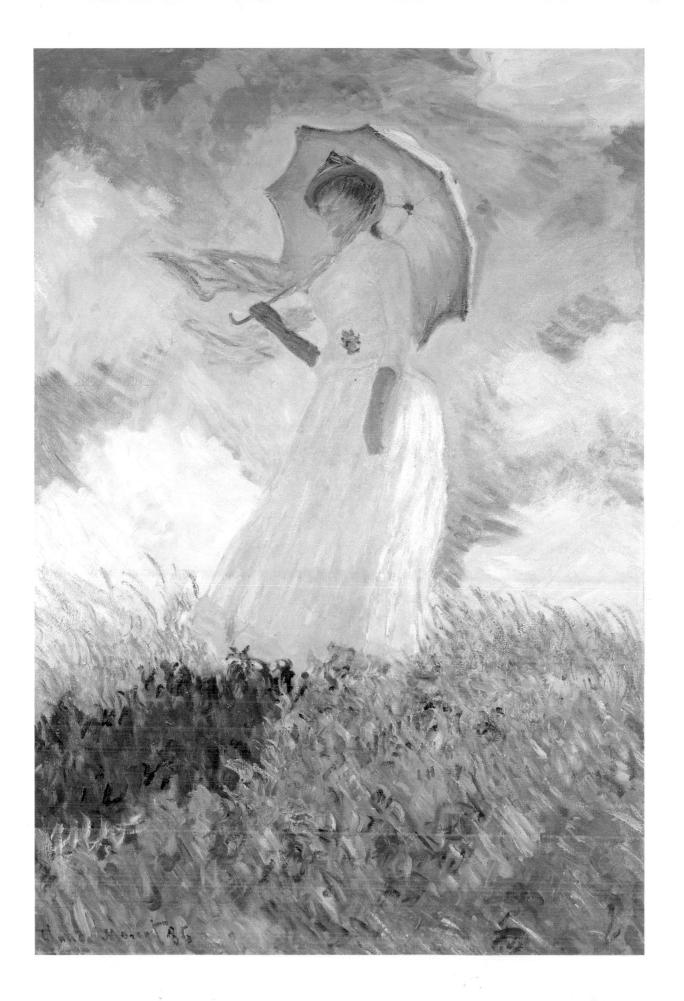

La cathédrale de Rouen, le portail, temps gris (Rouen Cathedral, the West Portal, Dull Weather), dated '94', painted 1892

Oil on canvas, $39_8^3 \times 25_8^5$ (100 × 65) Count Isaac de Camondo bequest, 1911 (R.F. 1999)

La cathédrale de Rouen, le portail et la tour Saint-Romain, plein soleil, harmonie bleue et or

(Rouen Cathedral, the West Portal and Saint-Romain Tower, Full Sunlight, Harmony in Blue and Gold), dated '94', painted 1893

Oil on canvas, $42\frac{1}{8} \times 28\frac{3}{4}$ (107 × 73) Count Isaac de Camondo bequest, 1911 (R.F. 2002)

In the 1890s, Monet's art underwent a decisive change, presaged in work done earlier. It was now only very rarely that the painter tackled a motif in isolation. He worked on several 'series' at sites near his house at Giverny, depicting oat-fields, haystacks and poplars. In these he analysed the variations of light as the hours and seasons passed.

The process of making works in series, on the same theme, was done in an especially systematic way when Monet set up his easel in front of the west façade of Rouen cathedral. Although the pictures are dated 1894, they were done in two sessions in 1892 and 1893 (on each occasion from February to mid-April), from three very slightly different viewpoints. They were then brought to completion in the studio at Giverny.

The many letters he wrote to his wife reveal Monet's method of work and the persistence with which he tackled the subject during his two visits to Rouen. In April 1892 Monet wrote to Alice: 'every day I add something, and catch something by surprise which I hadn't previously been aware of. It's terribly difficult, but things are progressing, and give me a few more days of fine weather and a good number of pictures will be saved. I'm worn out, I can't go on, and yet ... I had a night full of nightmares: the cathedral was tumbling on top of me – it was all blue and pink and yellow.'

continued on next page

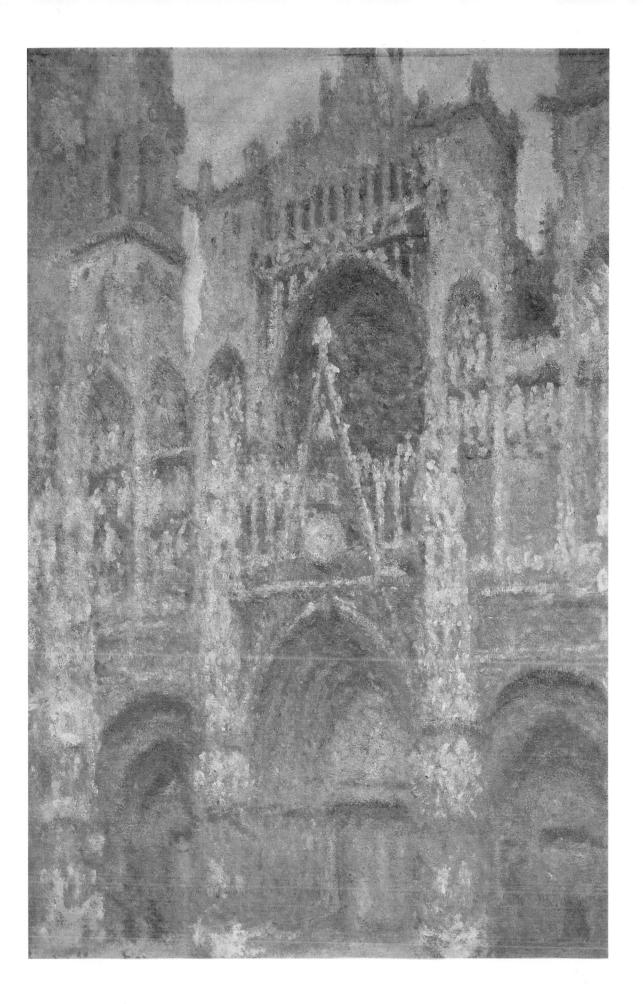

continued from previous page

This series is the most important of all in matter of numbers. There are thirty different versions in which the theme, always identical, is shown from the same point of view – unlike those of haystacks, where the point of view differs. These cathedrals provide the most spectacular demonstration of Monet's determination to catch the instantaneous. The multiplication of canvases corresponds to Monet's sensitivity, which became more and more finely attuned to atmospheric variation with changing weather conditions, and to changes in the light during the course of the day. He directed his attention to the play of light and shadow on the façade of the cathedral. He did not study its architecture for its own sake, but as a support for pictorial researches which aimed to make perceptible the way forms changed in ever-different conditions of lighting. Even a monument as solid and permanent as this one was subject to these transformations. 'Everything alters, even stone', as the artist himself noted in 1893. In order to suggest the physical substance of what he was painting, the painter used a distinctive rough texture to catch the light and give the effect of sunlight moving across stone.

After having several times put off showing the cathedrals, Monet included twenty versions in an exhibition of recent work organized by Durand-Ruel in 1895. The importance and originality of Monet's development was not lost on contemporary painters and writers. Among the eulogies which appeared in the press, the one which touched the artist most was the long article by Georges Clemenceau, in *La Justice* of 20 May 1895, entitled 'Révolution de cathédrales' ('Revolution of Cathedrals'). 'The painter shows us, in twenty canvases, each judiciously different in its effect, the feeling he could have, or would have, experienced in making fifty, or a hundred, or a thousand paintings – as many paintings as there might be moments in his life, if his life was to last as long as this monument made of stone.'

Like Pissarro in his correspondence with his son, Clemenceau stressed the 'lesson' they taught and the unity which could be learned from the whole series, and both of them regretted its imminent dispersal. The presence of five versions, each with a different colour 'harmony', in the Musée d'Orsay (one of them bought by the state from Monet in 1907 and the other four forming part of the Camondo bequest) allows us to imagine how the exhibition of 1895 may have looked, when these were shown with the others.

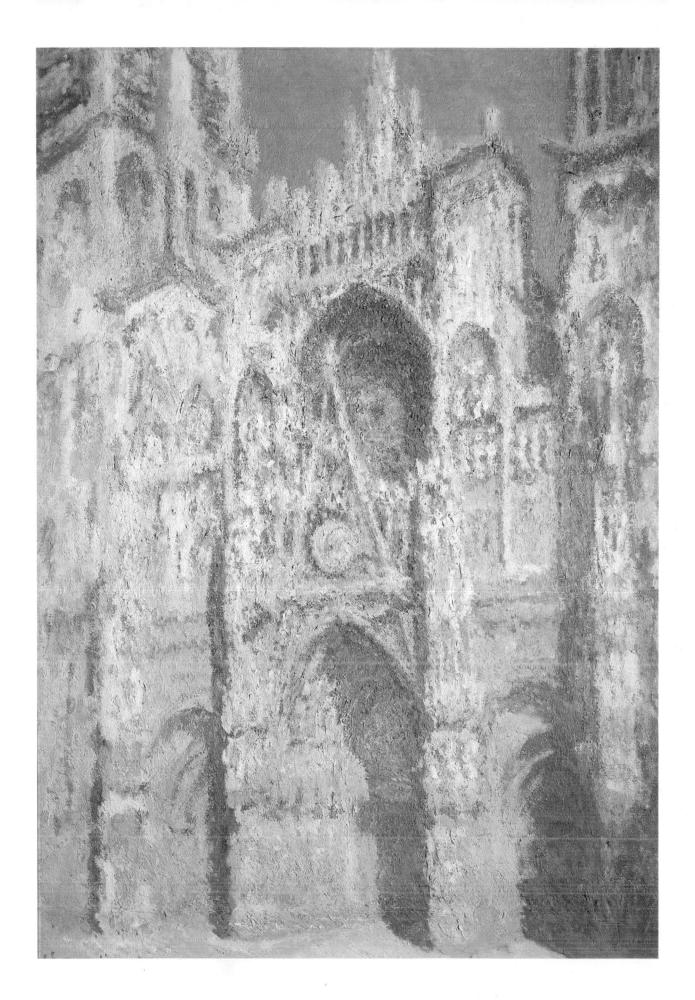

Nymphéas bleus (Blue waterlilies), nd

Oil on canvas, $78\frac{3}{4} \times 78\frac{3}{4}$ (200 × 200) Purchased in 1981 (R.F. 1981–40)

In 1893, Monet had the famous waterlily pool made at Giverny. The originality of this water garden, which also reveals the influence of Japanese prints, stems from the fact that it was made entirely to the artist's own design. He thought of it as a painting – something which was stressed by Proust at the beginning of this century.

Monet painted the pool from 1895 onwards, but it was only in 1898 that several works were entirely devoted to it. From 1904 the surrounding landscape and Japanese bridge progressively disappeared and were finally eliminated. The surface of the water itself now occupied the whole canvas. This became the painter's chief subject during the last twenty years of his life. Monet himself wrote to his friend Geffroy in 1908: 'I'm absorbed in work. These landscapes showing water and reflections have become an obsession. I'm an old man, and it's beyond my strength, but I want to represent what I experience.'

The artist made use of the contrasts between the waterlilies and the pond, between the leaves and the flowers, and between the areas which absorbed light and those which reflected it. To give an illusion of unlimited space, the waterlilies are often cut by the edge of the picture. The composition itself is perfectly square – a format very often adopted by Monet at this time. The intense violet colouring is sometimes attributed to changes in the painter's eyesight – he was by this time suffering from eye-trouble. –

Monet's researches culminated in the eight large pictures given by him to the state in 1922, and hung in the Orangerie des Tuileries in 1927. With these *Nymphéas*, Monet, the leader of the Impressionists, became a twentieth-century artist – the precursor of abstraction. Ever since he painted them, his 'landscapes in water' have aroused the admiration of painters, writers and musicians.

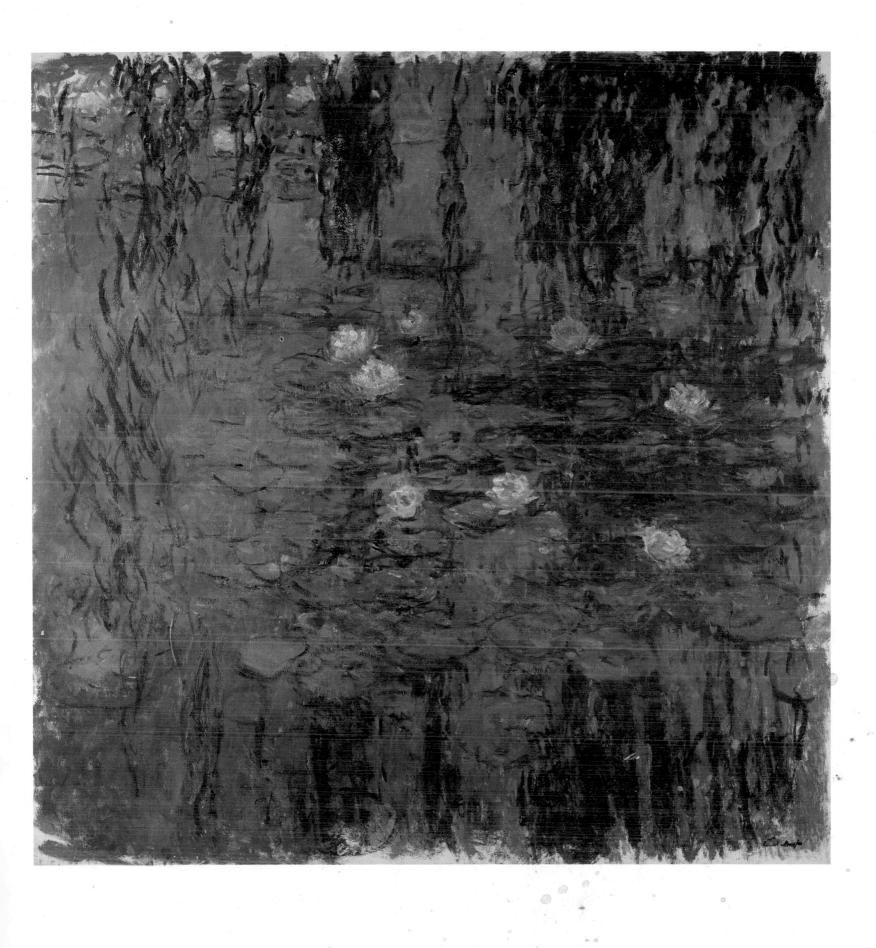

Alfred SISLEY (1839–1899)

Le Chemin de la Machine à Louveciennes, or La route, vue du chemin de Sèvres

(The Chemin de la Machine at Louveciennes, or The Road to Sèvres), 1873

Oil on canvas, $21\frac{1}{4} \times 28\frac{3}{4} (54 \times 73)$

Gift of Joanny Peytel, but retained by him for his lifetime, 1914; retention abandoned, 1918 (R.F. 2079)

The thing which Sisley strived for in his landscapes was a certain kind of spatial organization. His feeling for construction, probably inherited from Corot, led him to respect the relationship between one plane and another. Thus a road losing itself at the horizon was one of his favourite themes, and recurs frequently in his work. Often it is used to link the foreground to what lies in the distance, helping the eye to 'discover' the space, and contributes to sophisticated effects of perspective.

This three-dimensional illusion is particularly striking when the road recedes at right angles to the picture-plane. To accentuate the effect of depth, the artist has here risked some daring foreshortening in his painting of the trees beside the road. He establishes an interplay of lines between the verticals of the tree-trunks and the horizontals of their shadows. Sisley often took care to humanize his landscapes by putting in some small figures, in the manner of Jongkind. Here he has judiciously used the fact that the road is going slightly uphill to create a vanishing-point which is slightly off-centre, and to provide a view down into the sun-filled distance. (It is now thought that the painting represents the Chemin de la Machine at Louveciennes rather than the Rue de Sèvres, by which title it was formerly known.)

Sisley devoted much study to Corot and to the Barbizon School, and also to landscapes by Dutch seventeenth-century masters. No doubt he discovered, during the period he spent in London when he was young, Hobbema's famous *Avenue at Middleharnis*. And following the example of Ruysdael, who gave a predominant place to the sky, Sisley here accords it considerable importance.

Sisley never managed to obtain French nationality, but has here succeeded wonderfully in rendering the quality of light of the Ile-de-France. The picture certainly was worthy of the honour of being chosen to commemorate Sisley in the Centennial Exhibition of French Art held in connection with the International Exhibition of 1900.

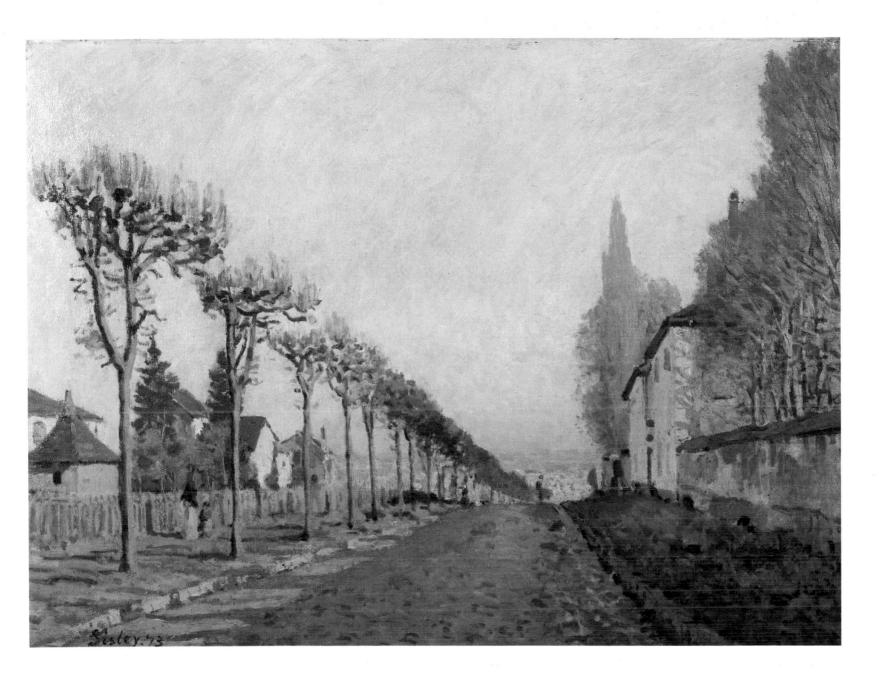

Alfred SISLEY (1839–1899)

Le brouillard, Voisins (Mist at Voisins), 1874

Oil on canvas, $19\frac{3}{4} \times 25\frac{5}{8}$ (50 × 65) Antonin Personnaz bequest, 1937 (R.F. 1937–64)

Sisley had lived at Voisins since 1871. In 1872, Pissarro painted his *Entrée du village de Voisins* (part of the Ernest May triptych, see p. 50). Now Sisley also wanted to paint some views of this little village in what used to be the *département* of Seine-et-Oise, near Louveciennes.

Voisins is probably the spot where he captured this effect of mist. To the left can be seen a group of trees, and in the background a fence enclosing a garden. Under a tree with twisted branches, a woman bends to pick some flowers. The large flowering thickets in the foreground suggest that it is springtime. 'All this is seen through a silvery mist which blurs the forms and gives a grey-blue tonality to the whole', wrote Germain Bazin, suggesting that one can 'perhaps compare the picture with Corot's mysterious early morning scenes.'

'Which painters do I love? To speak only of contemporary artists, our masters Delacroix, Corot, Millet, Rousseau, Courbet. All those who have loved nature and who have felt a close sympathy with it ...', confided Sisley to the art-critic Adolphe Tavernier in 1892. The artist thus linked himself to the great names of the French school of the nineteenth century; he saw himself as a successor of the Barbizon painters who had abandoned the traditional, classical principles of the artificially composed historical landscape, and who also rejected the picturesque aspect of romantic landscape in favour of a vision closer to nature. This rejection of academic convention can be felt in this work, which is comparable to Monet's 'impressions' and very different from the kind of painting appreciated at the Salon. Sisley did nevertheless show there in 1866, 1868 and 1878 – but this picture dates from 1874, the year of the first Impressionist exhibition in Nadar's studio, in which the artist was represented by five pictures.

0

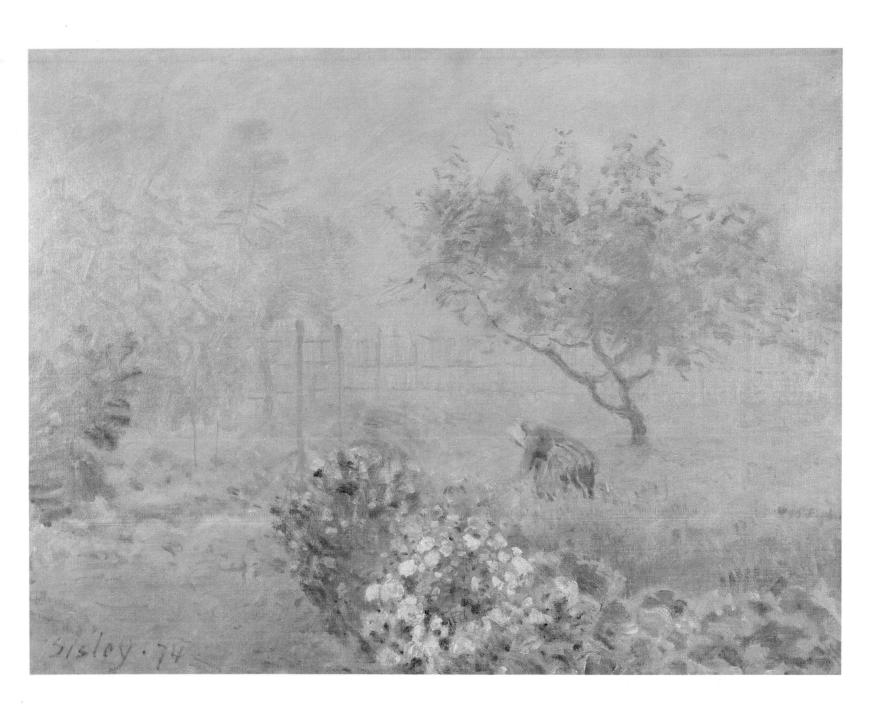

Alfred SISLEY (1839–1899)

L'inondation à Port-Marly (The Flood at Port-Marly), 1876

Oil on canvas, $23\frac{5}{8} \times 31\frac{7}{8}$ (60 × 81) Count Isaac de Camondo bequest, 1911 (R.F. 2020)

The most celebrated of the paintings done by Sisley during his period at Marly-le-Roi (1874–77) are probably those which immortalized the nearby village of Port-Marly, on the banks of the Seine, when it was flooded.

The artist had been interested in this theme from 1872, but it was above all in 1876 that he was able to treat it fully, in a group of six pictures. The best known of these is the large *Inondation à Port-Marly* left to the Louvre by Count Isaac de Camondo. The dominant hues are the grey-blue tints of the sky reflected in the water and interrupted by the more positive colours of the building painted in three horizontal bands. These, with the red of the flag, bring a note of gaiety into the composition. The curtains in the windows recall that the scene would normally have been inhabited; here little black silhouettes, figures whom the artist seems to have borrowed from Jongkind, animate a kind of landscape whose serenity is quite different from the dramatic conception of nature which was dear to the Romantics.

Another picture, also part of the Camondo Collection, *La barque pendant l'inondation (The Boat during the Flood*), is smaller, and the artist has adopted a slightly different point of view. It may have been, as P. Jamot says, the 'first thought for the definitive composition'.

In 1880, Monet represented ice being broken on the Seine at Vétheuil in a series of works of a much more dramatic quality than this one. Both painters were attracted by a fleeting and unusual event which allowed them to make a special study of light and of reflections in the river, as well as of the fusion of trees, sky and water. But, although Sisley was influenced at this time by Monet, he differs from his friend in his interest in pictorial construction which leads him to respect the structure of the forms.

This picture appeared at the sale of the critic Tavernier's collection in 1900, barely a year after the artist's death, and was the first work by him to fetch a high price. SG-P

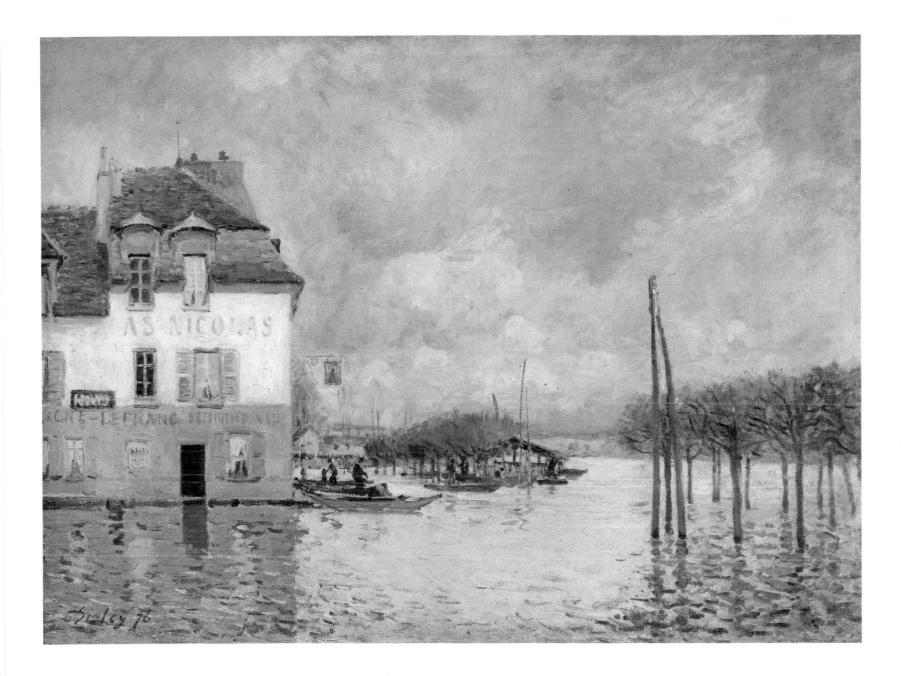

Alfred SISLEY (1839–1899)

Le canal du Loing (The Loing Canal), 1892

Oil on canvas, $28\frac{3}{4} \times 36\frac{5}{8} (73 \times 93)$

Given to the Musée du Luxembourg by a group of the artist's friends, 1899 (INV. 20723)

In 1880 there was a great change both in Sisley's life and in his work; the painter left the *département* of Seine-et-Oise where he had lived and worked since 1871, and took up residence in Seine-et-Marne, where he lived until his death nineteen years later. First, he settled south of Fontainebleau, at Veneux-Nadon; then in September 1882 he went to Moret-sur-Loing, which he left in 1883 for Les Sablons. In November 1889 he returned to Moret-sur-Loing for good; his choice is not surprising, as it was a picturesque little town, with a charming position beside the river Loing.

In the last twenty years of his life, Sisley often painted views beside the Loing, or on the Seine at Saint-Mammès, where the Loing runs into the Seine. On 7 March 1884, Sisley wrote to Durand-Ruel: 'I've started work again, and I have several pictures on the go (views beside the river)'.

This, one of Sisley's numerous paintings of the Loing Canal, came to the Luxembourg in 1899, as the gift of a group of the artist's friends organized for the purpose by Monet. The structure of the composition is original. The painter chose a spot where the canal was just entering a bend and from which he could see the opposite bank through a screen of poplars with bare trunks. His way of tackling the motif recalls the perspective effects he had created previously with views of roads turning and then losing themselves on the horizon.

In the same year that this picture was painted, Sisley gave the following explanation of his art to the critic Tavernier: 'The sky cannot be merely a background ... I stress this element in landscape painting because I'd like to get you to understand the kind of importance I attach to it ... When I start a painting, I always start with the sky.' SG-P

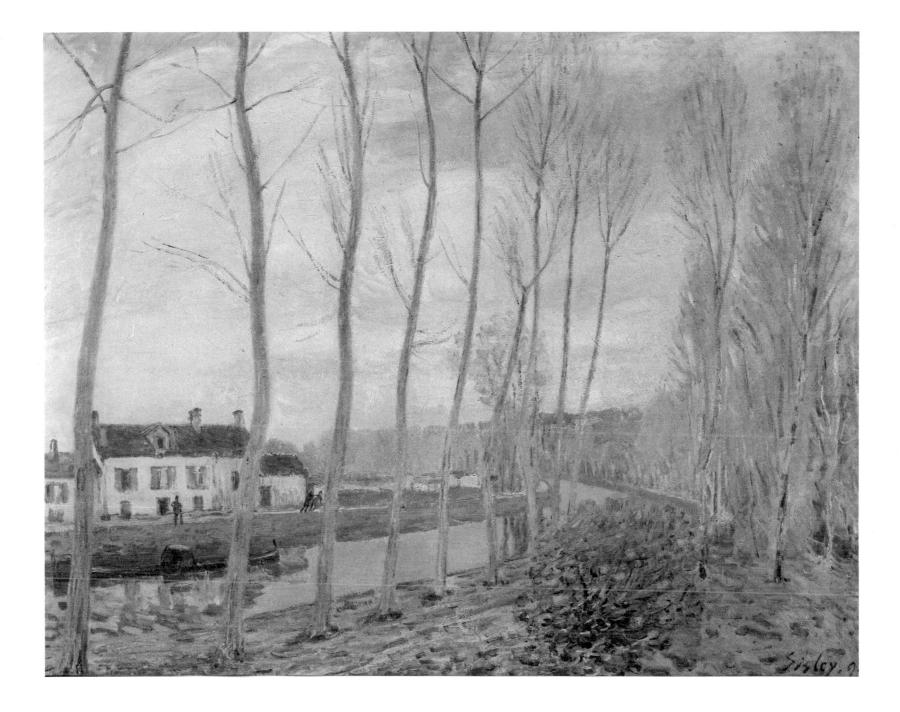

La liseuse (Woman Reading), c. 1874–76

Oil on canvas, $18\frac{1}{8} \times 15$ (46 × 38) Gustave Caillebotte bequest, 1894 (R.F. 3757)

Renoir was born at Limoges, but moved to Paris when he was still very young. His father was a tailor of modest means. Renoir enrolled at the Ecole des Beaux-Arts in 1862, and joined Gleyre's studio, which had the reputation of being the most liberal. There he met Sisley, Bazille and Claude Monet. From 1864 onwards he showed work almost every year at the Salon, with no great success, and in 1874 he took part in the first Impressionist exhibition.

In the 1860s Renoir was strongly influenced by Courbet and by reminiscences of Delacroix. However, he soon created for himself a technique which, although certainly inspired by Manet and Monet, was already strongly individual, supple and fluid. He was above all a figure painter, and had a particular penchant for painting, on a fairly small scale, portraits of women in intimate brightly lit interiors. Women reading, sewing, embroidering – these were the traditional themes which Renoir tackled throughout his career. The model for this particular *Liseuse* is not known, but she can be recognized in other pictures by the artist. Although we do not have the precise information necessary for an exact date, a comparison with the *Moulin de la Galette* (see p. 118), which is more bluish in tone and slightly different in handling, suggests the approximate date of 1874-76. AD

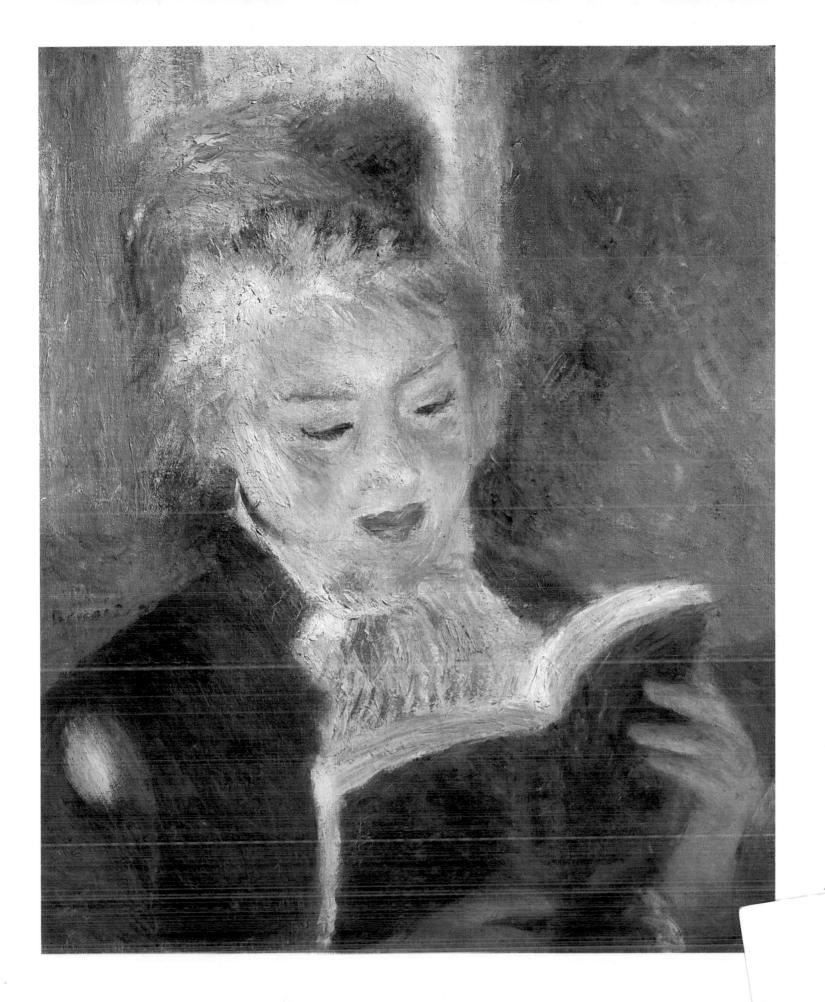

Chemin montant dans les hautes herbes

(Path Going up Through Long Grass), c. 1875

Oil on canvas, $23\frac{5}{8} \times 29\frac{1}{8} (60 \times 74)$

116

Gift of Charles Comiot through the Friends of the Louvre, 1926 (R.F. 2581)

Renoir's reputation is that of a figure painter, but throughout his career he continued to be interested in landscape. His first landscapes, strongly influenced by Diaz, were painted in the Forest of Fontainebleau, working side by side with friends from Gleyre's studio. His last are of his property near Nice: Les Collettes at Cagnes-sur-Mer. In between, he painted innumerable landscapes in other parts of France – around Paris, in Brittany, in Champagne (particularly at Essoyes, near Troyes, where his wife came from), in Provence and in the Pyrenees. He also found subjects abroad – in Venice, Naples and North Africa.

Although this painting cannot be pinned to a precise spot, there is reason to think that it is a view of a place somewhere near Paris, as it reminds one in many ways of Monet's *Coquelicots* (p. 86). In any case the comparison between these two almost contemporary works is very revealing about the respective styles of the two artists. Monet is bolder and more structured; Renoir plays delightfully with the charm of the unfinished, contrasting passages of silky smoothness with others treated with a thickish impasto.

Le Moulin de la Galette, 1876

Oil on canvas, $51\frac{5}{8} \times 68\frac{7}{8} (131 \times 175)$ Gustave Caillebotte bequest, 1894 (R.F. 2739)

In 1876, at the time this picture was painted, Montmartre was still a suburb of Paris. Amid gardens and waste land there were several windmills. One of these, the Moulin de la Galette, had given its name to an open-air café, where dances were held on Sundays. At the end of the 1860s Renoir had painted the colourful working-class crowd which frequented the small open-air drinking-places beside the Seine at Chatou. *Bal au Moulin de la Galette*, as this painting was called when it was shown at the third Impressionist exhibition in 1877, uses similar subject-matter as an excuse for representing figures in the open air – a dominant theme in Impressionist painting.

Two sketches for the composition are known – a very cursory one at the Ordrupgaard museum in Copenhagen; a larger and much more finished one in the collection of John Hay Whitney in New York. The latter is actually dated 1876, which has led some people to believe that it is not a sketch but a replica. Renoir's friends posed for the figures, and several of them are identifiable – in the foreground Estelle, seated on a bench; near her Franc-Lamy, the painter Norbert Goeneutte and Georges Rivière, Renoir's future biographer, are grouped round a table covered with glasses. There are other painters among the people dancing; one is the young Gervex, who was to become a member of the Institut National de France. Despite witnesses to the contrary, it is by no means certain that Renoir painted this large canvas entirely on the spot, and it seems probable that it was taken up again and rehandled in the studio, using studies made from life. Although they expressed strong reservations about the work, contemporary critics did understand the artist's intention, and his wish to catch the effect made by light filtering through the leaves and playing on figures which were themselves in movement. The picture entered the national collections with the Caillebotte bequest at a time when Impressionism was still controversial. It soon became famous, and inspired Picasso and Dufy. AD

La danse à la ville (The Dance in Town), 1883

Oil on canvas, $70\frac{7}{8} \times 35\frac{3}{8}$ (180 × 90) Acquired in lieu of estate duties, 1978 (R.F. 1978–13)

These pictures have been famous since they were shown together at Durand-Ruel's gallery, at Renoir's first one-man show in April 1883 - 'a marvellous exhibition – obviously a great artistic success, for here one can't count on anything else', as Pissarro remarked at the time. They also signal an important new stage in the development of his work. Conceived as a pair, they are in a direct line of descent from Sisley et sa femme dansant (Sisley Dancing with His Wife, 1868, Wallraf-Richartz Museum, Cologne) and from Le Moulin de la Galette (p. 118). The way in which the artist's work was developing in the 1880s is shown by their style; the greater precision of drawing, and the simplification both of form and colour mark a break with the vibrant touch of earlier work. As Renoir himself avowed, the attention he was now paying to draughtsmanship corresponds to the need he felt to renew himself. This was encouraged by a recent trip to Italy, which taught him to appreciate Raphael, and culminated in the great achievement of his Grandes baigneuses (Large Bathers, Philadelphia Museum of Art).

La danse à la campagne (The Dance in the Country), 1883

Oil on canvas, 70 × 35 (180 × 90) Purchased in 1979 (R.F. 1979–64)

The identity of the models has long been the subject of debate, but it seems that Paul Lhôte, a friend of Renoir, posed as the man; in *La danse à la ville* the young woman dancing with him is Suzanne Valadon (herself a painter, as well as being Utrillo's mother), and in *La danse à la campagne* the model is his wife Aline.

The large painting in the Boston Museum of Fine Arts called *Le bal à Bougival*, also painted in 1883, is close to the composition of *La danse à la campagne*, but reversed left to right. AD

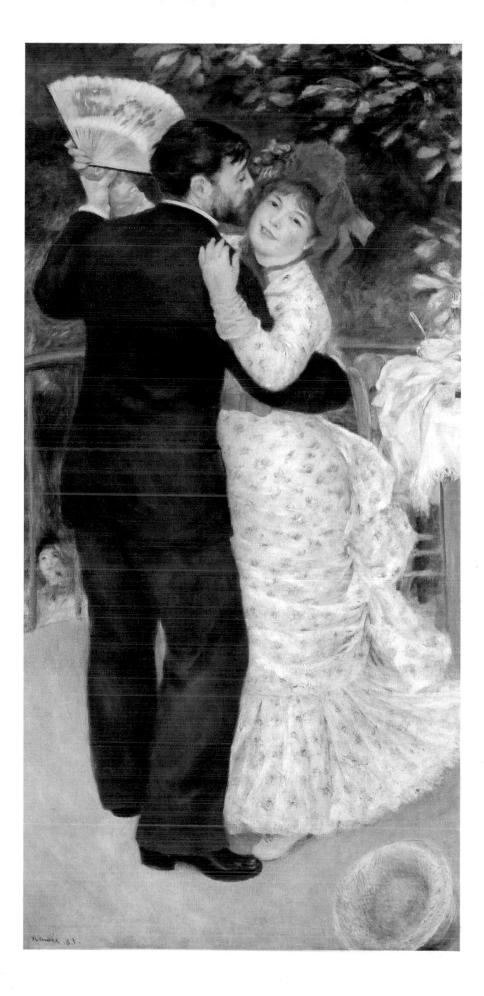

Jeunes filles au piano (Girls at the Piano), 1892

Oil on canvas, $45\frac{5}{8} \times 35\frac{3}{8}$ (116 × 90) Purchased in 1892 (R.F. 755)

In the 1880s Renoir was attentive to line and draughtsmanship, and adopted an unexpected palette of cold but bright tones. With *Jeunes filles au piano*, painted in 1892, he is returning to a suppler conception. Nevertheless this painting, with its acidulated colour, demonstrates his concern for compositional balance and for precise modelling – note the hands of the young pianist for instance – something far removed from *Le Moulin de la Galette* (see p. 118).

Renoir loved music, and several times painted girls playing the piano. Some of his pictures on this theme are in fact portraits. But it is not known who posed for this painting in the Musée d'Orsay or for other versions of this composition elsewhere (one in the Lehman Collection in the Metropolitan Museum, New York; one in the Niarchos Collection; a third which once belonged to Gustave Caillebotte; and another very sketchy version in the Walter-Guillaume Collection). These girls at the piano are the quintessence of the physical type Renoir preferred, and are in perfect harmony with the cosy bourgeois interior which encloses them like a kind of jewel-case. The whole composition encapsulates perfectly one stage in the evolution of Renoir's painting.

Berthe MORISOT (1841–1895)

Le berceau (The Cradle), 1872

Oil on canvas, $22 \times 18\frac{1}{8} (56 \times 46)$ Purchased in 1930 (R.F. 2849)

Berthe Morisot, the daughter of an important government official, began drawing lessons very early, then from 1861 worked in the open air under the tuition of Corot. Her parents were happy to entertain her artist friends, Degas, Stevens and Fantin-Latour. Through the last she met Manet in 1868, when she was copying paintings by Rubens in the Louvre. Manet gave her advice, and she posed for some of his most striking portraits. (She appears seated in *Le balcon*, p. 28, which was shown at the Salon of 1869.) Later, in 1874, she married Manet's brother Eugène. Despite these links, she did not refuse – as Manet did – to take part in independent exhibitions organized by Renoir, Monet and their friends. She ceased to exhibit at the Salon, and showed her work, from 1874 to 1886, in seven of the eight Impressionist exhibitions, missing that of 1879 only because of the birth of her daughter Julie.

To the exhibition of 1874, at Nadar's studio, where she was the only woman to exhibit, she sent nine works: paintings, pastels and watercolours. The first of her exhibits in the list is *Le berceau*, a miracle of charm and freshness. The model is her sister Edma, now Madame Pontillon – who had studied painting at the same time as Berthe, and who had exhibited at the Salon in 1864 and 1868 – together with her new baby, Blanche. Blanche, a blonde child, can also be recognized, together with her older sister Jeanne, a brunette, in *La chasse aux papillons (Chasing Butterflies*, Musée d'Orsay), painted at Maurecourt, where Berthe often went to visit, in 1874. Her ambition, as she noted a little later in her grey notebook, was 'limited to a wish to record something of the passing moment', but she knew how to do this – in her landscapes as well as her portraits – with a kind of classicism, a lightness of touch which attracted praise from the critics.

Mary CASSATT (1844–1926)

Femme cousant (Woman Sewing), c. 1880-82

Oil on canvas, $36\frac{1}{4} \times 24\frac{3}{4} (92 \times 63)$ Antonin Personnaz bequest, 1937 (R.F. 1937–20)

Like Eva Gonzalès and Berthe Morisot, who were pupils of Manet, Mary Cassatt was one of the special and unusual women connected with the Impressionist movement. Daughter of a rich Pittsburgh banker, she wanted to be a painter from a very early age. To achieve her ambition, she had to brave the scepticism and mockery of her family, at a time when it was not at all the thing for a woman to be an artist. Disappointed by the quality of the art instruction available in the United States, she soon returned to France where she had already spent part of her early childhood. After a short period in the studio of the Salon painter Chaplin, a good technician who specialized in society portraits, she turned resolutely to the study of the Old Masters, copying them with great enthusiasm during her travels in Italy, Spain, Belgium and Holland. She also tried her luck at the Paris Salon, where in 1874 Degas took special note of one of the portraits she had submitted: 'There is someone who thinks like me', he said to Joseph Tourny, a mutual friend.

Degas, for whom Cassatt had the greatest admiration, nevertheless waited three years before coming to visit her studio and inviting her to take part in the fourth Impressionist exhibition of 1879 – which she did, with La loge (The Theatre Box) and La tasse de thé (The Cup of Tea). She also showed in the fifth (1880), sixth (1881), and last Impressionist exhibitions (1886). One of the works she showed was the Femme cousant, reproduced here, which then became part of the famous collection left to the Louvre by Antonin Personnaz.

Though several of Cassatt's paintings are close to Manet (*Jeune femme en noir* [Young Woman in Black], 1883) and to Renoir (A l'Opéra [At the Opera], 1880), her work as a whole shows that she never swerved from her admiration for Japanese art. This is evident above all in the important series of prints which Cassatt showed so proudly at her first solo exhibition, held at Durand-Ruel's gallery in 1891. Moreover, she confines herself almost entirely to images of women and children, and achieves powerful effects within an intimist framework, as evinced by *Femme cousant*, which also demonstrates her exceptional talent as a colourist. It should not be forgotten that, by encouraging Durand-Ruel to show the Impressionists in the United States, and by becoming the enlightened adviser of the great American collector H.O. Havemeyer, Cassatt played a major role in the diffusion of Impressionism on the other side of the Atlantic.

Gustave CAILLEBOTTE (1848–1894)

Voiliers à Argenteuil (Sailing-boats at Argenteuil), c. 1888

Oil on canvas, $25\frac{5}{8} \times 21\frac{5}{8}$ (65 × 55) Purchased in 1954 (R.F. 1954–31)

Caillebotte came from an upper-middle-class family and inherited a substantial fortune on the death of his father in 1873, which allowed him to pursue his vocation as an artist. Having been a pupil of Bonnat, he entered the Ecole des Beaux-Arts in 1873, but left it early after his work was rejected by the Salon in 1875. It was probably through Degas, who was a friend of Bonnat, that he came into contact with the Impressionist group, then newly established. From 1876 onwards he participated in its exhibitions, playing an important part as organizer, but twice did not exhibit (in 1881 and 1886) after dissensions within the group.

His early work is characterized by a daring naturalism, taking urban life as its theme, but he returned deliberately to Impressionist methods in his brilliant Argenteuil period. He thus seemed old-fashioned, or at any rate lagging behind the times, when he exhibited his work in 1888 at Durand-Ruel's gallery, and with the Group of XX in Brussels where he showed paintings of boats on the Seine. Some, such as the one reproduced here, are expecially successful in the balance of their composition and evocation of the quality of light. Since 1882 Caillebotte had owned a house by the river, with a large flower-filled garden, at Le Petit-Gennevilliers, across the river from Argenteuil. He settled here permanently in 1887. The river bank and the landing-stage near his house appear in this picture, and on the horizon, behind the old wooden bridge at Argenteuil, are the supports of the railway bridge and the hills of Sanois and Orgemont.

Caillebotte is equally famous for the role he played as patron of his friends the Impressionists as he is as a painter – in fact in 1876 he made them beneficiaries of his first will. Thanks to him, many of their paintings entered the Musée du Luxembourg (then the museum of modern art in Paris) in 1896, despite both the refusal of part of his legacy and the scandal which followed the opening of the Caillebotte room in 1897. He was also one of those who subscribed to buy Manet's *Olympia* – the first work by this artist to enter the French national collections (see p. 22).

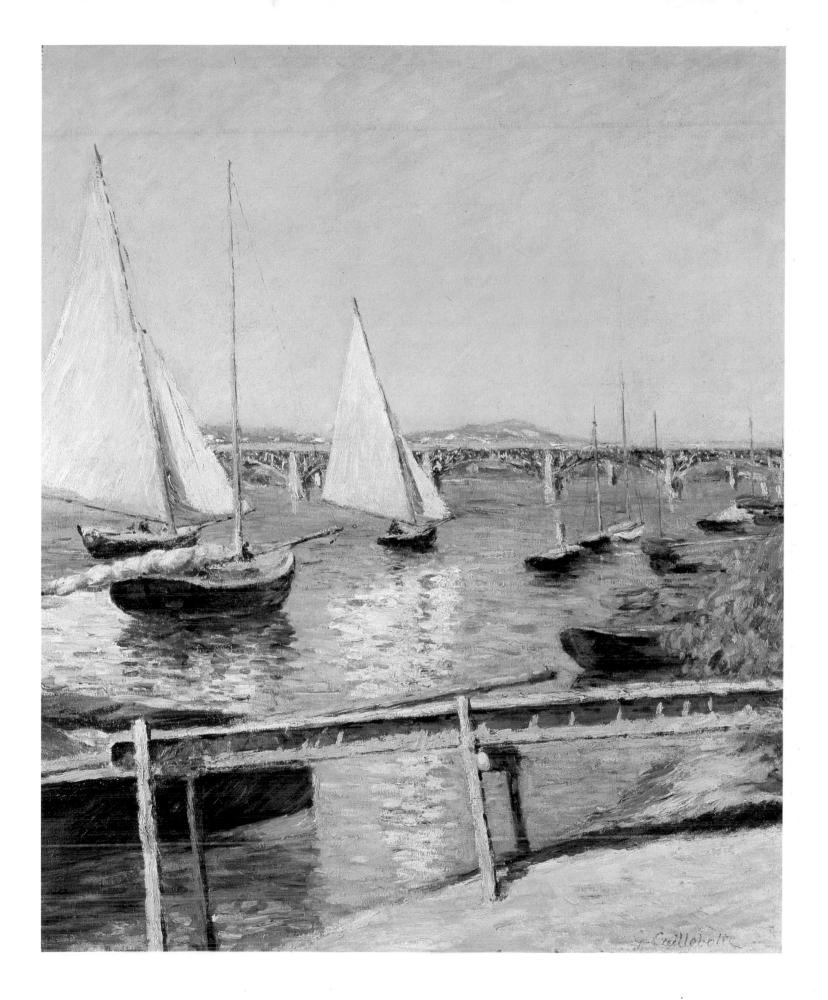

Port breton (Breton Port), nd

Oil on paper mounted on cardboard, $10\frac{1}{2} \times 14\frac{3}{4}$ (26.5 × 37.5) Suzanne Redon bequest, 1982 (R.F. 1984–82)

It often seems to be believed that Odilon Redon's early work consisted almost entirely of drawings in charcoal, followed, from 1879, by lithographs – a technique which allowed him to make multiple copies of his 'black-and-whites'. It was in 1879 that his album *Dans le rêve (In Dreams)* was published, and the title as much as the plates themselves shows his predilection for the world of the imagination. However, since Suzanne Redon, widow of his son Arï, left the complete contents of Redon's studio (preserved intact by her husband for this purpose) to the French national collections, it has transpired that Redon was also a landscape painter capable of paying close attention to reality. From around 1865, the date when he left Gérôme's studio, he produced small landscapes which he entitled 'Studies Made for the Artist' when he exhibited a number of them in 1889 and 1894. The fact that he often used an oil-on-paper technique for these may be a relic of his academic training, which otherwise gave him very little satisfaction. It was Pierre-Henri de Valenciennes who around 1800 had recommended the method to practitioners of historical landscape, as a means of building up a 'repertoire of motifs'.

The painting is undated, but it is worth recalling that Redon visited Brittany long before Gauguin thought of going there. In May 1875 he was at Barbizon, then spent the summer at Douarnenez, after first visiting Quimper. At Quimper he noted in his journal *A Soi-même* for 3 July: 'A mournful country, full of dark colours.' We also know that he was at Morgat in 1883 and Vannes in 1884. From Vannes he wrote: 'One must go to the Morbihan to see the sombreness of Brittany, and plunge one's soul into melancholy.' The precise spot depicted in this painting is not known. The nostalgic tones of grey and ochre, barely highlighted by the white walls of the houses, with no picturesque touches, make one think of the dreamy solitude of a painting by the Belgian Symbolist Fernand Khnopff: his *La ville abandonnée (The Deserted Town*) of 1904 (Musées Royaux des Beaux-Arts, Brussels).

Les yeux clos (Closed Eyes), 1890

Oil on canvas mounted on cardboard, $17\frac{3}{8} \times 14\frac{1}{4}$ (44 × 36) Purchased in 1904 (R.F. 2791)

This painting, which is dated 1890, marks a turning-point in Redon's work: the beginnings of his use of colour for Symbolist subjects. This does not mean, however, that he abandoned black and white; in fact, the same theme is used in a lithograph, also of 1890. The model was his wife Camille, whose features are recognizable, but she has been given the pose, her head tilted to one side, of Michelangelo's famous sculpture in the Louvre, the *Dying Slave*. In his journal *A Soi-même*, in May 1888, Redon wrote as follows about this work: 'What marvellous brainwork goes on behind the closed eyes of Michelangelo's *Slave*! He is sleeping, and the uneasy dream which moves beneath that marble brow bears away our own dreams to a realm full of thought and emotion.'

The head rises out of a broad band which creates a kind of horizon in the foreground; it is thus immediately situated within the universe of dream, the creation of which was for Redon the purpose of art. This work, combining elements taken from art history and from reality, becomes a definitive 'personal invention', a 'new organism', in which the artist's vision imposes itself upon the spectator. It was the first painting by Redon to be acquired by the Musée du Luxembourg, in 1904 – the year in which the artist achieved genuine celebrity outside the avant-garde milieu of the Symbolists. This success was the result of a retrospective of sixty-two of his paintings, organized within the framework of the Salon d'Automne.

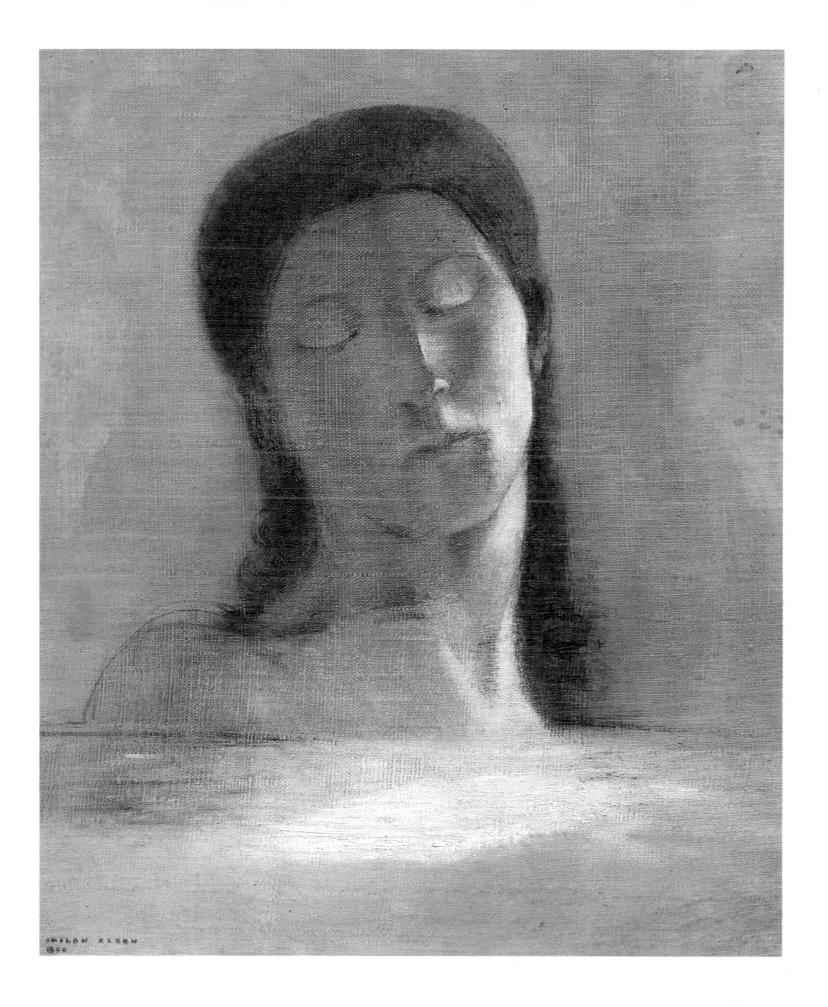

Le Bouddha (The Buddha), c.1905

Pastel on paper, $35\frac{1}{2} \times 28\frac{3}{4}$ (98 × 73) Purchased in 1971 (R.F. 34555)

From 1895 onwards, pastel formed a major part of Redon's work, but it was only after 1900 that the tone became more serene and optimistic, and the colour range so rich and varied. Here, as so often, he rehandles a theme he had already used in black and white: Buddha appears in two lithographs dating from 1895 and 1896, inspired by Flaubert's *Temptation of St Antony*. In these he is a hallucinatory figure, or a haunted magus with a serpent's body. In a pastel purchased by Matisse in 1900, Redon showed *The Death of Buddha* in a serene world full of shifting hues; and in 1904, for a large decorative panel, he depicted The Youth of Buddha, setting the scene in a garden. At this time he wrote to the Bordeaux collector Gabriel Frizeau that he would like to be reincarnated in India. Yet it seems to have been Japanese art which inspired the pastel illustrated here; the iconography is that of a Jizõ, or Merciful Buddha, with a shaven skull, a golden ornament on his breast, and his staff in his right hand. In the midst of a paradisal garden, with imaginary flowers, there rises the same tall tree with bare branches that appears in several of Redon's lithographs. It is based on one of the drawings after nature made by Redon in his teens, which depict the surroundings of the family house at Peyrelabade, in the Bordelais area. This austere image contrasts with the sumptuous, heavily patterned fluorescent hues of the background, a contrast which is echoed in Buddha's downcast gaze, the symbol of his withdrawn meditations, set against the sumptuousness of his multi-coloured robe.

This pastel, one of Redon's most highly finished works, shows his supreme mastery of the medium, which can only be compared to Degas' audacious use of the same technique, and provides a synthesis of the artist's most essential themes. It was shown at the Salon d'Automne of 1906, and was immediately acquired by Marcel Kapferer, one of Redon's most enthusiastic collectors. It remained with Kapferer throughout his life.

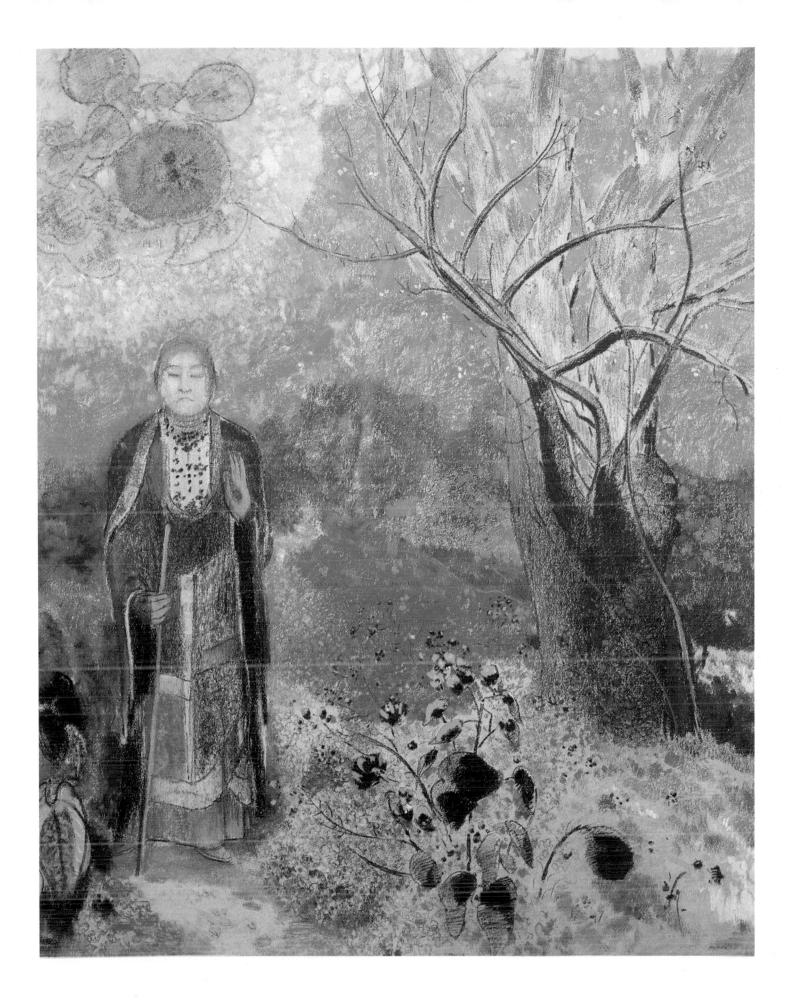

Parsifal, c.1912

Pastel on beige paper, $26 \times 20\frac{1}{2}$ (66×52) Purchased in 1977 (R.F. 36521)

Three years after Wagner's death in 1883, Redon published his first lithograph with a Wagnerian theme. It appeared on 8 August 1886 in the *Revue Wagnérienne*, founded in 1885, and shows a bust of Brünnhilde, wearing a helmet, seen against a rocky landscape that is barely sketched in. The same avoidance of the picturesque and same rejection of 'vague German sentimentalism' – qualities with which Redon reproached Fantin-Latour, a longtime enthusiast for Wagner – appear in this markedly sober pastel, which is in all probability a reworking of an earlier drawing in charcoal. The last anecdotal details, which make their appearance in a lithograph of the same subject done in 1892 (the lance of the Grail which Parsifal had to recover from the magician Klingsor and the knight's helmet), have now disappeared. Amid varying hues of pink, blue and velvety black the spectator meets the serious gaze of the hero, and senses his determination, his role as the symbol of the triumph of believers over unbelievers, purity over sin, which is the theme of Wagner's final opera, completed in 1882. We are a long way here from the *Knight with Flowers* by Rochegrosse (also in the Musée d'Orsay). True to academic tradition, this shows Parsifal clad in shining armour, his eyes uplifted, moving across a field among the flower-maidens who try to tempt him.

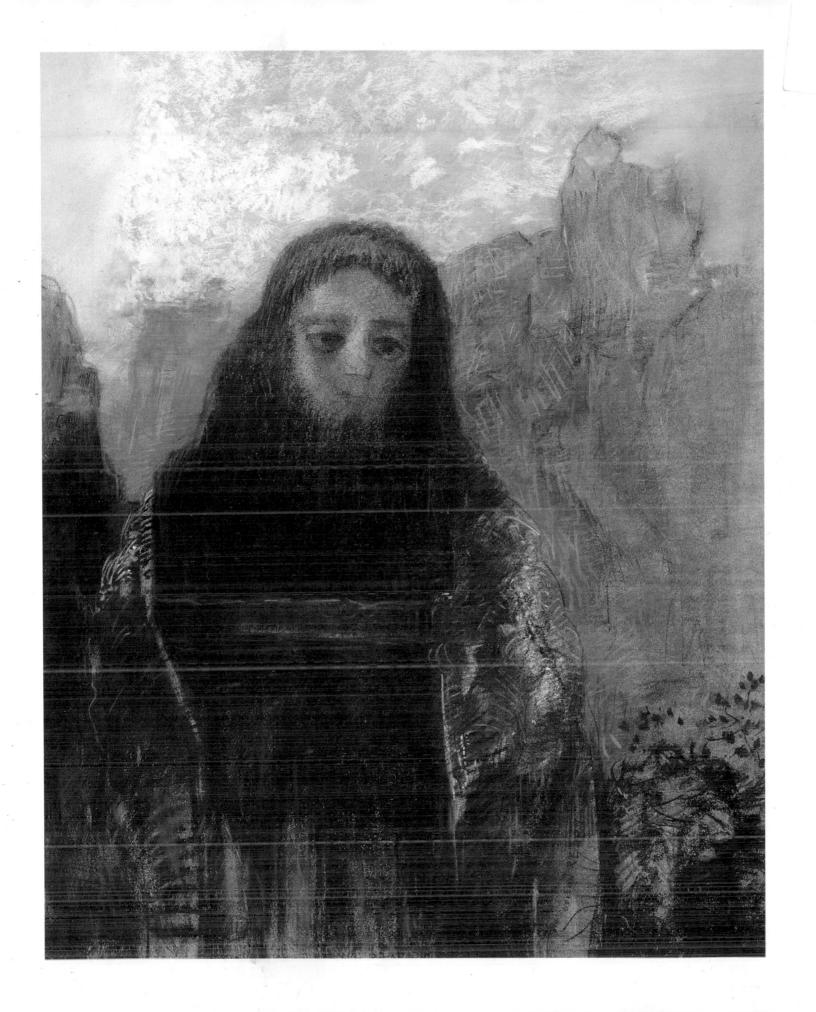

La coquille (The Seashell), 1912

Pastel on paper, $20\frac{1}{2} \times 22\frac{3}{4}$ (51 × 57.8) Suzanne Redon bequest, 1982 (R.F. 40494)

The seashell depicted in this sumptuous pastel was piously preserved by Arï Redon, the painter's son, and stood for many years on the mantelpiece in the living-room of the apartment at 129 Avenue de Wagram in Paris, to which Redon moved in 1909. Madame Redon came from Réunion in the Indian Ocean and still longed for warmer climes; it was she who was partly responsible for inspiring Gauguin's desire to flee to the tropics, and she had a taste for objects of this sort. But the shell could also be a simple studio prop: one very much like it belonged to Gustave Moreau, and still forms part of the collections of the Musée Gustave Moreau in Paris. We know the admiration which Redon felt for this great precursor of Symbolism, who inspired several of his own compositions.

Whatever the case may be, Redon had previously tried to depict this shell in an oil painting which remained unfinished. Leaving the proportions unchanged, he took up the theme again in pastel. The shell is life size, and the main form is surrounded by a black outline, while to the right another shell is summarily adumbrated. The technique recalls that of Gustave Moreau, who surrounded his *Galatea*, shown in the Salon of 1880, with aquatic plants. Redon metamorphoses the motif through a skilful manipulation of hue and tonality, the medium giving full impact to the pink and pearly hues, and also by his organization of the picture space, which remains fluid and imprecise. Thanks to these devices, the shell takes on a radiance which transforms it into a visionary object.

Redon was also to make use of the same shell for variations on the theme of the *Birth of Venus*. In a pastel in the Petit Palais in Paris, it becomes a skiff, bearing the goddess towards the shore; in a painting at Fort Worth (Kimbell Art Museum), it becomes a vast aureole surrounding her naked form.

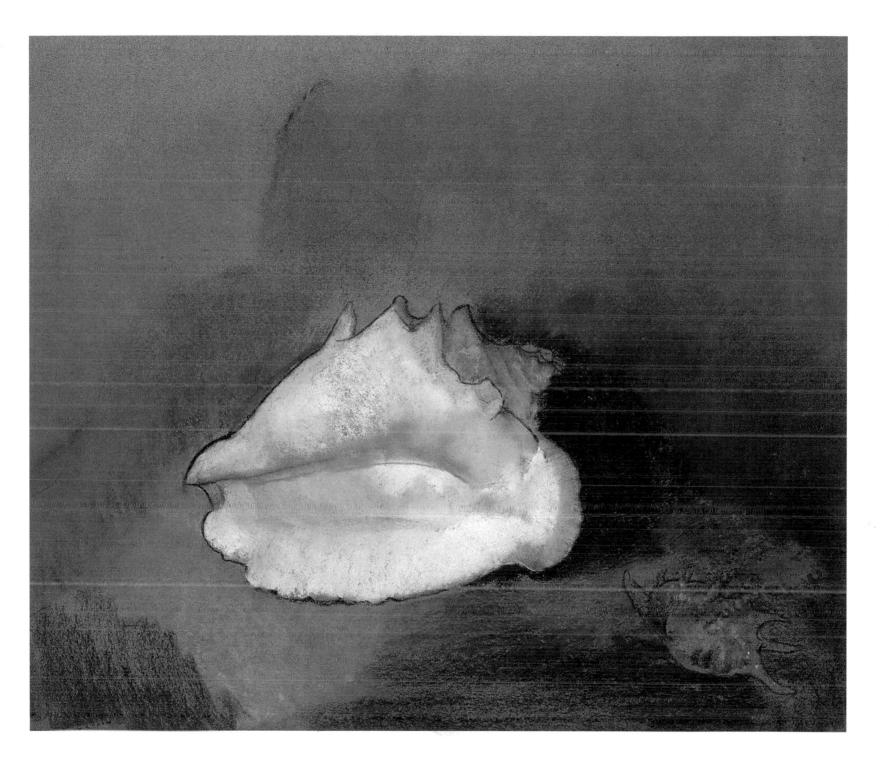

Les Alyscamps, Arles, 1888

Oil on canvas, $35\frac{7}{8} \times 28\frac{3}{8} (91 \times 72)$

Gift of Countess Vitali in memory of her brother, Viscount Guy du Cholet, 1923 (R.F. 1938–47)

'I went to Arles to join Vincent van Gogh, after numerous pleas from him. He said he wanted to set up a studio in the Midi, of which I was to be the head'. So wrote Gauguin in 'Diverses Choses' ('A Variety of Things'), a manuscript of 1896–97. These two ardent solitaries thus came together in the Midi in the autumn of 1888, Gauguin extremely conscious of his prestige as head of the Pont-Aven Group and Van Gogh avid for comfort and human warmth.

The view of the celebrated Christian necropolis of the Alyscamps, with the cupola of the Chapel of Saint-Honorat in the background, inspired the two artists to paint a group of paintings in which it is difficult to distinguish the influences each had on the other. Gauguin's brilliant version shows a 'synthetist' understanding of the landscape, which is boldly cut into zones of colour delimited by decorative arabesques which pay no attention to exact topography. Gauguin here employs particularly bright hues and brushwork that harks back to Impressionism in its fragmentation, to interpret the brilliance of the Mediterranean scene. But it is the arbitrariness of the colour that is so striking – for example, the blue tree-trunk and the violent red splash on the right. It shows clearly how Gauguin opened the way for modernism, from the Nabis to the abstractionists of the present day via the Fauves. This picture illustrates the lesson that Gauguin had just taught the young painter Sérusier, shortly before his own departure from Brittany, which gave rise to the famous picture by Sérusier known as *Le talisman* (p. 196).

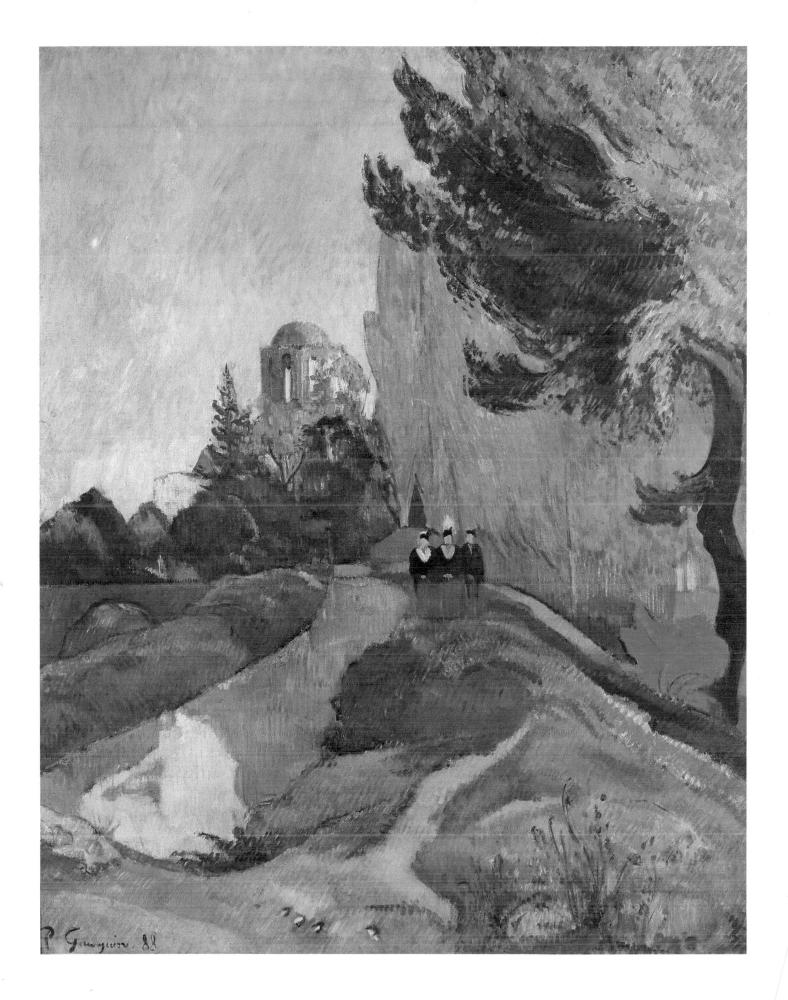

Le repas (The Meal), 1891

Oil on canvas-backed paper, $28\frac{3}{8} \times 36\frac{1}{4} (72 \times 92)$

Gift of M. and Mme André Meyer, but retained by the donors for their lifetimes, 1954; retention abandoned, 1975 (R.F. 1954–27)

Gauguin's period in Brittany was followed in 1891 by escape and voluntary exile in Tahiti. In rebellion against a public which did not understand the first thing about his art, in flight from material and family problems, disgusted with civilization and spurning odious realism in art everything encouraged him to cast off his moorings. By suggesting he read Pierre Loti, Van Gogh was certainly responsible in great measure for sending Gauguin to this island where he hoped to find the lost Eden of his dreams. Le repas, also described in one of the painter's Tahitian notebooks as Nature morte fei (Fei Still-life, fei being Tahitian for 'banana'), is one of the first pictures he produced after his arrival. Its plastic and decorative qualities make it also one of the finest, and show clearly that Gauguin's art had found its true stature in the tropics. In the foreground, occupying two-thirds of the table which is rhythmically divided into horizontal bands, is a splendid still-life full of tropical savour, where blue shadows emphasise the colours. A native drinking-bowl is prominent in the centre. (In a showcase beside the picture there is a similar bowl carved by Gauguin himself, which once belonged to the celebrated dealer Vollard.) Even seen in isolation, this detail shows that Gauguin was Cézanne's equal in defining space and volume by means of colour. The frieze-like composition, and the faces of the three fascinated children, give this work a powerful, enigmatic CF-T allure.

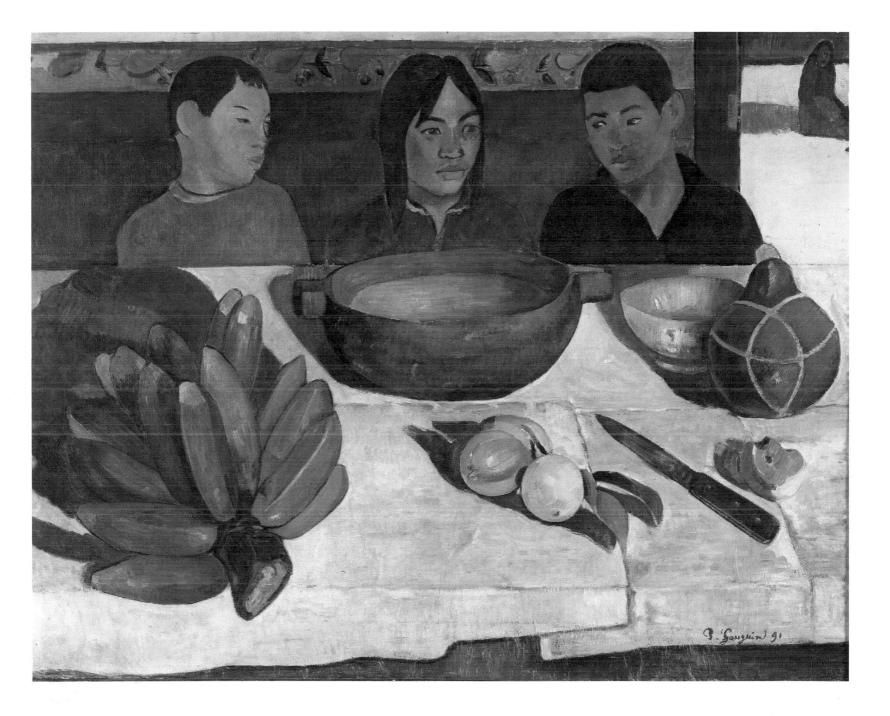

Femmes de Tahiti or Sur la plage (Tahitian Women or On the Beach), 1891

Oil on canvas, $27\frac{1}{8} \times 35\frac{7}{8} (69 \times 91)$ Viscount Guy du Cholet bequest, 1923 (R.F. 2765)

'It's always silent. I can understand how these people pass hours and days seated, in melancholy contemplation of the sky. I feel all this beginning to invade me', wrote Gauguin in July 1891 to his wife Mette, who had taken refuge in Denmark with her family. It was through Tahitian women, his successive mistresses, that the artist became increasingly aware of the indolent and melancholy charm of the Polynesian soul. This painting, contemporary with *Le repas* (p. 146), and also with his finest Tahitian portraits such as the famous *Vahine no te tiare (The Woman with the Flower)* in Copenhagen, offers a splendid image of a way of life which was as vegetative as it was difficult to break free of. The picture obeys the same compositional rules as *Le repas*, in the way that it links broad, space-denying horizontal bands with the two large figures in the foreground – a scheme already fully worked out by the artist during his years in Brittany. The Tahitian motif of the flowered *pareo* reinforces the decorative effect made by this canvas, which the artist enlivens with bold colour harmonies. The chaste attitudes of his Tahitian women here contrast with the tempting sensuality of those in a picture hanging near it, aptly entitled *Et l'or de leur corps (And the Gold of Their Bodies*).

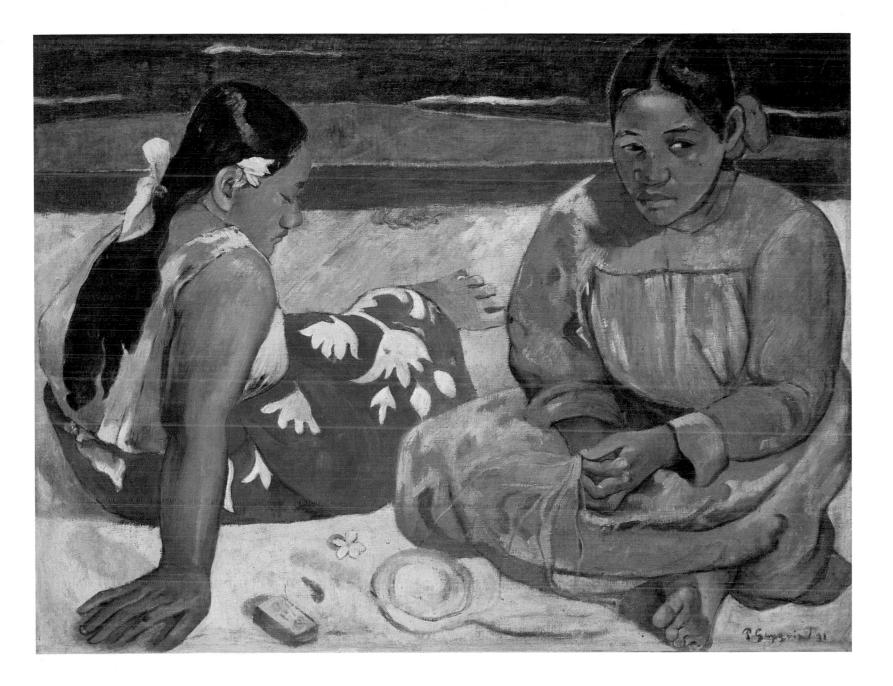

Portrait de l'artiste (Self-portrait), c. 1893-94

Oil on canvas, $18\frac{1}{8} \times 15$ (46 × 38)

Purchased in 1966 (R.F. 1966–7)

Gauguin, Van Gogh and Cézanne, in contrast to Impressionist painters such as Monet, Renoir and Sisley, are among the artists most pre-occupied with their own image, which they treat in their own different ways. The Musée d'Orsay has important self-portraits by each of them, revealing as much about their attitudes towards themselves as about their pictorial experimentation. On the one hand there is the anguished introspection of Van Gogh – of which his *Self-portrait* of 1889 (see p. 164) is a moving example – and on the other, the lofty, refined compositions of Gauguin, always concerned with symbolic allusions, and the solid constructions of Cézanne. In addition to the *Self-portrait* of *c*. 1893 illustrated here, which was completed after Gauguin's first return to Paris from Tahiti, the Jeu de Paume has another, painted earlier and dedicated to his friend Daniel de Monfreid, in which the painter shows himself in profile.

Following the classic tradition, Gauguin liked to show himself against a background containing paintings of his own for which he felt a particular affection. Recognizable in the background here is *Manau Tupapu (The Spirits of the Dead Keep Watch)*, painted in Tahiti in 1892. Gauguin had previously painted himself in 1889 in front of his famous *Christ jaune (Yellow Christ)*. There were two good reasons for doing so: in all modesty he thought of himself as the new Christ of painting, and considered this work to be in the front rank of his Breton experiments. Van Gogh, Carrière and Charles Morice were all of them the dedicatees of self-portraits with symbolic messages. In this one, on the back of which is a portrait of his Parisian neighbour the composer William Molard, Gauguin postures arrogantly in an extravagant costume which tells one a great deal about his theatrical temperament. The almost sculptural force of the painting makes it one of the most important images of the artist.

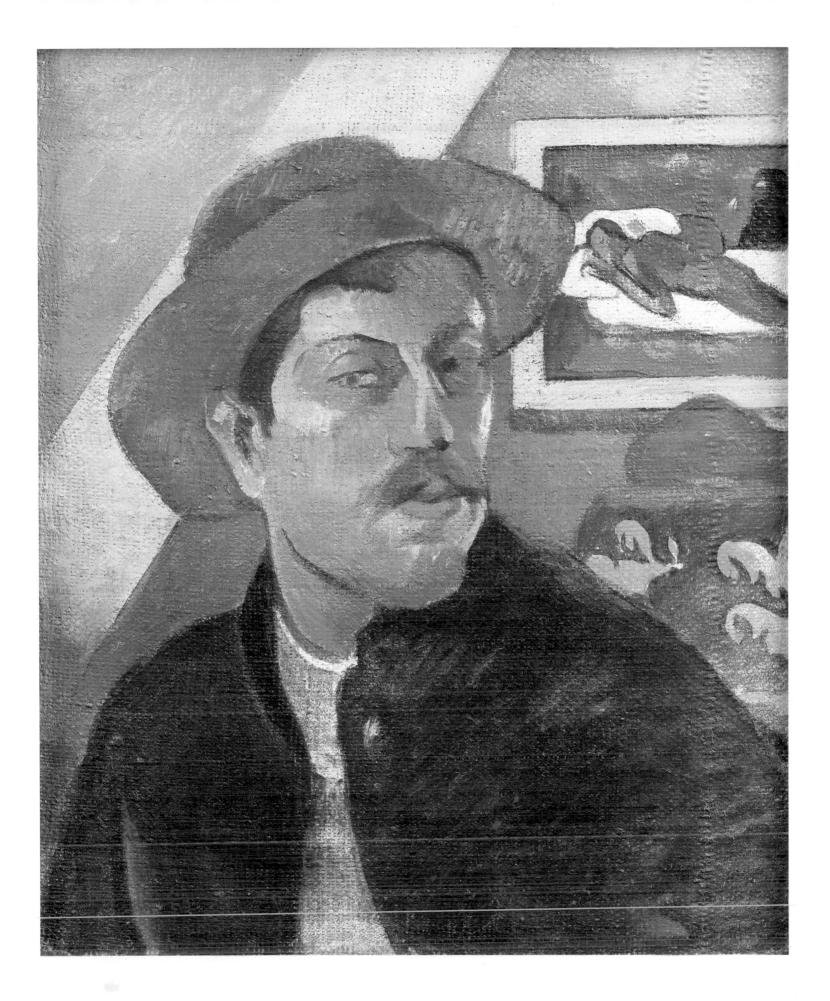

Paul GAUGUIN (1848–1903)

Paysannes bretonnes (Breton Peasant Women), 1894

Oil on canvas, $26 \times 36\frac{1}{4}$ (66×92)

Gift of Max and Rosy Kaganovitch, 1973 (R.F. 1973–17)

This canvas dates from 1894, that is from after Gauguin's first period in Tahiti, and thus may represent a return to the past, a new pilgrimage to his Breton roots. This seems likely from the fact that Gauguin has returned to one of his favourite subjects at the time of his visits to Le Pouldu and Pont-Aven in earlier years. The left-hand side of the picture, with a man bending towards the ground and two immobile silhouettes in traditional costume, recalls Gauguin's earliest Breton landscapes, and what was borrowed from him by his colleagues Emile Bernard, Paul Sérusier and Jacob Meyer de Haan. There is the same strictly constructed landscape, and a similar opposition of flat zones of colour. But if the two women – who are presumably Breton – are wearing local headdress, their features and postures are nevertheless far more evocative of the Tahitians Gauguin had already immortalized than they are of the rustic inhabitants of the Breton countryside, as depicted for instance in his zinc etchings of the Le Pouldu period. Even the landscape to the right has exotic resonances and mingles Tahitian touches with memories of Gauguin's first voyage to Martinique in 1887.

It must be said that Gauguin hardly found this last visit to Brittany inspiring. He dreamed only of one thing: 'In December', he wrote, 'I am going back [to Paris], and I shall spend every day trying to sell all I possess... Once I've got the money in my pocket I'm leaving for Oceania. Nothing will stop me going, and I'm leaving forever.'

This picture, like Monet's *L'église de Vétheuil* (see p. 94), formed part of the important Kaganovitch gift which enriched the Jeu de Paume with numerous Impressionist and Post-Impressionist works. (Paintings by Cézanne and Pissarro among the former, and by Bonnard, Derain and Vlaminck among the latter.)

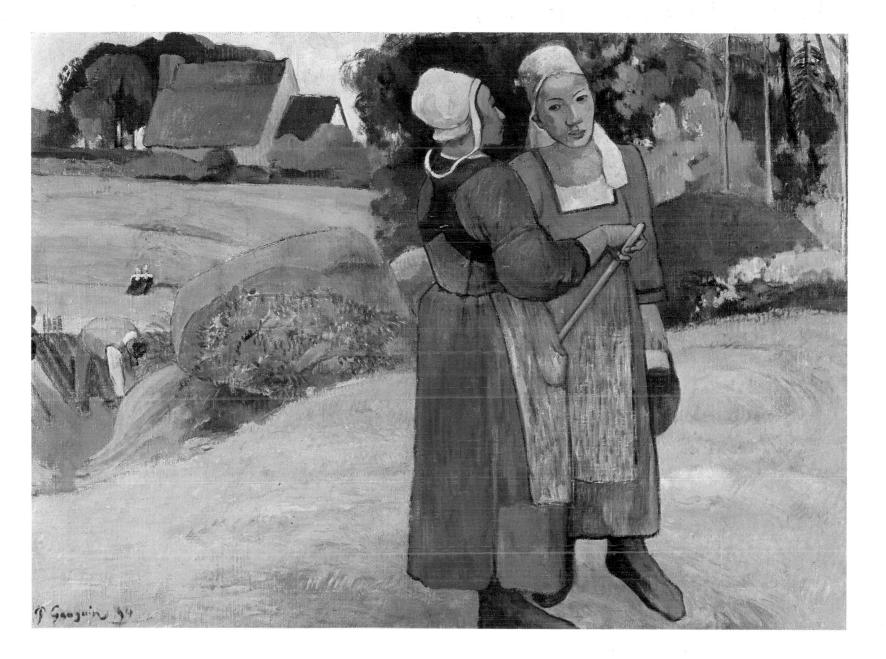

Paul GAUGUIN (1848–1903)

Vairumati, 1897

Oil on canvas, $28\frac{3}{4} \times 37$ (73 × 94)

Formerly Matsukata Collection. Ceded under the terms of the peace treaty with Japan, 1959 (R.F. 1959–5)

At the end of 1898, Gauguin sent this picture from Tahiti, where he had settled once again in 1895, to the Parisian dealer Ambroise Vollard. 'The dream which brought me to Tahiti has been cruelly shattered by present circumstances; it was the Tahiti of former times which I loved, and I couldn't resign myself to the idea that it was entirely extinguished, that this beautiful race had preserved none of its splendour', wrote Gauguin in *Noa-Noa*. If we are to judge by this work, it would seem that he sublimated his disappointment in painting, as the Tahitian dream here becomes flesh in a warm harmony of red and ochre. The heroine of the canvas is the beautiful Vairumati (Gauguin's misspelling of the Tahitian name Vairaumati) who was a legendary being among the Tahitians of Ariois. She was said to have attracted the great Oro to earth and thus to have become the mother of the Ariois race, masters of the island in prehistoric times. Gauguin thus describes her in *Noa-Noa*: 'She was tall, and the fires of the sun shone in the gold of her flesh, while all the mysteries of love slept in the night of her hair.' Her image reappears, with the symbolic bird, in the large triptych in the Boston Museum of Fine Arts, *D'où venons-nous? Que sommes-nous? Où allons-nous?* (*Where have we come from? What are we? Where are we going?*). The sculptures of the Javanese temple of Borobudur probably supplied Gauguin with the inspiration for the two female figures in the background. cf-r

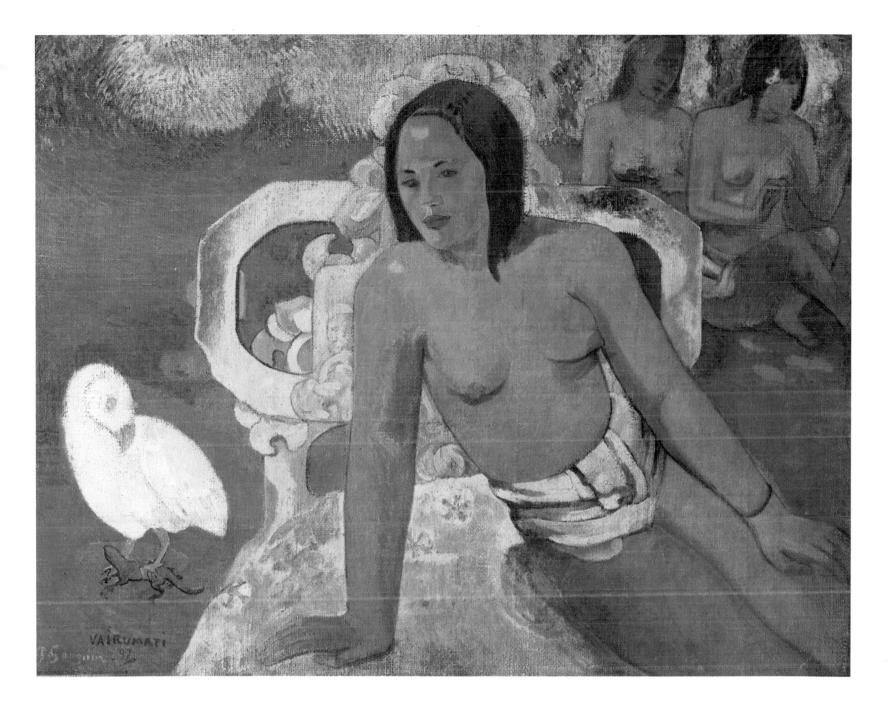

Paul GAUGUIN (1848–1903)

Le cheval blanc (The White Horse), 1898

Oil on canvas, $55\frac{1}{8} \times 35\frac{7}{8} (140 \times 91)$ Purchased 1927 (R.F. 2616)

'But the horse is green! Horses like that don't exist!' exclaimed the man for whom this picture was intended, a pharmacist insensitive to its strange poetry, and who therefore refused to accept it. *Le cheval blanc* thus went to join other Tahitian paintings which Gauguin had already sent to his faithful friend Daniel de Monfreid. The latter spared no effort to sell Gauguin's work in Paris, so as to send financial help to the artist, who was always in desperate need of money. Finally Monfreid offered the painting to the French national collections, and thus it became part of the museum of modern art of that epoch – the Musée du Luxembourg.

Long misunderstood, this painting is nevertheless one of the artist's finest Tahitian works, the decorative effect and the strangeness of the content being wonderfully combined in a richly coloured symphony. Original though it is, the painting has its roots in the purest antique tradition. Gauguin took the stance of the horse from the west frieze of the Parthenon, of which he possessed old collotype photographs, while the tree betrays the Japanese influence which is already to be felt in paintings of the Breton period. There are also affinities with several paintings of horses by Degas, which Gauguin much admired. These different iconographic sources are inextricably intermingled with local Polynesian mythology, where the white horse was a symbol of the sacred.

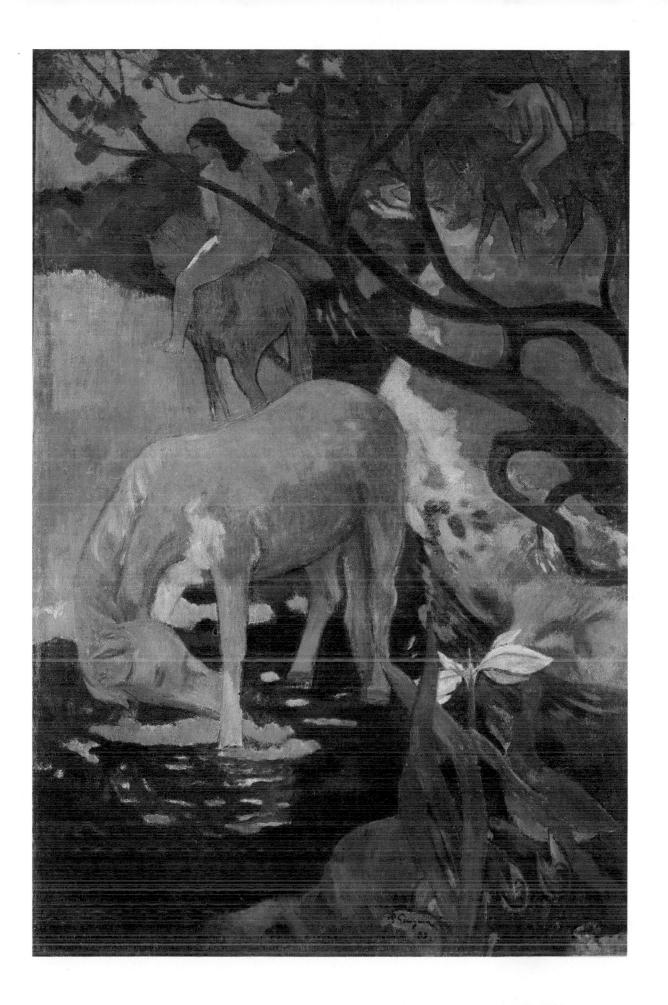

L'Italienne (The Italian Woman), 1887

Oil on canvas, $31\frac{7}{8} \times 23\frac{5}{8} (81 \times 60)$

Gift of Baroness Eva Gebhard-Gourgaud, 1965 (R.F. 1965–14)

Van Gogh, son of a Dutch pastor, only discovered his vocation as a painter in 1880, when he was twenty-seven. Before that there had been a time of drifting during which, uncertain of his vocation, he studied theology, then worked for the picture-dealer Goupil at The Hague, in London, and finally in Paris. His discovery of what he wanted to do was followed by a series of dark pictures, with thick impasto; typical of these is the *Tête de paysanne hollandaise (Head of a Dutch Peasant Woman)* of 1884, in the Musée d'Orsay Very different are the paintings which Van Gogh painted in Paris, after he came there to live with his brother Theo in 1886. *L'Italienne* is a dazzling example. The artistic milieu which Van Gogh then discovered was in a state of full effervescence, and he came into contact with avant-garde artists like Toulouse-Lautrec and Emile Bernard. He was at once able to make use of the innovations introduced by Impressionism, whose status was now confirmed. The immediate effect was to convert him to colour – his palette needed only to be unleashed in its full force as can be seen in *La guinguette (The Open-air Tavern*) of 1886, and in *Le Restaurant de la Sirène* of 1887.

The sitter for *L'Italienne*, in her brilliant costume, was in all probability Agostina Segatori, the owner of a Paris cabaret called Le Tambourin. She was well known in the world of painters, particularly as one of Manet's former models. Her establishment, where Van Gogh hung his own paintings and some of his Japanese prints, was frequented by artists and writers – among them Steinlen, Forain, Bonnard and Gauguin. The severe design of the picture, which is almost abstract with its monochrome yellow background and rigid edging striped with red and green, is derived from Japanese models. It is vigorously painted, with a nervous brush-stroke which gives the whole composition a dazzling chromatic vibration. Taking a hint from Seurat, Van Gogh made use of complementary colours, arbitrarily employed, and thus shows himself to be a precursor of Fauvism, and of the expressionist and abstractionist art movements which followed.

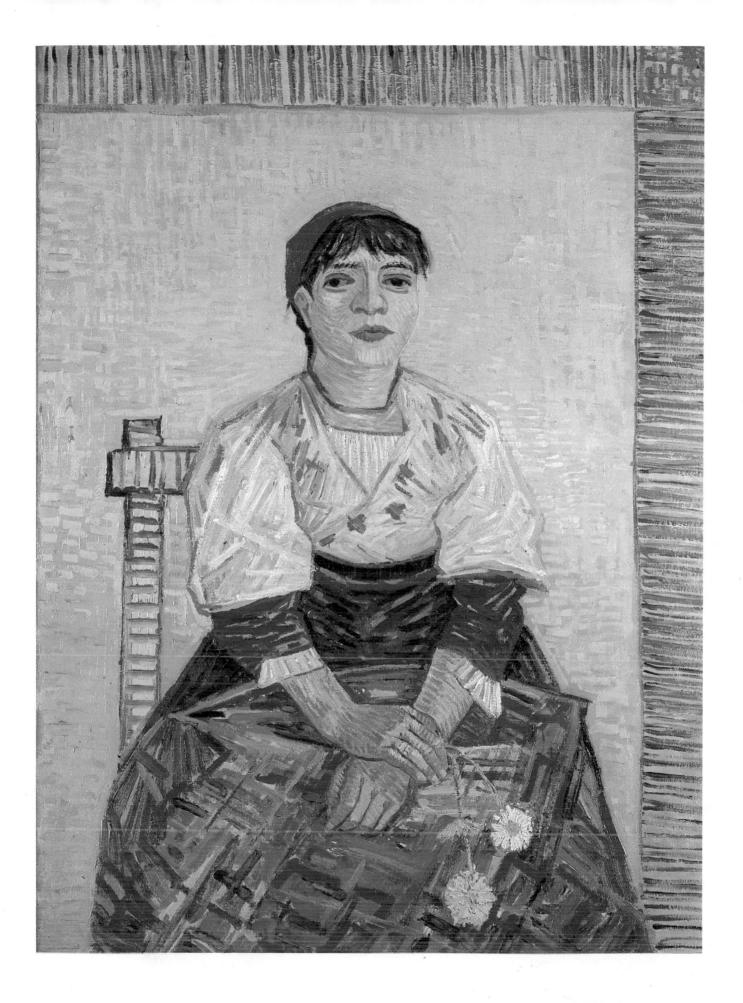

L'Arlésienne (Madame Ginoux) (Woman of Arles [Madame Ginoux]), November 1888

Oil on canvas, $36\frac{1}{4} \times 28\frac{3}{4} (92 \times 73)$

Gift of Mme R. de Goldschmidt-Rothschild, but retained by her for her lifetime, 1952; entered the national collections in 1974 (R.F. 1952–6)

Madame Ginoux (1848–1911), with her husband Joseph Ginoux, ran the Café de la Gare in the Place Lamartine at Arles. This establishment, known to us through paintings by both Gauguin and Van Gogh, remained open all night, and so attracted all kinds of destitute vagabonds. Van Gogh occupied a room there from May to September 1888, before settling in the yellow house next door, where he made a painting which immortalized his room (see p. 166).

'I have an Arlésienne at last,' wrote the artist to his brother Theo in November 1888, 'a figure (size 30 canvas) slashed on in an hour, background pale citron, the face grey, the clothes black, black, black, with perfectly raw Prussian blue. She is leaning on a green table and seated in an armchair of orange wood.'

In addition to four later versions of the same portrait, done at Saint-Rémy between May 1889 and May 1890, with backgrounds of different colours, there are two versions of the *Arlésienne* against a yellow background – this one, and one in the Metropolitan Museum of Art, New York. The particularly rapid technique of the former, and the coarse canvas on which it is painted (supplied by Gauguin in September 1888, as R. Pickvance was able to demonstrate in connection with the exhibition 'Van Gogh in Arles' held at the Metropolitan Museum in 1984), lead to the supposition that this is the earlier, and is the one Van Gogh describes in his letter. In the other portraits of Madame Ginoux the gloves and umbrella on the green table are replaced by books.

In any event, this painting lies at the heart of the artistic relationship between Van Gogh and Gauguin. Gauguin, too, painted a portrait of Madame Ginoux in November 1888, showing her in a similar pose in the right-hand half of $Au \ café$ (Pushkin Museum, Moscow). Gauguin's preliminary drawing of the sitter was used by Van Gogh for his later Arlésiennes. This fruitful artistic exchange did not, however, obscure the differences between the two artists. Van Gogh's canvas has a dramatic tension thanks to the strident harmonies – or rather, clashes – of colour, and to the nervous brushwork which seems to carve out the paint. These elements are in general alien to Gauguin's art. In this respect, Van Gogh can be seen as one of the progenitors of Expressionism, and as a member of the same artistic family as the great Norwegian Edvard Munch.

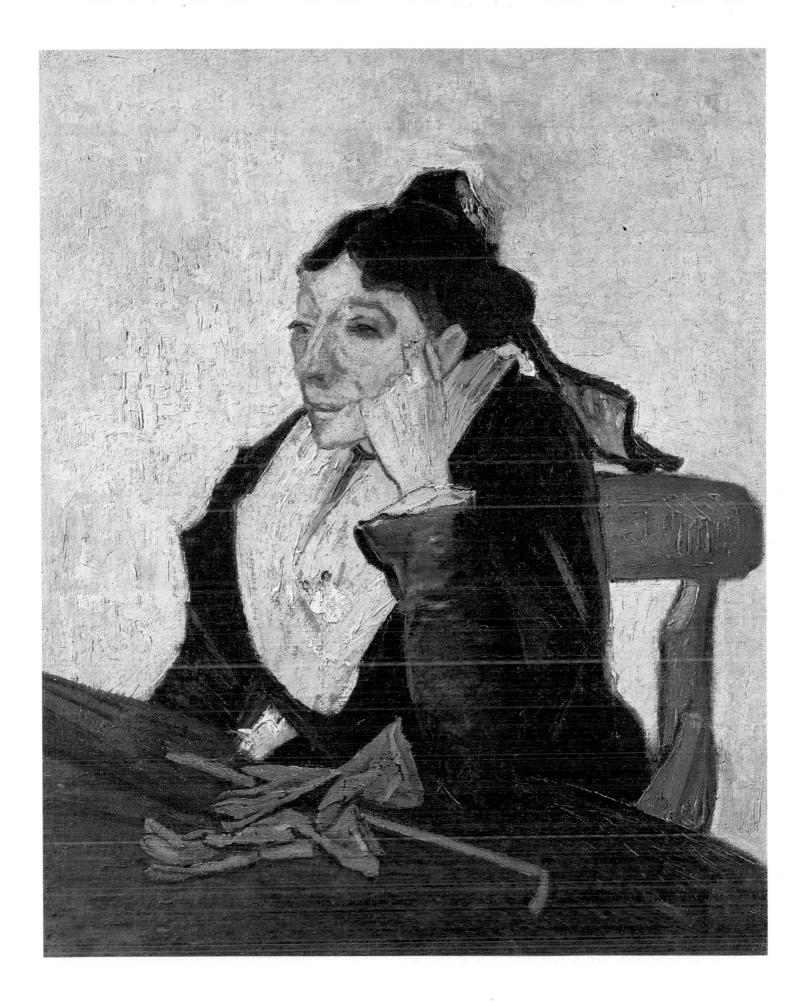

La salle de danse à Arles (The Dance-hall at Arles), 1888

Oil on canvas, $25\frac{5}{8} \times 31\frac{7}{8} (65 \times 81)$

Gift of M. and Mme André Mayer, but retained by them for their lifetime, 1950; retention abandoned, 1975 (R.F 1950-9)

Van Gogh fled from Paris to the Midi, and arrived at Arles in February 1888. Dazzled by the southern light, he proceeded to paint some of his best-known works, for example Les Tournesols (The Sunflowers), Le facteur Roulin (Roulin the Postman) and L'Arlésienne (Woman of Arles, p. 160). No sooner had he got to Arles than Van Gogh began to try to get Gauguin to come there too - for Gauguin completely fascinated him. La salle de danse à Arles is without any doubt the painting where Gauguin's influence over Van Gogh is most visible, and, through Gauguin, also that of his young disciple at Pont-Aven, Emile Bernard. Gauguin had in fact brought with him a surprising painting by Bernard of Bretonnes dans une prairie verte (Breton Women in a Green Meadow) in an extremely synthetist style, much removed from any kind of realism and in which the figures of the peasant women were encircled by harsh black lines and appeared against a raw green background. Van Gogh made a copy of this picture and borrowed several technical devices from it in La salle de *danse* – for example, the outlines of the forms; bold, flatly painted colours as opposed to the broken touch of the Impressionists; and the irregular silhouettes of the women in the foreground. What we have here is a semi-experimental work in which Van Gogh is trying to get to the bottom of a pictorial theory which is verging on abstraction. But his fiery temperament imbues the picture with a kind of frenzy in which the faces are pushed to the brink of caricature. It is nevertheless possible to identify Madame Roulin, wife of Van Gogh's friend the postman, on the right; the painter has immortalized them both in the individual portraits he painted of them. At exactly the same period Seurat and Lautrec were both using this kind of subject-matter – night-scenes done in popular dance-halls – as the basis for works which were radically new. CF-T

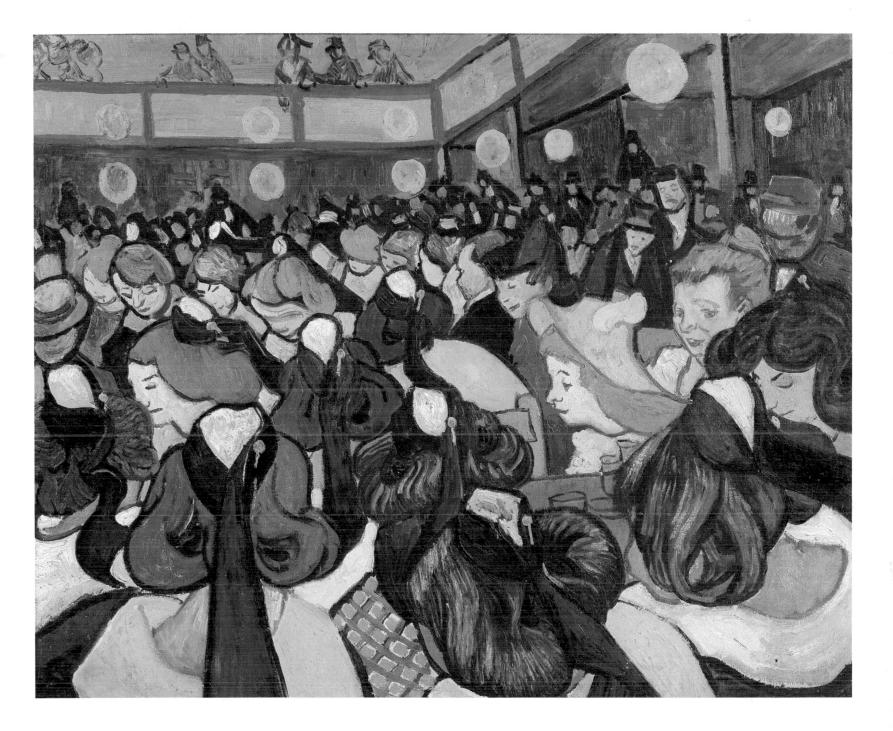

Portrait de l'artiste (Self-portrait), 1889

Oil on canvas, $25\frac{5}{8} \times 17\frac{3}{4} (65 \times 45)$ Gift of Paul and Marguerite Gachet, 1949 (R.F. 1949–17)

This moving self-portrait is one of the last in a long series. There are about forty of them, in oils, done by an artist obsessed with the idea of confronting his own image. There can be nothing astonishing about the fact that this man – who was mentally unstable and subject to frequent and violent nervous crises – should have tried to exorcize his demons by projecting them into art. He is the precursor here of a succession of Expressionist artists, such as Munch, Ensor, Jawlensky and Kokoschka, all of whom frequently turned to the self-portrait.

Van Gogh is simultaneously the classic instance of the *artiste maudit* ('accursed artist') – an idea often put forward and widely accepted during the nineteenth century – and one of the founding fathers of our own conception of the modern: this is something which readily explains the immense popular success of the self-portrait and others such as the famous *Autoportrait à l'oreille coupée* (*Self-portrait with Severed Ear*), or the example showing Van Gogh in a straw hat. In this picture, which, according to indications given in his correspondence with Theo, was probably painted in September 1889, when he was still in the hospital at Saint-Rémy, Van Gogh makes use of a striking monochrome field brought violently to life by undulating movements of the brush. The idea of a background carrying a strong emotional charge is typical of Van Gogh and very different from the sophisticated scene-setting of Gauguin. His approach to painting, so vital and authentic, explains the universality of Van Gogh's message. He gave this picture to his friend Dr Gachet, and was to commit suicide a year later.

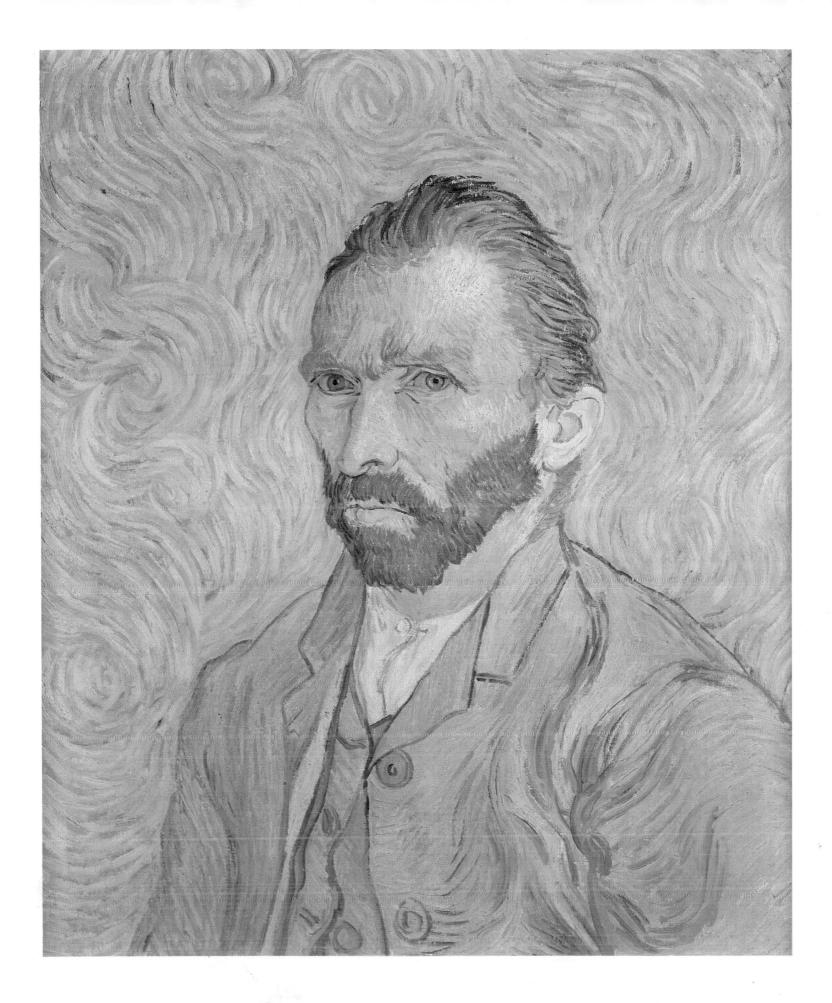

La chambre de Van Gogh à Arles

(Van Gogh's Room at Arles), 1889

Oil on canvas, $22\frac{1}{2} \times 29\frac{1}{3} (57 \times 74)$

Former Matsukata Collection. Ceded under the terms of the peace treaty with Japan, 1959 (R.F. 1959–2)

La chambre de Van Gogh à Arles is perhaps the best-known of Van Gogh's paintings. It admits us into the painter's intimacy, but only partly reveals his secret. Full of blazingly discordant colour, this room is, with its rustic simplicity and bareness, the one which the painter occupied at Arles in the year 1888. Van Gogh made several drawings of it, and also three versions in oil, the first one in October 1888, followed by two copies (the painting in the Musée d'Orsay is one of these) in September the following year. He speaks of it several times in his letters to Theo.

Van Gogh had dreamed of creating around himself a true artistic community – the famous 'Studio of the Midi' – and had persuaded Gauguin to come to live with him. But the stormy relationship between the two men inevitably deteriorated rapidly, and it was here that the famous incident took place – when, in the grip of a fit of madness, Van Gogh attacked his friend and afterwards cut off his own ear. The following spring, Van Gogh committed himself to the Hospice of Saint-Paul at Saint-Rémy, and there painted this picture. 'I'm working with a will in my room. It does me good and chases away my imaginings, my abnormal ideas', he wrote to Theo in September 1889. The picture is thus the radiant testimony of a man then confirmed to a madhouse, but also, as a retrospective view of his room at Arles, was done as an act of exorcism by someone for whom painting was truly therapeutic. The strident colours, which bear little relationship to reality, the shaky perspective, and the yawning void which fills this paradoxically tidy room, together create a painting which is enormously evocative. Its freedom of inspiration also had a considerable influence on Matisse in his *Large Interiors*.

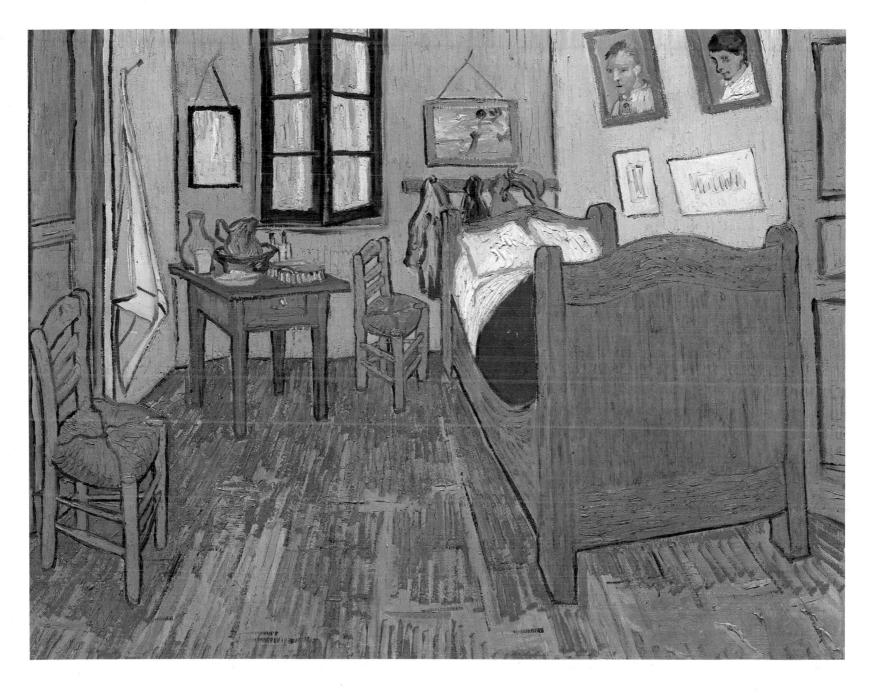

Le docteur Paul Gachet, 1890

Oil on canvas, $26\frac{3}{4} \times 22\frac{3}{8} (68 \times 57)$

Gift of Paul and Marguerite Gachet, 1949 (R.F. 1949–15)

'What impassions me most - much, much more than all the rest of my métier - is the portrait, the modern portrait. I seek it in color, and surely I am not the only one to seek it in this direction.... I should like to paint portraits which would appear after a century to the people living then as apparitions', Van Gogh wrote to his sister Wilhelmina in June 1890. From this period comes the portrait of Dr Gachet, generously given - together with the self-portrait of 1889 - to the Jeu de Paume in 1949 by the sitter's children. After a brief stay in Paris, from 18 to 20 May, Van Gogh, now back on his feet again, went off to Auvers in the valley of the Oise. There he was made welcome by Dr Gachet. The valley itself was already a favoured spot with the Barbizon painters Daubigny, Corot and Dupré; others, such as Pissarro, Cézanne and Guillaumin, also worked there. And here the doctor, whose speciality was mental illness (he had published a treatise on melancholy), helped, with exceptional discernment and total disinterest, the painters who were also his friends. This man, 'incontestably the chief enthusiast for the new painting', as Gustave Cocquiot called him, provided Van Gogh with the last friendship of his dolorous career, and was to ease his last moments after the fatal self-inflicted wound. Gachet promised that 'if the melancholy or anything else became too much for me to bear, he could easily do something to lesson its intensity', wrote Van Gogh, who painted three poignantly expressive portraits of him.

The Gachet donation, made to the national collections by Dr Gachet's children and of which this painting is part, is one of the crowning glories of the Musée d'Orsay. Here are shown side by side a number of masterpieces – paintings by Cézanne (*Une moderne Olympia*, p. 62, and *La maison du docteur Gachet*), Sisley, Renoir and Guillaumin, together with Van Gogh's final works, *Le jardin du docteur Gachet* and *L'église d'Auvers-sur-Oise* (p. 170). CF-T

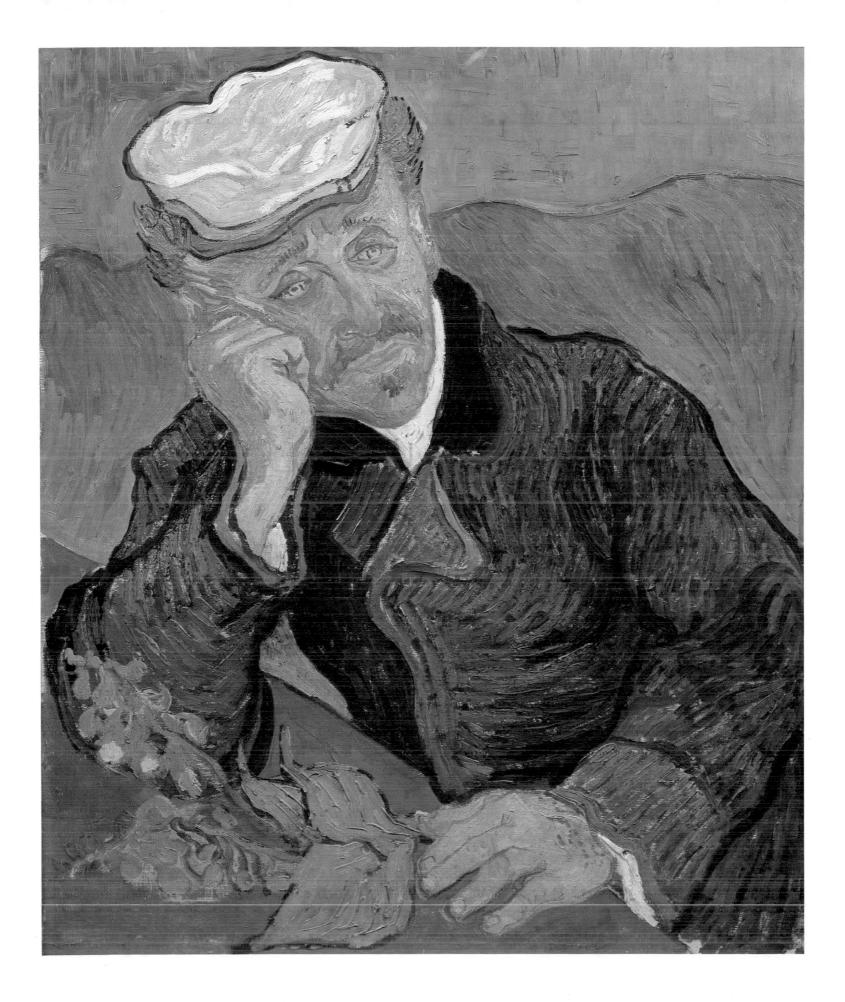

L'église d'Auvers-sur-Oise (The Church at Auvers-sur-Oise), 1890

Oil on canvas, $37 \times 29\frac{1}{8}(94 \times 74)$

Purchased with the help of Paul Gachet and of an anonymous Canadian donation, 1951 (R.F. 1951-42)

'Here the faith of one man, maintained despite madness, maintained despite the menace of death, is equal to the fervour of the multitude', wrote André Malraux in 1952. The acquisition of L'église d'Auvers in 1951 provided the Jeu de Paume, and now the Musée d'Orsay, with one of the artist's final masterpieces. Van Gogh wrote about the picture to his sister, in a letter which can be dated between 4 and 8 June 1890: 'Apart from these I have a larger picture of the village church – an effect in which the building appears to be violet-hued against a sky of a simple deep blue colour, pure cobalt; the stained-glass windows appear as ultramarine blotches, the roof is violet and partly orange. In the foreground some green plants in bloom, and sand with the pink glow of sunshine on it. And once again it is nearly the same thing as the studies I did in Nuenen of the old tower and the cemetery, only it is probable that now the colour is more expressive, more sumptuous.' Van Gogh was to die two months later, on 29 July 1890. The animated silhouette of the church, seen looking towards the apse, appears against a brilliantly blue sky which seems lit from within by an intense mystical fervour. All the energy of the picture is concentrated into a last uprush of colour, punctuated by lively brush-strokes here and there in the foreground. The figure of the little peasant girl rapidly brushed in to the left symbolizes perhaps the trivial nature of everyday events. Very different from the Monet of the cathedrals which can be admired in a neighbouring room, this painting comes close to the nocturnal visions which were soon to be orchestrated by Expressionists such as Munch and Kirchner, or by Mondrian and Kandinsky at the beginning of their careers.

CF-T

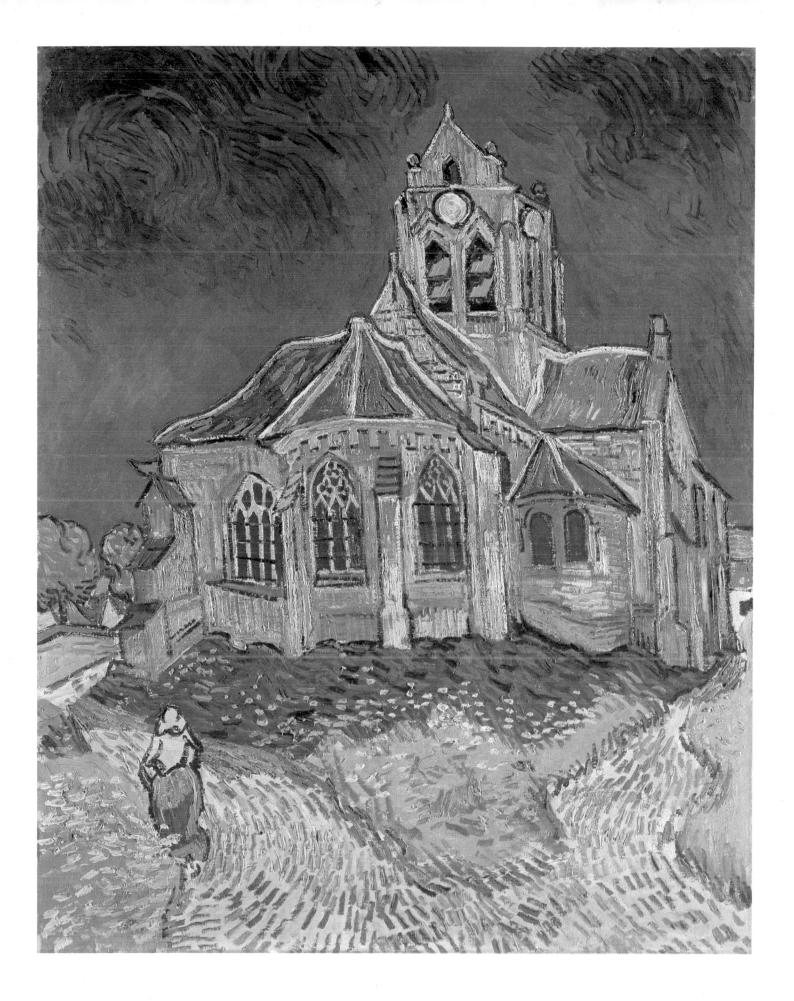

Georges SEURAT (1859–1891)

Port-en-Bessin, avant-port, marée haute (Port-en-Bessin, Outer Harbour, High Tide), 1888

Oil on canvas, $24\frac{1}{2} \times 32\frac{1}{4}$ (61 × 82)

Purchased with the income from an anonymous Canadian donation, 1952 (R.F. 1952–1)

Seurat is separated from the Impressionists by the space of a generation. In the course of his astonishing career, punctuated regularly by a series of masterpieces – Une baignade à Asnières, 1883-84 (Bathers, Asnières, National Gallery, London); La Grande Jatte, 1884-86 (Art Institute, Chicago); Les poseuses, 1886–88 (The Models, Barnes Foundation, Merion, Pennsylvania) – Seurat took up and rehandled the heritage left to him by his seniors, giving art a new direction. His attitude towards Impressionism is comparable to that of Cézanne or Gauguin, in the sense that he rejected the philosophy of instantaneity and also the fluidity and evanescence of the technique by which this was translated into paint. Profoundly classical in temperament, a great admirer of the old masters, particularly Piero de la Francesca, and a pupil of Henri Lehmann – who had himself been a pupil of Ingres at the Ecole des Beaux-Arts – Seurat combined a quasi-obsessional technique worthy of a miniaturist with an implacable scientific intelligence. Adapting the unblended brushwork of the Impressionists, he tried to submit painting to his own scientific demands. The sources of his Divisionist technique were the writings of Delacroix, and the treatises written by scientists such as Eugène Chevreul, Charles Blanc and Ogden Rood. He tried to achieve the maximum intensity of light and colour by juxtaposing little dots or points of different colours upon the canvas – hence the name Pointillism, also given to this method. The mechanism of sight is such that the eye itself synthesizes the different elements used, mingling them upon the retina.

During the summer of 1883 Seurat made six paintings of the little Normandy seaport of Port-en-Bessin – variations on a single landscape theme which are notable for their harmony and the rigour of their construction. It is easy to detect in them the influence of Charles Henry's theory concerning the symbolism of lines (see p. 174). This particular landscape, in which time seems suspended, breathes a poetic charm which makes it, like the other paintings in the same series, one of the great triumphs of Divisionism. Like Seurat's other late works, the image has been given a painted border of little dots, no doubt as a final addition, which is meant to ensure a harmonious transition between the painting and its frame.

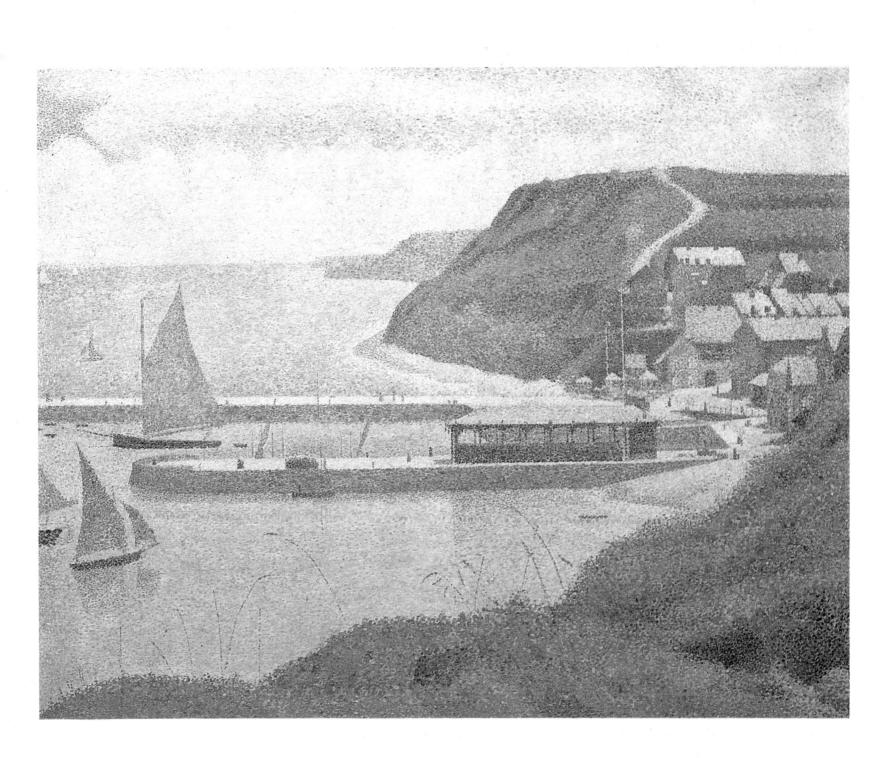

Georges SEURAT (1859–1891)

Le cirque (The Circus), 1891

Oil on canvas, $73\frac{1}{4} \times 59\frac{1}{2} (186 \times 151)$

John Quinn bequest, 1925; entered the national collections in 1927 (R.F. 2511)

Le cirque is Seurat's last painting, left unfinished. It was shown as such in the seventh exhibition of the Artistes Indépendants in the spring of 1891, just a few days before the artist's death. The theme of the circus had already inspired Seurat to paint his celebrated *Parade*, of 1887–88 (Metropolitan Museum of Art, New York).

The subject of *Le cirque* is the Cirque Fernando, one of the best-known places of entertainment in Paris, which also supplied Toulouse-Lautrec with subjects for his paintings. Seurat's large-scale painting was preceded by several sketches and a small study in oil, the latter also in the Musée d'Orsay. Pursuing his theoretical researches, Seurat here applies the ideas of his friend Charles Henry concerning the symbolism of lines: the ascending lines (the bareback rider, the clown) produce sensations of pleasure, the horizontal ones feelings of calm and stability. The ring, where all the lines speak of movement and excitement, is contrasted with the seating area where the spectators are outlined like silhouettes, flat against the horizontal tiers of the arena. Two rhythmical sequences are thus opposed to one another, as are the complementary tones blue-orange, yellow-violet, which follow the 'law of simultaneous contrasts'. The importance given to areas of white reinforces the luminosity of the canvas, which has been given a border painted in the same Divisionist technique. The large blue frame was added after Seurat's death, but in the style he favoured.

Vibrant, acid and surprising, *Le cirque* presents a decorative, quasi-abstract, intellectualized character, very different from the harsh or touching versions of the same theme by Toulouse-Lautrec or by the Picasso of the *Harlequins*. Seurat's final masterpiece belonged to his friend Signac, who bought it in 1900 and made certain that it would find its way into the national collections. In fact, he persuaded the American collector John Quinn, who bought the picture from him, to leave it to the Louvre.

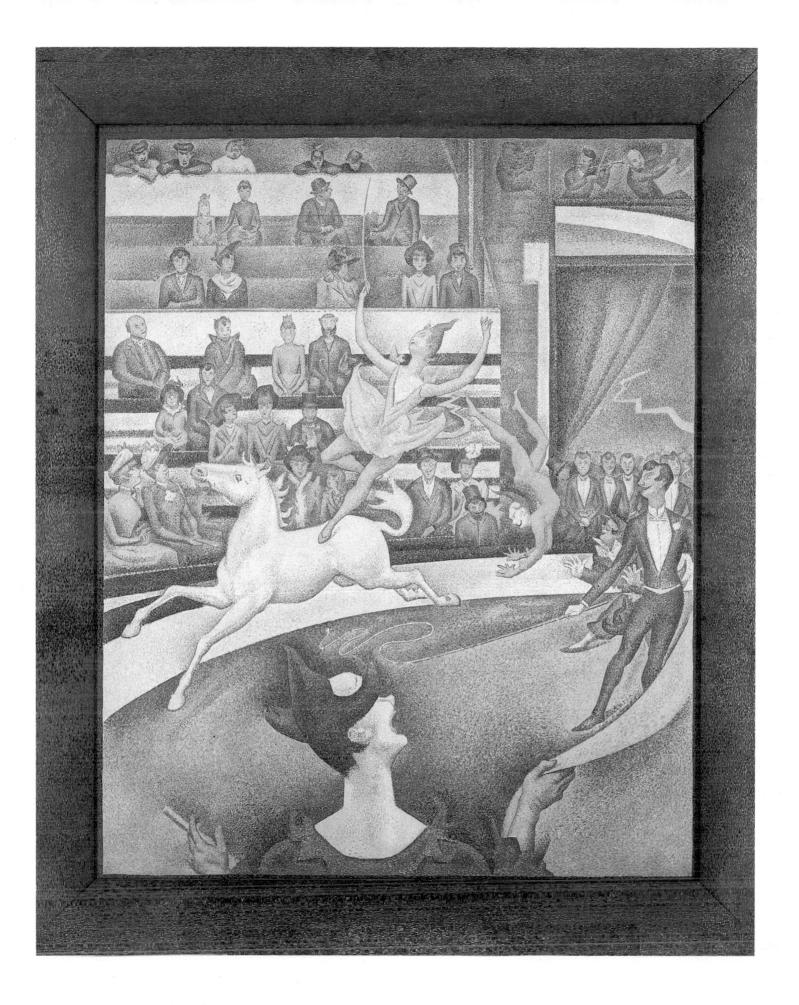

Henri-Edmond CROSS (1856–1910)

Les Iles d'Or (The Isles of Gold), 1892

Oil on canvas, $23\frac{1}{4} \times 21\frac{1}{4} (59 \times 54)$

Purchased at the Fénéon sale, 1947 (R.F. 1977–126)

Cross was, like Seurat and Signac, a founder member of the Société des Artistes Indepéndants in 1884, but only adopted a Divisionist technique some time later, around 1891, most conspicuously in the large portrait of Madame Cross which is now in the Musée d'Orsay.

A man from the north of France (he came from Douai), Cross was in advance of his colleagues, among them Signac, in his discovery of the Mediterranean landscape of the Midi. He settled at Cabasson, near Le Lavandou, in 1891.

'I can see the sea near by, and the mountain chain of Les Maures, and far away in the distance the Iles d'Hyères, so beautiful that people call them the Isles of Gold.' Thus wrote the Belgian poet Emile Verhaeren, a friend of the artist, in a letter written as a preface to Cross's exhibition at the Galerie Druet in Paris in 1905. The islands in question are those of Levant, Port-Cros and Porquerolles, which cut into the distant line of the horizon as one looks out to sea from Saint-Tropez. This painting, with its composition of coloured bands – sand, sea, sky – is heavily influenced by the Japanese prints which were rousing the enthusiasm of artists at this epoch. A schema of the same sort is sometimes used by the great Japanese artist Hokusai.

What Cross has done, in this particularly audacious work, is to combine an almost abstract variation – in the musical sense of the term – on colour with a visual representation of the sense of wonder one experiences when one is actually confronted with the Mediterranean landscape in all its brilliance. The brushmarks grow gradually smaller as they approach the top of the canvas, which gives an illusion of infinite distance, and the artist makes much play with gentle colour harmonies containing a great deal of white. The subtlety of Cross's researches into colour influenced Matisse when he was moving towards Fauvism (see p. 198).

176

Théo van RYSSELBERGHE (1862–1926)

Voiliers et estuaire (Sailing Boats on an Estuary), c.1892-93

Oil on canvas, $19\frac{5}{8} \times 24$ (50 × 61) Purchased in 1982 (R.F. 1982–16)

Théo van Rysselberghe was a friend of the poet Emile Verhaeren and a founder member of *Les XX* in Brussels; he played a leading role in the artistic relationship between France and Belgium.

When he first saw Seurat's manifesto painting, Un dimanche après-midi dans l'île de la Grande Jatte (A Sunday Afternoon on the Island of La Grande Jatte, Art Institute, Chicago) at the eighth and last Impressionist exhibition, or perhaps at the Salon des Indépendants, in 1886, he disliked it, but was later instrumental in bringing it to Brussels in 1887 for exhibition with Les XX, where it was accompanied by six landscapes painted at Grandcamp and Honfleur. The next year he played a part in the presentation at the Les XX exhibition of works by Signac, Dubois-Pillet and Cross, other adherents of Neo-Impressionism. He himself then adopted their methods, using them for both portraits and landscapes. From 1889 to 1895 he concentrated exclusively on a Divisionist technique, but thereafter gradually abandoned this. He saw landscapes by Seurat again at the Les XX show in 1891, and also at the posthumous retrospective of 1892. It seems likely that he painted Voiliers et estuaire at this time, but, because documentation is lacking, it is difficult to tell whether it was among his landscapes then being shown in Paris and Brussels. The tight handling and the general tonality of the painting suggest a comparison with Gros nuages (Large Clouds, Holliday Collection, Indianapolis Museum of Art), which dates from 1892.

This landscape, even more than *L'homme à la barre* of 1892 (*Man at the Helm*, also in the Musée d'Orsay), is a superb example of Van Rysselberghe's Neo-Impressionist manner, in theme as well as technique. It allies the classic rigour of a deliberately stylized composition to the systematic use of fragmented touches of colour – lighter and darker blues, carmine, yellow, orange, green and white – according to the principles of optical mixing and the 'law of simultaneous contrasts' adopted by Seurat. One can justly apply to this painting the fine phrase used by the critic of *La Plume* on 1 April 1898, when he declared that Van Rysselberghe's art showed 'all the luminous beauty the new school can offer.'

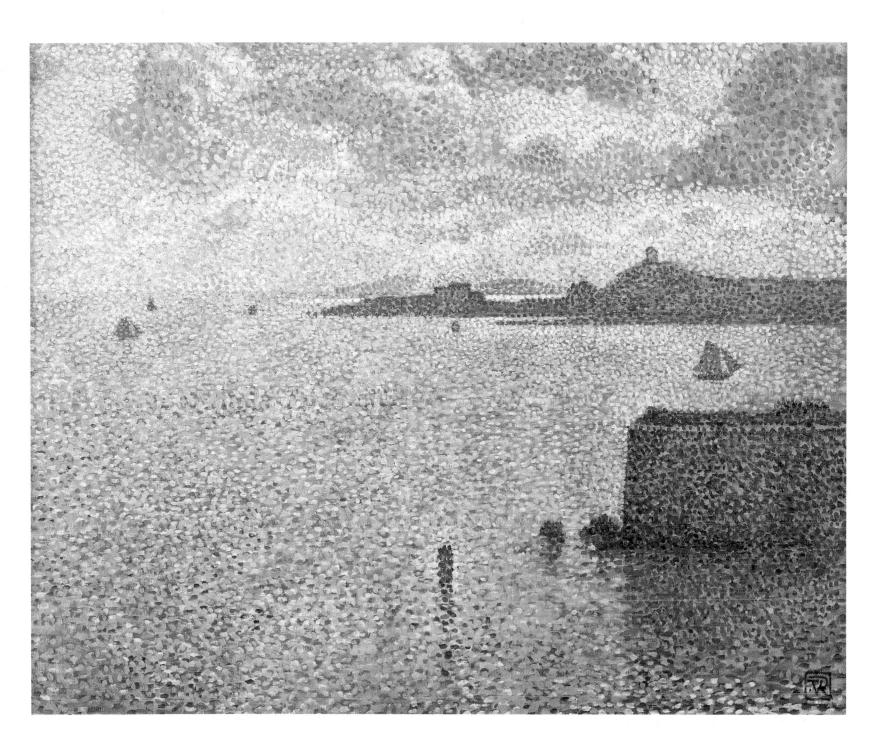

Paul SIGNAC (1863–1935)

Les femmes au puits (Women at the Well), 1892

Oil on canvas, $76\frac{3}{8} \times 51\frac{1}{4} (194 \times 130)$

Purchased from the artist's daughter, Mme Ginette Signac, 1979 (R.F. 1979–5)

Shown at the ninth Salon des Indépendants in 1893, under the title Provençales au puits, décoration pour un panneau dans la pénombre (Provençal Women at the Well, Decorative Panel to be Seen in Half*light*), this painting provides one of the most extreme examples of the application of Divisionist theory. It also marks a turning-point in the career of the artist, following the death of Seurat in 1891 and the disarray that ensued in the ranks of the Neo-Impressionists. Thanks to the repeated recommendations of his friend Cross, Signac discovered the little village of Saint-Tropez on the Côte d'Azur, and soon established himself there in a villa overlooking the sea (where this painting was hung until recently). Obsessed at this time by the problems posed by decorative painting on a large scale, he borrowed the general arrangement of his composition from Puvis de Chavannes, but used a Divisionist technique to push beyond Puvis's wan harmonies of blue and grey. The definitive version was preceded by numerous studies, both drawn and painted (now also in the Musée d'Orsay), which show the considered way in which it was developed. The painting is brilliant in colour, and the rigorous composition is based on the symbolism of lines which fascinated Seurat (see p. 174). This symbolism is placed at the service of the essentially decorative character of the work, in which can be traced early evidence of the Art Nouveau arabesque. The broken touch juxtaposes the various hues according to their position in the colour circle, and their contrasts are stressed so as to attain maximum luminosity. The effect is reinforced by the stippled blue frame, painted by the artist himself. Seductive to a modern audience through its acid charm and its tendency towards extremism, this painting was little understood in its own time; even Gauguin made fun of it for being too systematic. Although Signac's subsequent evolution towards a free style contradicted the tendencies shown here, it was Les femmes au puits, and other paintings like it that influenced the artists who were to become the Fauves, and most notably Matisse when he stayed with Signac in 1904. CF-T

Paul SIGNAC (1863–1935)

La bouée rouge (The Red Buoy), 1895

Oil on canvas, $31\frac{7}{8} \times 25\frac{5}{8} (81 \times 65)$

Gift of Dr P. Hébert, but retained by him for his lifetime, 1957; entered the national collections in 1973 (R.F. 1957–12)

Signac loved sailing, and was delighted by the little port of Saint-Tropez, then still almost unknown, when he arrived there in 1892. The tall houses of the port and its brightly painted fishing boats provided him from then on with one of his chief sources of inspiration. It was at this time that Saint-Tropez began to emerge as a favourite haunt of painters, and was launched on its rise to fame. *La bouée rouge* is a good example of the way in which Signac's style evolved after 1892 (see p. 180). Without giving up Divisionism, he moved away from the over-restrictive theories of Neo-Impressionism. Minute dots gave way to a broader touch which allowed greater spontaneity and expressiveness. But chromatic experiment remained his central concern, as is demonstrated by the watercolour studies done from life which preceded the execution of this painting. Its subject is the reflections made by a red buoy in the water, which the painter dissolves into a multitude of brush-strokes, balanced by complementary blue-orange hues whose contrasts are reinforced with white.

La bouée rouge was among the works Signac sent to the avant-garde Salon of the Libre Esthétique in Brussels in 1896, and then to the Salon des Indépendants in Paris the following spring. Its brilliance was remarked upon, particularly by Thadée Natanson, editor-in-chief of the famous *Revue Blanche*, who wrote about it as follows: 'It achieves a luminous vibrancy of colour and shows a wonderful compositional ingenuity in filling the picture space, which compel admiration: it breathes serenity. [Signac] makes admirable use of paint in *La bouée rouge*.'

Henri de TOULOUSE-LAUTREC (1864–1901)

Jane Avril dansant (Jane Avril Dancing), c.1892

Paint on cardboard, $33\frac{5}{8} \times 17\frac{3}{4} (85.5 \times 45)$

Antonin Personnaz bequest, 1937 (R.F. 1937–37)

Toulouse-Lautrec was a descendant of the Counts of Toulouse, and was born at Albi in 1864. A bone disease and two successive accidents meant that he grew up deformed; he caricatured his own appearance in bitter self-portraits. His gifts as a draughtsman were evident even in childhood. To begin with, he was influenced by the animal-painter René Princeteau, and by the English artist John Lewis-Brown. Later he did *académies*, or studies of the male nude, in the studio of Bonnat, who described his drawing as 'simply awful', then in 1883 moved to Cormon's studio, where he met Van Gogh. In the mid 1880s, he settled in Montmartre.

Both the theatre and the café-concerts which were then popular gave him the opportunity to exercise his powers of observation. At the Moulin Rouge, he admired the dancer Jane Avril (1868–1923), nicknamed 'La Mélinite' ('Dynamite'), whose subtlety and elegance formed a contrast to the vulgarity of La Goulue. Here, wearing a white mousseline dress with a green sash, black stockings and a hat, she is lifting her skirts to perform one of the dance-steps so much admired by Lautrec. The man in the background, seated in a box, is Mr Warner, the subject of Lautrec's lithograph *The Englishman at the Moulin Rouge* (1892). Jane Avril made solo appearances at the Jardin de Paris, for which Lautrec did a poster in 1893.

Although Lautrec's work shows certain similarities with that of Degas – a taste for subjects taken from contemporary life, a passion for movement expressed through nervously incisive line, an interest in the novel compositional formulae suggested by Japanese prints, and a wish to rival the immediacy of photographs – their respective worlds, and the models they used, were quite different.

SG-P

Henri de TOULOUSE-LAUTREC (1864–1901)

Le lit (*The Bed*), *c*.1892

Paint on cradled panel, $21\frac{1}{4} \times 27\frac{3}{4}$ (54 × 70.5) Antonin Personnaz bequest, 1937 (R.F. 1937–38)

In his quest for the true and the natural, Lautrec was attracted from 1891 onwards by *maisons closes*, or licensed brothels, and he went so far as to live in them for a while, so as to gain the confidence of the girls and observe them freely. Never passing judgment, he shows them dressing or doing their hair, or surprises them as they exchange melancholy confidences, sitting waiting on red velvet divans, or huddled underneath the bedclothes. In *Le lit* two female heads, turned towards one another, half visible amid the sheets, are seen in bold perspective, outlined against the pillows. The coverlet which occupies the foreground is cut off by the frame and contrasts with the whiteness of the sheets.

Lautrec was particularly successful in rendering the cloistered atmosphere of this milieu. The studies he made in the brothels culminated in the ambitious composition *Au Salon (In the Salon,* 1894, Musée d'Albi, oil and pastel), and in the album of a dozen lithographs now called *Elles*, but first entitled *La fille (The Tart,* 1896). The theme of prostitution often occurs in the literature of the time, for example in Maupassant and Zola. SG-P

Henri de TOULOUSE-LAUTREC (1864–1901)

La clownesse Cha-U-Kao (The Female Clown Cha-U-Kao), 1895

Paint on cardboard, $25\frac{1}{4} \times 19\frac{1}{4}$ (64 × 49)

Count Isaac de Camondo bequest, 1911 (R.F. 2027)

In addition to Jane Avril, Lautrec was inspired by another artist who appeared at the Moulin Rouge: the female clown Cha-U-Kao. (Her name is a pun on the untranslatable French *chahut*, meaning a hurly-burly, and 'chaos', describing the reaction the performer evoked.) In this painting, one of several that Toulouse-Lautrec did of her, she is seen seated on a divan in her dressing room, putting on her yellow ruff, which winds around her in a spiral, and is echoed by the yellow ribbon on the topknot of her amusing wig. To the left is a table covered with a cloth and set for a meal, while the mirror hanging on the wall shows a man in evening dress. The intensity of colour and line heralds the approach of Fauvism and Expressionism.

'Only the figure counts; landscape is, and should always be, only an adjunct', Lautrec said once to Maurice Joyant, admitting his lack of interest in plein-air painting. He was concerned to render the personalities of his models, and did so with 'prodigious facility', according to Paul Leclercq, one of the founders of *La Revue Blanche*. In his book of memoirs, *Autour de Toulouse-Lautrec* (1921), he writes: 'I have a very clear recollection that I posed no more than two or three hours. . . . He peered at me through his eye-glasses, screwed up his eyes, took his brush, and having made a thorough examination of what he wanted to see, used diluted paint to make two or three light brush-strokes upon the canvas. . . .'

This portrait of a clown is also a reminder of Lautrec's passion for the circus. Towards the end of his life he produced *Au cirque (At the Circus)*, an astonishing suite of drawings done from memory; and also made use of the same theme in 1888, in his painting *Au Cirque Fernando*, *l'écuyère (Bareback Rider at the Cirque Fernando*, Art Institute, Chicago). From 1889 onwards this picture was on view at the Moulin Rouge, where Seurat saw it before tackling the same theme in a very different manner (see p. 174).

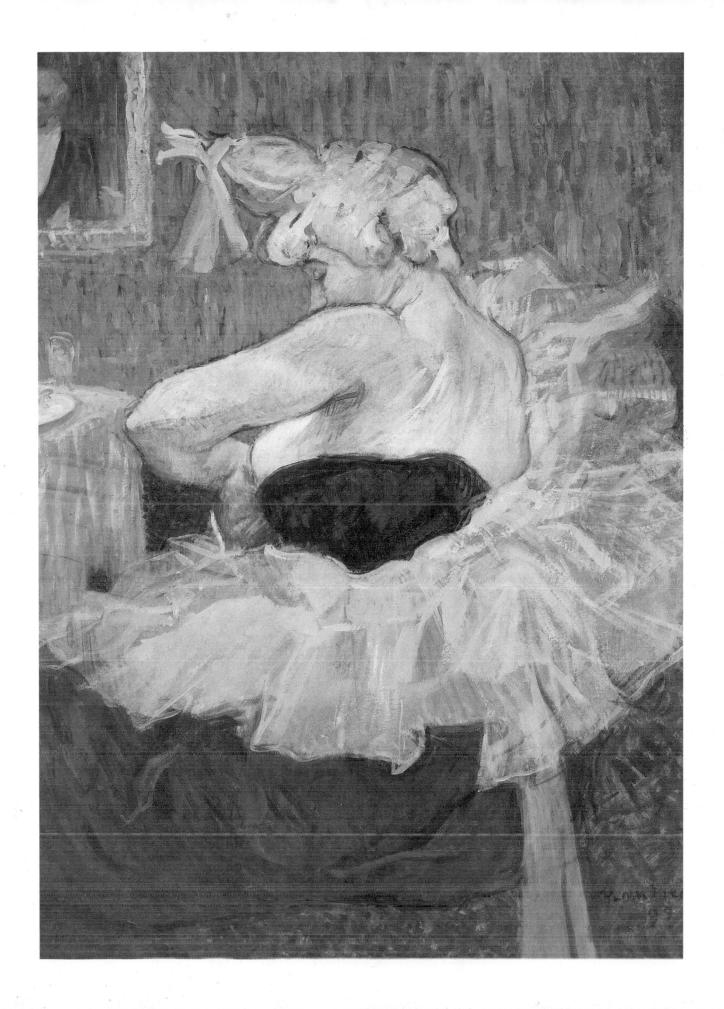

Henri de TOULOUSE-LAUTREC (1864–1901)

La danse mauresque or Les Almées (The Moorish Dance or The Oriental Dancing Girls), 1895

Paint on canvas, $112\frac{1}{4} \times 121$ (285 × 307.5) Purchased in 1929 (R.F. 2826)

In 1895 Toulouse-Lautrec made two large decorations for the front of La Goulue's booth at the Foire du Trône. She had been one of his favourite models some years previously in Montmartre, and on 6 April 1895 she wrote to him as follows: 'Dear friend ... my booth will be at the Foire du Trône – I have an excellent site, and would be extremely pleased if you could find time to paint something for me ...'

To the left of the entrance, the painter chose to create a reminder of La Goulue's past – her performances at the Moulin Rouge with Valentin-le-Désossé ('The Boneless Wonder'). She owed her nickname ('The Glutton') to her notorious capacity for food, while her partner owed his to his gangling figure. This was also the time when La Goulue was the chief performer in the *quadrille naturaliste* with La Môme Fromage ('The Cheese Kid'), Nini-patte-en-l'air ('Nini-paws-in-air') and Grille d'Egout ('Sewer Grating'). But now, having put on weight, she had to do something different.

The canvas shown here, placed to the right of the entrance, shows what she was doing in 1895. Dressed as an oriental dancing girl, she did exotic numbers of the kind usually known as 'belly dances'. Lautrec shows her accompanied by two seated figures, also in oriental costume. The pianist is the photographer Paul Sescau, and in the foreground to the left there is the imposing figure of the writer Oscar Wilde, wearing a top hat, and next to him Jane Avril in black, with her characteristically large hat. To her right, Lautrec represented himself, wearing a bowler, and at his side is the critic Félix Fénéon, of *La Revue Blanche*, recognizable by his distinctive profile.

These two paintings, shown at the Salon d'Automne in 1904, were unfortunately cut up by their owner in 1926. They were restored to their original form once they had been bought by the Louvre in 1929, some months after the death of La Goulue.

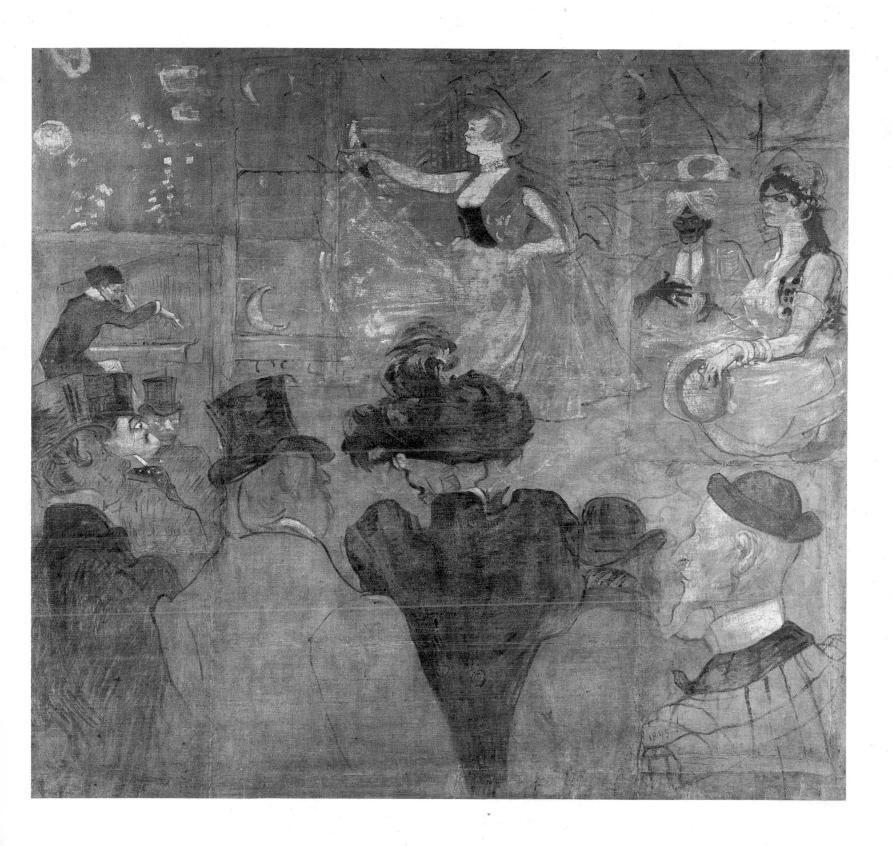

Henri de TOULOUSE-LAUTREC (1864–1901)

La toilette (The Toilet), 1896

Paint on cardboard, $26\frac{5}{8} \times 21\frac{1}{4}$ (67 × 54) Pierre Goujon bequest, 1914 (R.F. 2242)

Lautrec liked to show women in the intimacy of their daily lives, dressing, doing their hair, or washing themselves. He shared Degas' interest in realism, and tackled the same themes just as directly (see p. 48). His technique, too, is often close to that adopted by Degas: he uses very dilute paint, and the medium is absorbed by the cardboard support which sometimes remains visible under the rapid brush-strokes.

La toilette is one of the rare works by Lautrec where the painter demonstrates no interest in the features of the model; he has instead deliberately shown her from the back. Her torso is bare and her red hair is caught in a chignon low on the nape of her neck. In the background, a bathtub and two wicker armchairs are visible. The towels spread about the room give an impression of disorder which seems to emphasize the intimate character of the scene.

At this time Lautrec's alcoholism was affecting his health, and in 1899 he was put into a sanatorium in Neuilly, in an attempt to dry him out. He later went to live with his mother at the Château de Malromé, and there finished his brief life. His merit is to have experimented successfully in many different types of art, and to have found ways of expressing the artificial euphoria typical of the *fin de siècle*. Unaffiliated to any school, he was nevertheless the precursor of Expressionism; Rouault and Picasso were among his earliest admirers.

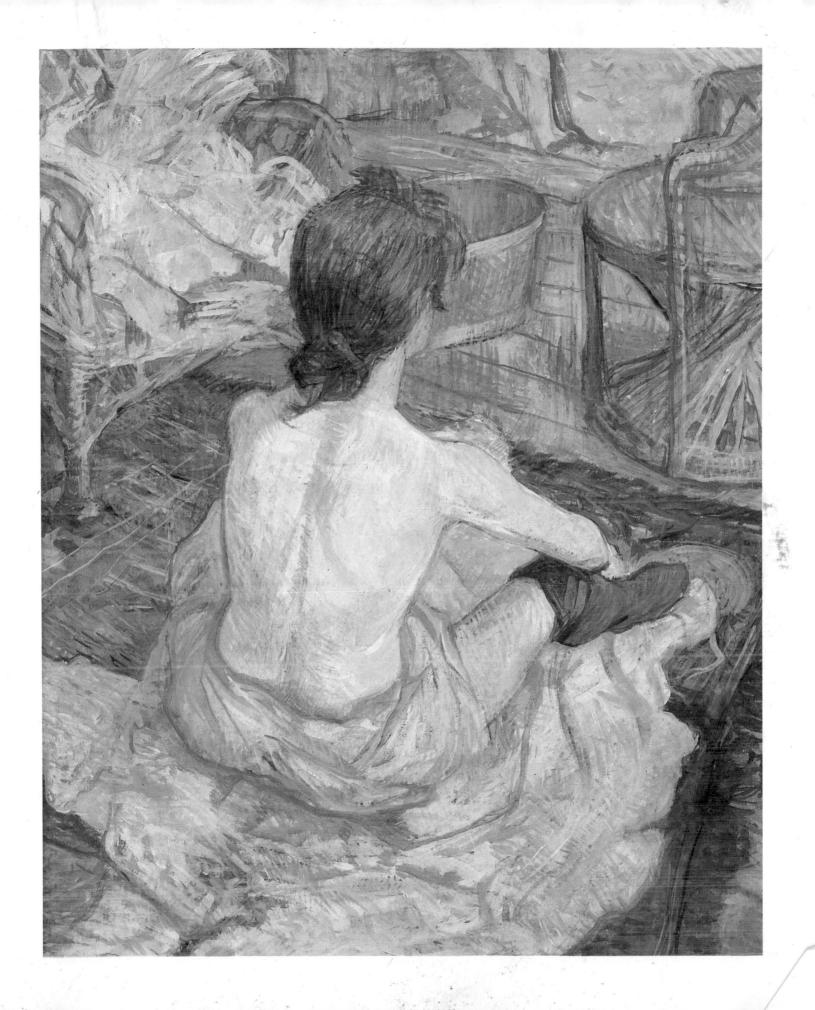

Emile BERNARD (1868–1941)

Madeleine au Bois d'Amour (Madeleine in the Bois d'Amour), 1888

Oil on canvas, $54 \times 64\frac{3}{8}$ (137 × 164) Purchased in 1977 (R.F. 1977–8)

Madeleine, the artist's sister, is here shown lying under the trees of the Bois d'Amour, near the bank of the River Aven, which flows through Pont-Aven. This imposing work was painted at the same time as Gauguin's bust-length portrait of Madeleine Bernard, now in the Musée de Grenoble. It marks a crucial moment in the brief friendship between the two artists. They were spending the summer together at Pont-Aven, where they had already met briefly in 1886. But now, from their discoveries and shared experiences, came a new way of painting: Synthetism. Gauguin, who was twenty years older than Bernard, was soon to gain a big reputation from this artistic revolution, both among young artists such as Sérusier (see p. 196), and among writers such as Mallarmé and Albert Aurier, who would laud his pictorial Symbolism. Emile Bernard never forgave him.

Nevertheless, during this summer of 1888 their friendship flourished; and in August Madeleine, accompanied by her mother, came to join her brother at the Auberge Gloanec. She was seventeen, and Gauguin is said to have fallen in love with her. Later she became engaged to the painter Charles Laval, who had accompanied Gauguin to Martinique in 1887; she died in 1895, aged twenty-four.

In the last years of his life Emile Bernard spelt out what his artistic intentions had been in 1888. 'Of course, both Gauguin and I made what were effectively speaking caricatures of my sister, given the ideas we held at that time about rendering character.' He here uses the word 'caricature' to mean the Synthetist deformation which they had elaborated into a style – forms outlined vigorously with blue lines, and a deliberate search for the primitive (which one can perceive in Madeleine's large hands). Bernard's words show an interesting similarity with those used by Maurice Denis about *The Talisman*, in *L'Occident* in October 1903: 'We understood that every work of art is a transposition, a caricature, the passionate equivalent of something perceived through the senses.'

This youthful work betrays a number of different influences – the pose is that of a medieval tomb figure, the atmosphere of the sacred wood comes from Puvis de Chavannes, the manner is Cézannesque, and the composition itself is a transposition in reverse of a print by Klinger, *The Beginning of Spring* (no. 4 of his *Opus I*). Emile Bernard probably knew this image – it had been shown in Brussels in 1879, and Klinger himself was at that time much appreciated in France, thanks to the perceptive account of his work given by Jules Laforgue in the *Gazette des Beaux Arts* for August 1883; and thanks, too, to his own stay in Paris between 1883 and 1886.

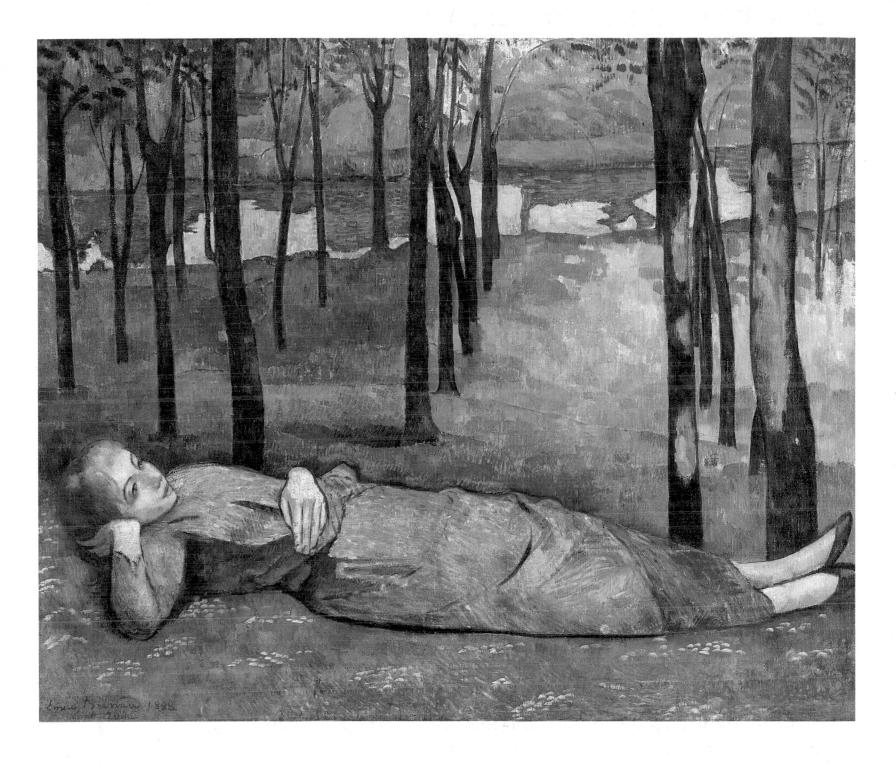

Paul SÉRUSIER (1864–1927)

Le talisman (The Talisman), 1888

Oil on panel, $10\frac{5}{8} \times 8\frac{5}{8}$ (27 × 22) Purchased in 1985 (R.F. 1985–13)

All his life Maurice Denis kept this little panel, which shows the trees of the Bois d'Amour reflected in the River Aven. Like Bonnard and Ranson, he studied in the little studios of the Académie Julian, where in 1888 Sérusier became the student in charge of collecting dues. These young artists, fascinated by the esoteric, and soon to come together as the Nabis, made this painting their talisman, because it brought them the liberating message of Gauguin and Symbolism, to whose banner they immediately rallied.

Earlier in the year Sérusier had made his Salon début with a thoroughly conventional painting, Le Tisserand (The Weaver, Musée de Senlis), but his meeting with Gauguin that summer was to provoke a remarkable change of direction. He spent the summer at Pont-Aven, a little Breton village very fashionable with artists at the time, putting up at the Auberge Gloanec, where Gauguin was also a guest. It was only at the end of his stay that, thanks to Emile Bernard, he was able to make Gauguin's acquaintance and seek his advice. During the immediately previous months, the young Bernard and Gauguin had elaborated a new Synthetist aesthetic, and Bernard had produced such major works as Madeleine au Bois d'Amour (p. 194), and Vision après le Sermon (The Vision after the Sermon, National Galleries of Scotland, Edinburgh). It was in October that Sérusier painted Le talisman under direct supervision from Gauguin. The story was told by Maurice Denis on several occasions, notably in an article published in L'Occident in 1903, just after Gauguin's death, and a second time in his book *Théories*, in 1910: 'When we arrived back after the summer holidays of 1888, the name of Gauguin was revealed to us by Sérusier, who had just returned from Pont-Aven. He showed us, not without an air of mystery, a cigar-box lid on which could be seen a landscape distorted by Synthetist formularization. It was done in violet, vermilion and Veronese green, with colours straight from the tube, and almost no admixture of white. "How do you see that tree?" Gauguin had said to him, when they were looking at a corner of the Bois d'Amour. "Is it green? Then make it green – use the finest green on your palette. And that shadow – perhaps it is blue? Don't be afraid to make it as blue as possible." We were thus confronted for the first time, in paradoxical and unforgettable guise, with the potent idea that a painting consists of "a flat surface covered with colours arranged in a certain order"." GL

Henri MATISSE (1869–1954)

Luxe, calme et volupté, 1904

Oil on canvas, $38\frac{5}{8} \times 46\frac{1}{2} (98 \times 118)$

Acquired in lieu of estate duties, 1982 (A.M. 1982–96P); on deposit from the Musée National d'Art Moderne, 1985 (DO 1985–1)

Luxe, calme et volupté, also called Les baigneuses (The Bathers), was purchased by Signac from the Salon des Indépendants of 1905. Matisse had painted it while staying with Signac at Saint-Tropez the previous year. A key work in the artist's evolution, it is equally interesting from the historic and the aesthetic point of view, as it illustrates the friendly relationship between the two men as well as the conflict between their respective attitudes, and serves as a summary of Neo-Impressionism's contribution to the development of modernism. It demonstrates how, in the first few years of the twentieth century, Neo-Impressionist theory moved in the direction of modernist abstraction, under the influence of Matisse and his peers.

Luxe, calme et volupté takes its arcadian theme from the great decorative compositions of Puvis de Chavannes, such as *Doux Pays (The Gentle Land,* Musée Bonnat, Bayonne), but also from the decoration done by Signac for Montreuil Town Hall. This, entitled *Au temps d'harmonie (Harmonious Times)*, was painted in 1893–95. Matisse also had in his own collection a particularly fine painting of *Bathers* by Cézanne, now in the Petit Palais, Paris. In 1904, following Signac's example, Matisse made conscientious use of Neo-Impressionist principles, but the brilliance of the result cannot conceal the contradictions from which the painter suffered. These are lucidly analysed in a letter to Signac written on 14 July 1905, in particular the conflict Matisse experienced between colour and line: 'Did you find, in my painting of *Bathers*, perfect congruity between the character of the drawing and the character of the painting? To me, they seem totally different from one another, and even completely contradictory. Drawing depends on line and plasticity; painting depends on colour.' In the same year Matisse broke with Divisionism, and the result was the explosion of Fauve colour to be seen in *La femme au chapeau (Woman in a Hat*, private collection), which was shown at the memorable Salon d'Automne of 1905.

Now that he was free to use colour to full expressive effect – largely as a result of his Divisionist phase – Matisse began to accentuate the monumental and decorative aspect of his work, a tendency which is already perceptible in *Luxe, calme et volupté*. Through the combination of linear arabesque with areas of flat colour, this tendency underwent a continuous development via *Le luxe (I)* of 1907 and *La danse* of 1910, right up to the celebrated paper cutouts of his last years.

LIST OF PLATES Page numbers are shown in bold

BAZILLE, Frédéric (1841-70) L'atelier de la rue de La Condamine, 1869-70 16.

BERNARD, Emile (1868-1941) Madeleine au Bois d'Amour, 1888 194.

BOUDIN, Eugène (1824-98) La plage de Trouville, 1864 78.

CAILLEBOTTE, Gustave (1848-94) Voiliers à Argenteuil, c.1888 130.

CASSATT, Mary (1844-1926) Femme cousant, c. 1880-82 128.

CÉZANNE, Paul (1839-1906)

Une moderne Olympia, c.1873-74 62. La maison du pendu, Auverssur-Oise, 1873 64. L'Estaque: vue du golfe de Marseille, c.1878-79 66. Le vase bleu, c.1885-87 68. La femme à la cafetière, c.1890-95 70. Les joueurs de cartes, c.1890-95 72. Baigneurs, c.1890-92 74. Nature morte aux oignons, c.1895 76.

CROSS, Henri-Edmond (1856-1910) Les Iles d'Or, 1892 176.

DEGAS, Edgar (1834–1917)

La famille Bellelli, 1858-60 34. L'orchestre de l'Opéra, c.1868-69 36. La classe de danse, c.1873-75 38. L'absinthe, 1876 40. L'étoile (La danseuse sur la scène), 1878 42. Chevaux de courses devant les tribunes, c.1879 44. Les repasseuses, 1884 46. Le tub, 1886 48.

GAUGUIN, Paul (1848–1903)

Les Alyscamps, Arles, 1888 142. Les meules jaunes (La moisson blonde), 1889 144. Le repas, 1891 146. Femmes de Tahiti (Sur la plage), 1891 148. Portrait de l'artiste, c.1893-94 150. Paysannes bretonnes, 1894 152. Vairumati, 1897 154. Le cheval blanc, 1898 156.

GOGH, Vincent van (1853-90)

L'Italienne, 1887 158. L'Arlésienne (Madame Ginoux), November 1888 160. La salle de danse à Arles, 1888 162. Portrait de l'artiste, 1889 164. La chambre de Van Gogh à Arles, 1889 166. Le docteur Paul Gachet, 1890 168. L'église d'Auvers-sur-Oise, 1890 170.

MANET, Edouard (1832-83)

Portrait de M. et Mme Auguste Manet, 1860 18. Le déjeuner sur l'herbe, 1863 20. Olympia, 1863 22. Le fifre, 1866 24. Portrait d'Emile Zola, 1868 26. Le balcon, 1868–69 28. Sur la plage, 1873 30. La serveuse de Bocks, 1879 32.

MATISSE, Henri (1869–1954) Luxe, calme et volupté, 1904 198.

MONET, Claude (1840-1926)

Femmes au jardin, 1866–67 80. La pie, c.1869 82. L'hôtel des Roches Noires à Trouville, 1870 84. Les coquelicots, 1873 86. Le pont d'Argenteuil, 1874 88. La gare Saint-Lazare, 1877 90. La rue Montorgeuil: fête du 30 juin 1878 92. L'église de Vétheuil, 1879 94. Femme à l'ombrelle tournée vers la gauche, 1886 96. La cathédrale de Rouen, le portail, temps gris, 1892 98. La cathédrale de Rouen, le portail et la tour Saint-Romain, plein soleil, harmonie bleue et or. 1893 100. Nymphéas bleus 102.

MORISOT, Berthe (1841-95) Le berceau, 1872 126.

PISSARRO, Camille (1830–1903)

Entrée du village de Voisins, 1872 50. Coteau de l'Hermitage, Pontoise, 1873 52. Portrait de l'artiste, 1873 54. Jeune fille à la baguette, 1881 56. Femme dans un clos, soleil de printemps dans le pré à Eragny, 1887 58. Le port de Rouen, Saint-Sever, 1896 60.

REDON, Odilon (1840–1016) Port breton, nd 132. Les yeux clos, 1890 134. Le Bouddha, c. 1905 136. Parsifal, c.1912 138. La coquille, 1912 140.

RENOIR, Pierre-Auguste (1841–1919)

La liseuse, c.1874–76 114. Chemin montant dans les hautes herbes. c.1875 116. Le Moulin de la Galette, 1876 118. La danse à la ville. 1883 120. La danse à la campagne, 1883 121. Jeunes filles au piano. 1892 122. Les baigneuses, 1918 124.

Rysselberghe, Théo van (1862–1926) Voiliers et estuaire, c.1892-93 178.

SÉRUSIER, Paul (1864-1927) Le talisman, 1888 196.

SEURAT, Georges (1859–91) Port-en-Bessin, avant-port, marée haute, 1888 172. Le cirque, 1891 174.

SIGNAC, Paul (1863-1935) Les femmes au puits, 1892 180. La bouée rouge, 1895 182.

SISLEY, Alfred (1839-99)

Le Chemin de la Machine à Louveciennes (La route, vue du chemin de Sèvres), 1873 104. Le brouillard, Voisins, 1874 106. L'inondation à Port-Marly, 1876 108. La neige à Louveciennes, 1878 110. Le canal du Loing, 1892 112.

TOULOUSE-LAUTREC, Henri de (1864–1901)

Jane Avril dansant, c. 1892 184. Le lit, c. 1892 186. La clownesse Cha-U-Kao, 1895 188. La danse mauresque (Les Almées), 1895 190. La toilette, 1896 192.